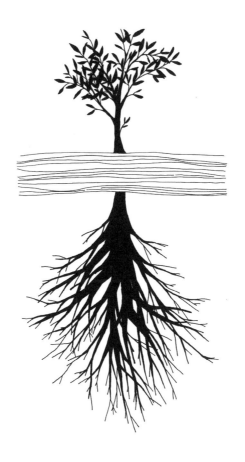

아리따가 자라온 과정은 차나무의 생장과 닮았습니다.
차나무는 키가 작습니다. 봄이면 화려한 꽃 대신 여린 잎으로 존재감을 드러냅니다.
하지만 땅 위의 소박한 모습과 달리 아래의 뿌리는 매우 거대합니다.

A process of Arita typeface development resembles the growth of a tea tree. Tea trees are short, and they reveal their existence with their tender leaves in spring, instead of flamboyant flowers. However, unlike what's revealed above ground, their roots are enormous.

차나무의 키보다 세 배 이상 자라는 뿌리는 땅은 물론 바위까지 뚫는
강인한 생명력을 지니고 있습니다. 제대로 뿌리 내린 차나무는 땅의 자양분을
잘 흡수해 1년에 열 번까지 찻잎을 수확할 수 있다고 합니다.

The roots grow more than three times the size of the tree itself, with a powerful vitality that can pierce through the ground, and even rocks. A tea tree that has properly taken root can adequately absorb nourishment from the ground, which makes it possible to harvest the tea leaves up to 10 times a year.

아리따 또한 많은 분의 애정을 자양분으로 어느덧 한글, 로마자, 중국의 한자까지
향기롭게 그 영역을 넓혔습니다. 품격있는 말씨와 글씨는 진정한 아름다움입니다.
아모레퍼시픽은 아리따를 '멋지음'으로써 아름다운 말씨와 글씨를 지니기 시작했습니다.

The Arita typeface has been able to expand its scope from Korean to Latin and Chinese characters. The elegance of any language is truly beautiful. By designing Arita, Amorepacific established its own beautiful "language" through the creation of the Arita family.

이제 아리따로 세상과 이야기합니다.

그리고 여기에서 아리따의 이야기를 나누려 합니다.

서경배, 아모레퍼시픽그룹 대표이사 회장

Now we are talking to the world in Arita,
and we are going to share our Arita story with the world.

Suh Kyungbae, Chairman & CEO of Amorepacific Group

아리따 말씨

Arita Diction

아리따 글씨

Arita Writing

아리따 말씨

Arita Diction

Arita Sans

Arita Sans

Arita Sans

Arita Sans

Arita Sans

아리따 산스
아리따 산스는 2012년 발표한 아리따의 첫 번째 로마자 글꼴입니다.
아리따 돋움의 굵기에 맞춰 총 다섯 종으로 개발했습니다.
아리따 산스는 휴머니스트산세리프 humanist sans serif 계열의 글꼴로서
부드럽고 우아한 표정을 지니고 있습니다.

Arita Sans
Arita Sans, presented in 2012, is the first Latin alphabet
typeface of Arita. It has five derivatives according to the weight
of Arita Dotum. Arita Sans is a part of Humanist Sans Serif,
and has a soft and refined style.

아리따 돋움

아리따 돋움

아리따 돋움

아리따 돋움

아리따 돋움

아리따 돋움
한글 글꼴을 만들 때 굵기는 대체로 기본 굵기를 중심으로 일정하게
파생합니다. 그러나 아리따 돋움은 글꼴이 어디에 쓰일지 고민하고
그 쓰임을 기준으로 굵기를 정해 활용성을 높이고자 했습니다.

Arita Dotum
When creating a typeface in Hangeul, different weights are
derived around the default weight. With Arita Dotum, however,
we were concerned about where the typeface would be used and
specified the weight based on usage to increase its usability.

가족 【아리따 가족 구성】

아리따는 한글, 로마자, 한자, 총 세 개의 언어, 열여덟 종의
글꼴가족으로 이루어져 있습니다. 글꼴 모양에 따라 쓰임이
다르기 때문에 글꼴마다 굵기를 다르게 개발했습니다.
다양한 목적에 맞도록 가장 얇은 '헤어라인hairline'에서
'볼드bold'까지 그 범위를 넓혀나갔습니다.

➡ p.120 일상에서 만난 아리따

Family 【Arita Family Composition】

Arita consists of three languages—Korean, the
Latin alphabet, and Chinese characters—
18 fonts in total. We developed various weights
because different fonts have different usages
depending on their shapes. We extended
weights from the thinnest, "HairLine," to "Bold,"
for a variety of purposes.

➡ p.120 Arita in Everyday Life

꼴【형태에 관해】

아리따는 주제어인 '건강함' '아름다움' '모던함'을
유기적인 형태로 담았습니다. '곧은 기역(ㄱ)' '손글씨의
곡선' 등 인상을 좌우하는 형태에서 지읒(ㅈ)과 비읍(ㅂ)의
모양, 시옷(ㅅ)의 내림, 이음보의 연결 방법에 이르기까지
글꼴의 특징을 세밀하게 다듬었습니다.

➡ p.106 벱씨를 만드는 노력

Form【About Arita's form】

Arita represents the keywords "healthy,"
"beautiful" and "modern" in an organic form.
The typefaces have been refined, from impression-
driven shapes, such as the straight *giyeok* (ㄱ)
and the curves of handwriting, to the shape of
jieut (ㅈ), and to how *bieup* (ㅂ) and *siot* (ㅅ) fall,
and how the joints are connected.

➡ p.106 Efforts for Improvement

아리따 부리

아리따 부리

아리따 부리

아리따 부리

아리따 부리

아리따 부리
아리따 부리는 아리따 돋움, 아리따 산스와 같이 다섯 종의 굵기를
개발했습니다. 씬thin보다 가는 헤어라인은 제목용 글꼴로도
사용할 수 있습니다. 헤어라인은 기존 한글 글꼴에 없던 새로운 굵기의
글꼴로 글꼴가족의 범위를 확장해 사용자가 폭넓게 사용할 수 있습니다.

Arita Buri
It was also made available in five different weights, just as Arita
Dotum and Arita Sans were. The thinnest weight, however, is
HairLine, which is thinner than the conventional Thin font, and
it can also be used for titles. This type of HairLine was the first
attempt in Korean type design of its kind, and has widened the
scope of the font family and its application.

阿丽达黑体

阿丽达黑体

阿丽达黑体

아리따 흑체

아리따 돋움과의 조화를 위해 아리따 돋움 다섯 종의 굵기를 참고했습니다. 흑체 라이트light는 아리따 돋움의 씬과 라이트 사이, 흑체 볼드는 아리따 돋움의 세미볼드semibold와 볼드 사이의 굵기로 만들었습니다.

Arita Heiti

Five weights of Arita Dotum were taken into consideration for determining Arita Heiti's ultimate weights. The final weight of Heiti Light was found to be somewhere between the Thin and Light of Arita Dotum, while Heiti Bold's ideal weight was found between the SemiBold and Bold of Arita Dotum.

Bold

제목용 굵기. 주목성이 강하므로 눈에 띄게 강조할 부분에 사용한다.
A weight for titles. This has received much attention, and can be utilized for emphasis.

SemiBold

소제목용 굵기. 본문용 굵기와 함께 본문을 강조할 때 사용한다.
A weight for subtitles. It can be used to highlight the body along with a weight for the body.

Medium

본문용 굵기. 디자인 작업에서 기본이 되는 굵기이다.
A weight for the body text, an essential weight in design works.

Light

본문용 굵기. 사용설명서와 같이 크기가 작은 작업물에 사용하면 가독성이 높다.
A weight for the body text that is highly readable when it is used for small-sized documents, such as a user manual.

Thin

본문용 굵기. 크기가 작고 굵기가 가늘어 작은 공간에서 밀도 있게 사용할 수 있다.
A weight for the body text. It is small in size and light in weight, so it can be used in small spaces with density.

HairLine

제목용 굵기. 한글 글꼴 디자인에서 최초로 시도한 굵기이다.
A weight for titles. This represents the first weight attempted in Korean typeface design.

글꼴가족

한글 열 종, 로마자 다섯 종, 한자 세 종, 총 열여덟 종의 글꼴가족으로
이루어져 있습니다. 글꼴가족마다 최적의 글꼴 이미지를 형상화할 수 있는
디자이너와 검수자를 선발했으며 한글의 모든 글자를 표기하는 데
불편이 없도록 기본자 외에 확장자를 개발해 만들었습니다.

Font Family

Arita is a font family consisting of 18 fonts in total: 10 in Korean,
five in the Latin alphabet, and three in Chinese characters. We
have selected the best designers and directors who can realize
the optimum font images for each font. In addition to the basics,
we have also expanded our development to include extensions so
that there is no difficulty in expressing all the letters in Hangeul.

19

곧은 기역(ㄱ)

아리따 돋움과 아리따 부리의 '곧은 기역(ㄱ)'은 기역(ㄱ)의 세로 줄기가 아래로 뚝 떨어지는 형태가 특징입니다. 고문서에서 볼 수 있는 곧은 기역(ㄱ)의 형태를 현대적으로 표현하고자 했습니다. 손글씨와 같은 유연한 움직임과 간결한 형태로 곧은 기역(ㄱ)을 완성했습니다.

Straight Giyeok(ㄱ)

Arita Dotum and Arita Buri feature the straight *giyeok* (ㄱ) shape, in which the horizontal stroke of *giyeok* (ㄱ) falls sharply downward. We tried to modernize the straight *giyeok* (ㄱ) that appears in ancient texts. That is why we completed it in the form of flexible movements and concise shapes, like hand-written letters.

꼭지, 기둥

아리따 돋움과 아리따 부리의 '치읓(ㅊ)' '히읗(ㅎ)' 꼭지는 왼쪽에서
오른쪽으로 부드럽게 휘어져 있습니다. 'ㅠ'의 왼쪽 기둥 곡선은 손으로
글씨를 쓸 때의 유연한 느낌을 담았습니다.

Stroke, Vertical Stroke

In Arita Dotum and Artia Buri, the short strokes in *chieut* (ㅊ)
and *hieut* (ㅎ) are curved downward smoothly. The soft curve in
the left column of the character *yu* (ㅠ) offers the fluid feel
of handwriting.

파임

아리따 돋움의 시옷(ㅅ) 계열 낱자에서 두 줄기가 만나는 부분은
뭉쳐보이는 문제점을 보완하기 위해 파임^{ink trap}을 적용했습니다.

Ink Trap

Paim (ink trap) is applied to resolve the problem of *siot* (ㅅ)
and affiliated letters of Arita Dotum where the intersection of
two diagonal lines look stuck together, as with glue.

꺾임, 내림, 맺음
아리따 부리는 글자 쓰는 순서를 꺾임에 반영하고, 손글씨의
곡선을 획의 맺음에 반영했습니다. '시옷(ㅅ)' '지읒(ㅈ)'의 내림은
꽃잎 형태에서 따왔습니다.

Angle, Downstroke, Terminal
In Arita Buri, angles reflect the order of writing letters, and the
terminals reflect the curves of handwriting. The downstrokes in
siot (ㅅ) and *jieut* (ㅈ) suggest the shape of a petal.

둥근 모서리

아리따 산스는 획의 끝 한쪽 모서리를 둥글게 처리했습니다.
직선과 곡선이 어우러진 형태는 강인하고 부드러운 인상을 줍니다.

Rounded Edges

In Arita Sans, one edge of the stroke is with a curve. The rounded
edge in harmony with the straight line gives both strong and soft
impressions at the same time.

너비【간격에 대한 고민】

한글은 전체 낱자의 글자너비가 같은 글꼴이 많습니다. 아리따는 글자줄기가 많고 적음에 따라 글자너비를 다르게 한 비례너비 글꼴입니다. 예를 들어 세로 줄기가 두 개인 '니'에 비해 줄기가 여섯 개인 '빼'의 너비가 넓습니다. 이로써 글자사이가 고르게 배열되어 조화로운 판짜기를 할 수 있습니다.

➡ p.160 아리따 돋움 · 한재준

Width【Concerns over Spacing】

Hangeul has many typefaces with the same width of entire letters. Arita consists of proportional fonts that vary the width of letters depending on the number of vertical strokes. For example, the width of "빼," which has six vertical lines, is wider than "니," which has two upward strokes. This allows a harmonized typesetting by even arrangement of the text.

➡ p.160 Arita Dotum · Han Jaejoon

928

950

947

900

898

910

980 940 950 920 900 910

910 950 910 960

980 900 1000

글자에 따른 너비값
Width Value for Each Character

비례너비
아리따는 조화로운 판짜기를 위해 낱자의 너비가 각각 다른 비례너비
글꼴로 만들었습니다. 비례너비 글꼴을 사용하면 글자사이가 일정해져
글줄 흐름이 자연스럽습니다.

Proportional Space
Arita consists of proportional fonts, and each letter is different
in width to ensure a harmonized layout. Proportional fonts allow
the flow of text lines to be natural with their consistent space
between letters.

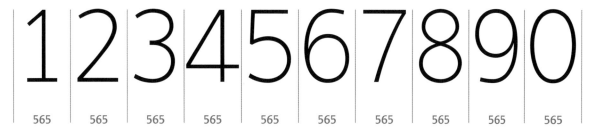

| 565 | 565 | 565 | 565 | 565 | 565 | 565 | 565 | 565 | 565 |

고정너비 숫자
Tabular Figures

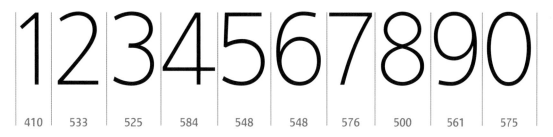

| 410 | 533 | 525 | 584 | 548 | 548 | 576 | 500 | 561 | 575 |

비례너비 숫자
Proportional Figures

고정너비 숫자

숫자는 고정너비와 비례너비, 두 종류로 만들었습니다. 고정너비 숫자는
모든 숫자의 너비값이 같아 표를 만들 때 자릿수가 가지런해보이고
비례너비 숫자는 본문에 사용하면 글자사이를 고르게 배열할 수 있습니다.

Tabular Figures

Figures are designed in two forms: tabular and proportional
figures. Tabular figures are neatly arranged to align numerals in
a numeration table; proportional figures show a natural flow in
a sentence with consistent spaces between letters.

디지털【글꼴에 필요한 기술】

16년 동안 아리따를 개발하면서 글꼴에 필요한 기술을
연구하고 적용했습니다. 인쇄뿐 아니라 화면에서도
깔끔하게 보이도록 글자 윤곽선을 다듬는 힌팅hinting
기술과 오픈타입open type 기능을 적용해 기호를 쉽고
다양하게 사용할 수 있습니다.

➡ p.47 아리따 부리 문장부호

Digital【Techniques for Typeface】

Over the 16 years we developed Arita, we
studied and applied the technology needed for
fonts. Using hinting technology and an open-type
function that trims the outline of a letter to make
it look neat—not only for printing but also for
the screen—the symbols are used in a variety of
aesthetically pleasing and diverse ways.

➡ p.47 Arita Buri Punctuation Marks

= AMOREPACIFIC

= (주)아모레퍼시픽

단축키

아리따 부리에는 아모레퍼시픽의 로고를 빠르게 입력할 수 있는 단축키가 포함되어 있습니다. 악센트 기호(`)와 숫자 1을 연달아 누르면 영문 로고를, 악센트 기호(`)와 숫자 2를 연달아 누르면 한글 로고를 입력할 수 있습니다.

Shortcuts

Arita Buri includes a useful keyboard shortcut feature that enables quick access to the Amorepacific logo. For the English logo, you can press the grave accent mark and the number 1; for the Korean logo, press the grave accent mark and the number 2.

힌팅

힌팅은 화면에서 글자가 뚜렷하게 보이도록 글자 형태를 변형하는
기술입니다. 아리따는 인쇄뿐 아니라 화면에서도 형태 왜곡이 없도록
글자 윤곽선을 다듬는 힌팅 기술을 적용했습니다.

Hinting

Hinting is a technique that transforms the shape of a character
so that it is more clearly visible on the screen. Arita applied it
to refine the contour of letters to make them appear without
distortion, not only in print, but also on the screen.

-67, 0

-398, 0

330, 0

0, 57

0, 337

0, -562

-161, 0

161, 0

-69, 0

-470, -45

471, 43

0, 443

0, -217

67, 0

따옴표【쓰임을 고려한 문장부호】

문장구조와 글의 의도를 명확하게 전달하기 위해 문장부호를 사용합니다. 아리따는 한글, 로마자, 한자의 쓰임을 고려해 글꼴별로 다른 형태의 문장부호를 만들었습니다. 아리따와 함께 아리따 문장부호를 사용하면 시각흐름선이 자연스러워집니다.

Quotation Marks【Punctuation in Written Text】

We use punctuation marks to convey the structure of sentences and the intent of the text. Arita created different types of punctuation marks for each font, depending on whether it was for Korean, Latin, or Chinese characters. When you use Arita's punctuation marks, it creates a natural visual flow line.

Exclamation Mark	Quotation Mark	Number Sign	Dollar Sign	Percent Sign	Ampersand
!	"	#	$	%	&

Apostrophe	Left Parenthesis	Right Parenthesis	Asterisk	Plus Sign	Comma
'	()	*	+	,

Hyphen-Minus	Full Stop	Solidus	Colon	Semicolon	Less-Than Sign
-	.	/	:	;	<

Equals Sign	Greater-Than Sign	Question Mark	Commercial At	Left Square Bracket	Right Square Bracket
=	>	?	@	[]

Left Single Quotation Mark	Right Single Quotation Mark	Left Double Quotation Mark	Right Double Quotation Mark	En Dash	Em Dash
'	'	"	"	–	—

Won Sign	Euro Sign	Degree Celsius	Degree Fahrenheit	Script Small L	Numero Sign
₩	€	℃	℉	ℓ	No.

Left Curly Bracket	Right Curly Bracket	Left-Pointing Double Angle Quotation Mark	Right-Pointing Double Angle Quotation Mark	Division Sign	Plus-Minus Sign
{	}	«	»	÷	±

아리따 돋움 문장부호
아리따 돋움은 글자와 문장부호의 어울림을 고려해 디자인했습니다.
시각흐름선이 자연스러워 보이도록 위칫값을 개선하는 과정을 거쳤습니다.

Arita Dotum Punctuation Marks
Arita Dotum is designed to maintain the harmony between letters and punctuation marks. To make the visual flow line look natural, we have improved the position value.

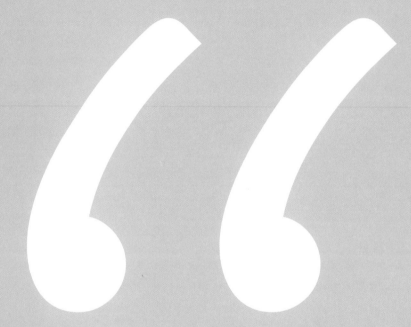

Hyphen-Minus	En Dash	Em Dash
—	—	—

Left Parenthesis	Left Square Bracket	Left Curly Bracket
([{

Middle Dot	Colon	Semicolon
·	:	;

Vulgar Fraction One Quarter	Vulgar Fraction One Half	Vulgar Fraction Three Quarters
¼	½	¾

아리따 산스 문장부호
아리따 산스의 문장부호에는 '건강한 아름다움'을 담고자 했습니다.
아리따 산스의 유연하고 간결한 형태는 친근하고 생동감 넘치는
인상을 줍니다.

Arita Sans Punctuation Marks
Arita Sans tried to capture a sense of "healthy beauty" through
punctuation marks. The simple flexibility of Arita Sans lends an
impression of friendliness and vividness.

" "

66 99

' '

Question Mark	Question Mark	Question Mark
Exclamation Mark	Exclamation Mark	Exclamation Mark
Horizontal Ellipsis	Horizontal Ellipsis	Horizontal Ellipsis
Comma	Comma	Comma

아리따 부리 문장부호
아리따 부리 헤어라인에는 기본 문장부호 외에도 문장부호 두 세트를
더 만들어 디자이너가 다양한 표현을 할 수 있도록 했습니다.

Arita Buri Punctuation Marks
We made two additional punctuation sets besides the basic one
for Arita Buri's HairLine to allow designers to express themselves
more diversely.

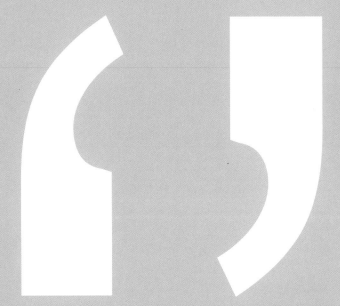

Full Stop	Ideographic Full Stop	Comma	Small Ideographic Comma
.	**○**	**,**	****

Exclamation Mark	Question Mark	En Dash	Em Dash
!	**?**	**–**	**—**

Left Single Quotation Mark	Right Single Quotation Mark	Left Double Quotation Mark	Right Double Quotation Mark
'	**'**	**"**	**"**

Left Parentheisis	Left Curly Bracket	Left-Pointing Double Angle Quotation Mark	Right-Pointing Double Angle Quotation Mark
(**{**	**《**	**》**

Copyright Sign	Resistered Sign	Yen Sign	Cyrillic Capital Letter Straight U With Stroke
©	**®**	**¥**	**Ұ**

아리따 흑체 문장부호

아리따 흑체의 쉼표는 안쪽을 곡선, 바깥쪽을 직선으로 그려 정교하고 부드러운 인상을 줍니다. 겹화살괄호(《》)는 다른 한자 글꼴보다 크기를 작게 디자인해 부드러운 느낌을 더했습니다.

Arita Heiti Punctuation Marks

The comma in Arita Heiti has a curve inside and a straight line outside to provide a soft, delicate impression. The caret brackets (《》) add a graceful touch by designing it smaller than that of other Chinese fonts.

로마자【로마자를 다듬는 과정】

아리따를 통해 전 세계인에게 고운 말씨를 전하고자 하는
여정에서 로마자 글꼴 디자인은 중요한 과제였습니다.
각 글꼴이 지닌 개성과 표정에 맞춰 끊임없이 고민한 끝에
서로 다른 모습의 아리따 로마자 네 종을 완성했습니다.

➡ p.84 어울림을 위한 과정

The Latin Alphabet【The Refining Process】

Through Arita, we share refined languages to
people all over the world. In this journey, the Latin
alphabet design of each font was a vital task.
The four different types of the Arita Latin alphabet
were completed by continuously addressing the
identity and appearance of each font.

➡ p.84 Process for Harmony with Arita

아리따 로마자

아리따 돋움과 아리따 부리의 로마자는 한글과 어울리도록 하는 것에 초점을 맞췄습니다. 아리따 산스는 화장품이나 포장용 상자 등에 작게 쓰일 때를 고려해 폭이 좁은 휴머니스트산세리프 계열로 디자인했습니다. 아리따 흑체 로마자는 아리따 돋움 로마자를 기본으로 흑체의 디자인 특성을 반영했습니다.

Arita Latin Alphabet

The development of the Latin alphabet of Arita Dotum and Buri focused on maintaining balance and harmony with their Korean typefaces. Arita Sans is designed as a kind of Humanist Sans Serif, which has a narrow width, considering the usage of the small typeface, such as cosmetics and packages. For the Arita Heiti Latin alphabet, we reflected the design features of Heiti based on the Latin alphabet of Arita Dotum.

51

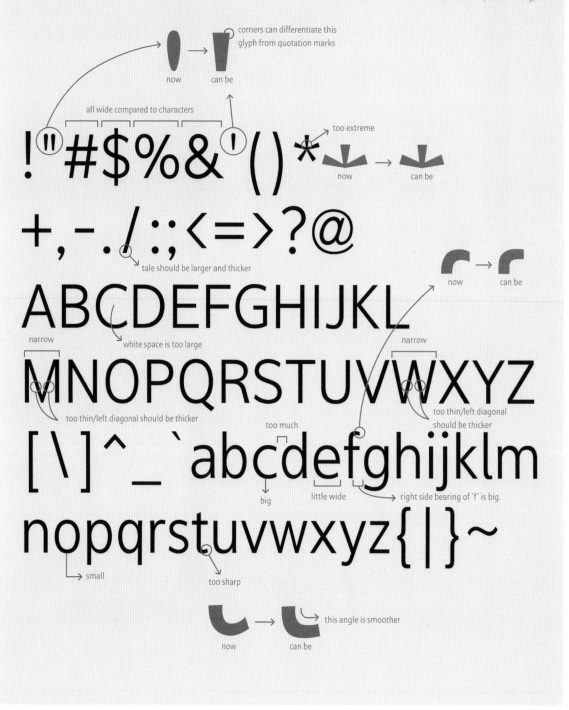

요아힘 뮐러랑세의 아리따 흑체 로마자 검수 자료, 2016. 4. 26
Joachim Muller-lance's evaluation of the Arita Heiti Latin alphabet, Apr. 26, 2016

소문자 [e]의 눈
The Eye of the Lowercase [e]

소문자 [e]의 눈이 커 보인다. 손글씨 느낌을 주어
소문자 [e]의 눈을 조금 줄일 수 있을 것 같다.
The eye of the lowercase [e] looks big. By reflecting the
impression of the handwriting, it can become slightly smaller.

[R]의 곡선을 더 각지게
Make It More Angular with the Round of the [R]

대문자 [R]의 오른쪽 위 곡선이 급하게 떨어지는 것 같다.
조금 더 가서 떨어지면 좋겠다.
The upper curve of the uppercase [R] falls too sharply.
Thus, it is better if it has a more rounded curve.

각진 [e]와 둥글린 [e]
An Angulated [e] and a Rounded [e]

가운데 이어지는 선의 끝을 위로 올리거나 둥글게 처리할 수 있다.
둥글게 처리하는 방법은 한글과 한자의 각진 느낌과 어울리지 않을 것이다.
The horizontal stroke can be moved upward or rounded at its edge.
However, rounding the edge might not match with Korean
and Chinese typefaces, which have an angulated sense.

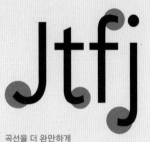

곡선을 더 완만하게
Gentler Curves

[J]의 끝부분 곡선이 상대적으로 급격하게 끝난다.
[t]와 [f]의 끝부분이 급하게 꺾이므로 약간 완만하게 수정하면 좋겠다.
The curve at the end of [J] is generally too stiff.
The bent edges of [t] and [f] show the same feature,
so it is better to modify them with a slightly wider curve.

소문자 [a]의 획이 얇은 부분
Thinner Part of the Lowercase [a]

[a]는 이어지는 곳이 얇아보인다. 작은 크기로 보면
[a]의 위쪽 획은 두꺼워보이고 아래 획은 얇아보인다.
The intersect of [a] looks too thin. In a small format,
its top stroke looks thicker than the bottom.

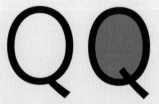

획으로 속공간을 줄이는 방법
A Way to Reduce the Counter with A Stroke

[Q]의 속공간이 커 보인다. [Q] 바깥으로 뻗친 획을
안쪽으로 넣어 속공간을 줄이는 방법이 있다.
The counter of [Q] looks large. There is also a way to reduce the
counter by inserting the diagonal stroke toward the inside of the bowl.

아리따 흑체 글꼴 검수 워크숍 회의록에서, 2016. 4. 26
From the minutes of Arita Heiti Typeface Evaluation Workshop, Apr. 26, 2016

매뉴얼 【바르고 쉬운 쓰임】

좋은 글꼴은 아름다운 타이포그래피와 만났을 때
더 빛납니다. 아리따가 바르고 아름답게 쓰일 수 있도록
타이포그래피 매뉴얼을 제작해 '아리따 글꼴 매뉴얼
4.0'까지 성장시켰습니다. 매뉴얼에는 프로젝트 참여자들의
글꼴 제작 과정을 담고 바른 글꼴 사용을 안내했습니다.

➡ p.84 어울림을 위한 과정

Manual 【Easy and Correct Usage】

Elegant fonts only shine when they meet beautiful
typography. We've created a typography manual
to make Arita fonts look appealing and work
beautifully, and developed it into version 4.0.
The manual transparently describes the
development process of Arita and shows the
recommended use of the fonts.

➡ p.84 Process for Harmony with Arita

Version 1.0

글꼴별, 굵기별로 권장 최소 크기, 적정 크기를 규정해 아리따의 기본 쓰임과 다국어 타이포그래피가 많아지는 환경에 맞춰 다양한 활용 방법을 제시했습니다.
Version 1.0 defines the recommended minimum size and proper size by fonts and weights, suggesting the primary usage of Arita and various ways to apply the fonts and weights in multi-language typographic environments.

Version 2.0

타이포그래피 매뉴얼 1.0에 웹 폰트 이름과 힌팅 내용을 추가했습니다.
Web font names and hinting information were added to the typography manual 1.0.

Version 3.0

타이포그래피 매뉴얼 2.0에 아리따 흑체의 매체별 활자 명세와 섞어짜기 내용을 추가했습니다.
Character statements by their medium and interweavement typography of Arita Heiti were added to typography manual 2.0.

Version 4.0

타이포그래피 매뉴얼 3.0에 아모레퍼시픽의 제목용 글꼴인 APHQ 로마자와 APHQ 한글의 기본 쓰임, 다국어 섞어짜기 내용을 추가했습니다.
The primary usages and multilingual interweavement typography of APHQ Latin alphabet and APHQ Hangeul were added to typography manual 3.0. APHQ is Amorepacific's font for titles.

아모레퍼시픽의 뿌리는 창업자 장원 서성환 선대회장의 어머니인 윤독정 여사가 손수 만들어 팔던 동백 머릿기름에서 시작되었습니다. 1930년대, 머릿기름을 발라 반듯하게 빗어 넘긴 하얀 가르마는 아름다운 여인의 상징이었습니다. 특히, 윤독정 여사는 동백 머릿기름 속에 고이 담긴 우리네 아름다움의 가치를 알았기에 까다롭게 좋은 원료만을 구하고 어렵사리 익힌 기술을 끊임없이 개선해가는 노력을 통해 최고의 동백 머릿기름을 만들어 파는 것으로 고객의 신뢰를 얻었습니다. 뿐만 아니라 윤독정 여사는 손님, 친구, 지나가던 나그네를 위해 언제나 집안 한 켠에 따뜻한

Arita Dotum·Medium 12pt
글줄사이 Interline Space 20 글자사이 Letter Space 0

아모레퍼시픽의 뿌리는 창업자 장원 서성환 선대회장의 어머니인 윤독정 여사가 손수 만들어 팔던 동백 머릿기름에서 시작되었습니다. 1930년대, 머릿기름을 발라 반듯하게 빗어 넘긴 하얀 가르마는 아름다운 여인의 상징이었습니다. 특히, 윤독정 여사는 동백 머릿기름 속에 고이 담긴 우리네 아름다움의 가치를 알았기에 까다롭게 좋은 원료만을 구하고 어렵사리 익힌 기술을 끊임없이 개선해가는 노력을 통해 최고의 동백 머릿기름을 만들어 파는 것으로 고객의 신뢰를 얻었습니다. 뿐만 아니라 윤독정 여사는 손님, 친구, 지나가던 나그네를 위해 언제나 집안 한 켠에 따뜻한 밥 한 끼를 준비해 두는 넉넉한 마음씨를 가지고 있었습니다. 남다른 생활력과 명민함, 그 속의 너그러움과 인정을 바탕으로 사업은 날로 번창하였고, 이런 어머니의

Arita Dotum·Medium 12pt
글줄사이 Interline Space 16 글자사이 Letter Space -50

Amorepacific is rooted in a long history of sustainable sourcing first established by Yoon Dokjeong, who began by creating pure, hand-pressed oil collected from camellia nut trees in the 1930s. Yoon was known for her generosity, and was always ready to provide a meal for a stranger, customer, or friend. She offered a product that connected customers with the simple elegance of the earth, and was committed to passing this purity on to them. Yoon believed in the importance of using the highest quality raw materials and refused to compromise on the quality of single product she sold. Her son, Suh Sungwhan, watched and learned from his mother's spirit of independence, intelligence,

Arita Sans·Medium 12pt
글줄사이 Interline Space 17 글자사이 Letter Space 0

Amorepacific is rooted in a long history of sustainable sourcing first established by Yoon Dokjeong, who began by creating pure, hand-pressed oil collected from camellia nut trees in the 1930s. Yoon was known for her generosity, and was always ready to provide a meal for a stranger, customer, or friend. She offered a product that connected customers with the simple elegance of the earth, and was committed to passing this purity on to them. Yoon believed in the importance of using the highest quality raw materials and refused to compromise on the quality of single product she sold. Her son, Suh Sungwhan, watched and learned from his mother's spirit of independence, intelligence, generosity, and compassion. In 1945, nearly 10 years after Yoon introduced her oil, her son founded Amorepacific, a company that grew from the seeds she planted. Following his dream

Arita Sans·Medium 12pt
글줄사이 Interline Space 14 글자사이 Letter Space -30

아모레퍼시픽의 뿌리는 창업자
장원 서성환 선대회장의 어머니인
윤독정 여사가 손수 만들어 팔던
동백 머릿기름에서 시작되었습니다.
1930년대, 머릿기름을 발라 반듯하게
빗어 넘긴 하얀 가르마는 아름다운 여인의
상징이었습니다. 특히, 윤독정 여사는
동백 머릿기름 속에 고이 담긴 우리네
아름다움의 가치를 알았기에 까다롭게
좋은 원료만을 구하고 어렵사리 익힌
기술을 끊임없이 개선해가는 노력을
통해 최고의 동백 머릿기름을 만들어
파는 것으로 고객의 신뢰를 얻었습니다.
뿐만 아니라 윤독정 여사는 손님, 친구,

Arita Buri · Medium 12pt
글줄사이 Interline Space 20 글자사이 Letter Space 0

아모레퍼시픽의 뿌리는 창업자 장원
서성환 선대회장의 어머니인 윤독정 여사가
손수 만들어 팔던 동백 머릿기름에서
시작되었습니다. 1930년대, 머릿기름을
발라 반듯하게 빗어 넘긴 하얀 가르마는
아름다운 여인의 상징이었습니다. 특히,
윤독정 여사는 동백 머릿기름 속에 고이
담긴 우리네 아름다움의 가치를 알았기에
까다롭게 좋은 원료만을 구하고 어렵사리
익힌 기술을 끊임없이 개선해가는 노력을
통해 최고의 동백 머릿기름을 만들어 파는
것으로 고객의 신뢰를 얻었습니다. 뿐만
아니라 윤독정 여사는 손님, 친구, 지나가던
나그네를 위해 언제나 집안 한 켠에 따뜻한
밥 한 끼를 준비해 두는 넉넉한 마음씨를
가지고 있었습니다. 남다른 생활력과 명민함,
그 속의 너그러움과 인정을 바탕으로 사업은

Arita Buri · Medium 12pt
글줄사이 Interline Space 16 글자사이 Letter Space -50

爱茉莉太平洋的前身可以追溯到创始人徐
成焕会长的母亲尹独亭女士亲手制作销售
山茶花油的岁月。在上世纪30年代，挑开
头路将秀发整齐地梳到两边，抹上发油，
一丝不乱，是端庄贤淑的女性之美的象
征。尹女士深知山茶花油中所蕴含的传统
美之价值，因此不厌其烦地精选上好的原
料，不断进行技术改良，终于研制出最优
质的产品，赢得了顾客的信任。而且她总
是在家中温暖舒适的一隅备好饭菜盛情待
客，无论是客人、朋友还是过路人。凭借
超乎常人的生活能力、敏锐的商业嗅觉和
宽容大度和、热情豁达的品性，她广结人
缘，生意风生水起，兴隆昌盛。在母亲的

Arita Heiti · Medium 12pt
글줄사이 Interline Space 20 글자사이 Letter Space 0

作为富有责任感的企业公民，爱茉莉太平
洋在女性、文化、自然生态三大领域不断
履 行企业社会责任。2016年，"妆典生
命"公益项目全新升级，设立"爱茉莉太
平洋 女性专项基金"，覆盖女性两癌（即
乳腺癌和宫颈癌）全程关护。2016年为
12,000 多名贫困地区女性提供了免费的
两癌筛查，为43,500余名女性组织了相关
健康知识作为富有责任感的企业公民，爱
茉莉太平洋在女作为富有责任感的企业公
民，爱茉莉太平洋在女性、文化、自然生
态三大领域不断履 行企业社会责任。2016
年，"妆典生命"公益项目全新升级，设
立"爱茉莉太平洋 女性专项基金"，覆
盖女性两癌（即乳腺癌和宫颈癌）全程关
护。2016年为12,000 多名贫困地区女性提
供了免费的两癌筛查，为43,500余名女性
组织了相关健康知识作为富有责任感的企
业公民，爱茉莉太平洋在女作为富有责任

Arita Heiti · Medium 12pt
글줄사이 Interline Space 14 글자사이 Letter Space -30

Left column (Arita Dotum · Thin):

6 아모레퍼시픽은 인류의 아름다움과 건강이라는 큰 꿈을 품고 세계를 향해 나아
7 아모레퍼시픽은 인류의 아름다움과 건강이라는 큰 꿈을 품고 세계를
8 아모레퍼시픽은 인류의 아름다움과 건강이라는 큰 꿈을 품고
9 아모레퍼시픽은 인류의 아름다움과 건강이라는 큰 꿈
10 아모레퍼시픽은 인류의 아름다움과 건강이라는
11 아모레퍼시픽은 인류의 아름다움과 건강이
15 아모레퍼시픽은 인류의 아름다을
18 아모레퍼시픽은 인류의 아
20 아모레퍼시픽은 인류의

Arita Dotum · Thin
10pt 이상으로 쓰는 것을 권장하며 8pt 아래로는 쓰지 않는다.
10 pt or larger is recommended, but do not use a size smaller than 8 pt.

Right column (Arita Sans · Thin):

6 A New Beauty that Combines Asian Culture and Western Technologies in perfect h
7 A New Beauty that Combines Asian Culture and Western Technologies
8 A New Beauty that Combines Asian Culture and Western Tech
9 A New Beauty that Combines Asian Culture and Wester
10 A New Beauty that Combines Asian Culture and V
11 A New Beauty that Combines Asian Culture a
15 A New Beauty that Combines Asi
18 A New Beauty that Combin
22 A New Beauty that Cor

Arita Sans · Thin
9pt 이상으로 쓰는 것을 권장하며 7pt 아래로는 쓰지 않는다.
9 pt or larger is recommended, but do not use a size smaller than 7 pt.

Left column (Arita Dotum · Medium):

6 아모레퍼시픽은 인류의 아름다움과 건강이라는 큰 꿈을 품고 세계를 향해 나아
7 아모레퍼시픽은 인류의 아름다움과 건강이라는 큰 꿈을 품고 세계를
8 아모레퍼시픽은 인류의 아름다움과 건강이라는 큰 꿈을 품고
9 아모레퍼시픽은 인류의 아름다움과 건강이라는 큰 꿈
10 아모레퍼시픽은 인류의 아름다움과 건강이라는
11 아모레퍼시픽은 인류의 아름다움과 건강이
15 아모레퍼시픽은 인류의 아름다을
18 아모레퍼시픽은 인류의 아
20 아모레퍼시픽은 인류의

Arita Dotum · Medium
8pt 이상으로 쓰는 것을 권장하며 6pt 아래로는 쓰지 않는다.
8 pt or larger is recommended, but do not use a size smaller than 6 pt.

Right column (Arita Sans · Medium):

6 A New Beauty that Combines Asian Culture and Western Technologies in perfect
7 A New Beauty that Combines Asian Culture and Western Technologie
8 A New Beauty that Combines Asian Culture and Western Tech
9 A New Beauty that Combines Asian Culture and Weste
10 A New Beauty that Combines Asian Culture and V
11 A New Beauty that Combines Asian Culture a
15 A New Beauty that Combines As
18 A New Beauty that Combin
22 A New Beauty that Co

Arita Sans · Medium
8pt 이상으로 쓰는 것을 권장하며 6pt 아래로는 쓰지 않는다.
8 pt or larger is recommended, but do not use a size smaller than 6 pt.

Left column (Arita Dotum · Bold):

6 아모레퍼시픽은 인류의 아름다움과 건강이라는 큰 꿈을 품고 세계를 향해 나아
7 아모레퍼시픽은 인류의 아름다움과 건강이라는 큰 꿈을 품고 세계를
8 아모레퍼시픽은 인류의 아름다움과 건강이라는 큰 꿈을 품
9 아모레퍼시픽은 인류의 아름다움과 건강이라는 큰 꿈
10 아모레퍼시픽은 인류의 아름다움과 건강이라는
11 아모레퍼시픽은 인류의 아름다움과 건강이
15 아모레퍼시픽은 인류의 아름다
18 아모레퍼시픽은 인류의 이
20 아모레퍼시픽은 인류의

Arita Dotum · Bold
11pt 이상으로 쓰는 것을 권장하며 9pt 아래로는 쓰지 않는다.
11 pt or larger is recommended, but do not use a size smaller than 9 pt.

Right column (Arita Sans · Bold):

6 A New Beauty that Combines Asian Culture and Western Technologies in perfe
7 A New Beauty that Combines Asian Culture and Western Technolog
8 A New Beauty that Combines Asian Culture and Western Te
9 A New Beauty that Combines Asian Culture and Wes
10 A New Beauty that Combines Asian Culture and
11 A New Beauty that Combines Asian Culture
15 A New Beauty that Combines As
18 A New Beauty that Combin
22 A New Beauty that Co

Arita Sans · Bold
8pt 이상으로 쓰는 것을 권장하며 6pt 아래로는 쓰지 않는다.
8 pt or larger is recommended, but do not use a size smaller than 6 pt.

Left column, Arita Buri HairLine:

8	아모레퍼시픽은 인류의 아름다움과 건강이라는 큰 꿈을
10	아모레퍼시픽은 인류의 아름다움과 건강이라
12	아모레퍼시픽은 인류의 아름다움과 건
14	아모레퍼시픽은 인류의 아름다운
16	아모레퍼시픽은 인류의 아름
18	아모레퍼시픽은 인류의 ㅇ
24	아모레퍼시픽은 인

Arita Buri · HairLine
16pt 이상으로 쓰는 것을 권장하며 14pt 아래로는 쓰지 않는다.
16 pt or larger is recommended, but do not use a size smaller than 14 pt.

6	아모레퍼시픽은 인류의 아름다움과 건강이라는 큰 꿈을 품고 세계를 향해 ㄴ
7	아모레퍼시픽은 인류의 아름다움과 건강이라는 큰 꿈을 품고 세계
8	아모레퍼시픽은 인류의 아름다움과 건강이라는 큰 꿈을 품
9	아모레퍼시픽은 인류의 아름다움과 건강이라는 큰
10	아모레퍼시픽은 인류의 아름다움과 건강이라
11	아모레퍼시픽은 인류의 아름다움과 건강ㅇ
15	아모레퍼시픽은 인류의 아름다
18	아모레퍼시픽은 인류의 ㅇ
20	아모레퍼시픽은 인류의

Arita Buri · Medium
9pt 이상으로 쓰는 것을 권장하며 7pt 아래로는 쓰지 않는다.
9 pt or larger is recommended, but do not use a size smaller than 7 pt.

6	아모레퍼시픽은 인류의 아름다움과 건강이라는 큰 꿈을 품고 세계를 향해 ㄴ
7	아모레퍼시픽은 인류의 아름다움과 건강이라는 큰 꿈을 품고 세
8	아모레퍼시픽은 인류의 아름다움과 건강이라는 큰 꿈을
9	아모레퍼시픽은 인류의 아름다움과 건강이라는 큰
10	아모레퍼시픽은 인류의 아름다움과 건강이라
11	아모레퍼시픽은 인류의 아름다움과 건강
15	아모레퍼시픽은 인류의 아름ㄷ
18	아모레퍼시픽은 인류의 ㅇ
20	아모레퍼시픽은 인류ㅇ

Arita Buri · Bold
11pt 이상으로 쓰는 것을 권장하며 9pt 아래로는 쓰지 않는다.
11 pt or larger is recommended, but do not use a size smaller than 9 pt.

Right column, Arita Heiti · Light:

6	爱茉莉一直致力于美丽和健康的事业，不懈追求东西方文化的和谐统一，和
7	爱茉莉一直致力于美丽和健康的事业，不懈追求东西方文化的
8	爱茉莉一直致力于美丽和健康的事业，不懈追求东西方
9	爱茉莉一直致力于美丽和健康的事业，不懈追求东
10	爱茉莉一直致力于美丽和健康的事业，不懈追
11	爱茉莉一直致力于美丽和健康的事业，不
15	爱茉莉一直致力于美丽和健康
18	爱茉莉一直致力于美丽和
20	爱茉莉一直致力于美丽

Arita Heiti · Light
10pt 이상으로 쓰는 것을 권장하며 8pt 아래로는 쓰지 않는다.
10 pt or larger is recommended, but do not use a size smaller than 8 pt.

6	爱茉莉一直致力于美丽和健康的事业，不懈追求东西方文化的和谐统一，和
7	爱茉莉一直致力于美丽和健康的事业，不懈追求东西方文化的和
8	爱茉莉一直致力于美丽和健康的事业，不懈追求东西方
9	爱茉莉一直致力于美丽和健康的事业，不懈追求东
10	爱茉莉一直致力于美丽和健康的事业，不懈追
11	爱茉莉一直致力于美丽和健康的事业，不
15	爱茉莉一直致力于美丽和健康
18	爱茉莉一直致力于美丽和
20	爱茉莉一直致力于美丽

Arita Heiti · Medium
8pt 이상으로 쓰는 것을 권장하며 6pt 아래로는 쓰지 않는다.
8 pt or larger is recommended, but do not use a size smaller than 6 pt.

6	爱茉莉一直致力于美丽和健康的事业，不懈追求东西方文化的和谐统一，和
7	爱茉莉一直致力于美丽和健康的事业，不懈追求东西方文化的和
8	爱茉莉一直致力于美丽和健康的事业，不懈追求东西方
9	爱茉莉一直致力于美丽和健康的事业，不懈追求东
10	爱茉莉一直致力于美丽和健康的事业，不懈追
11	爱茉莉一直致力于美丽和健康的事业，不
15	爱茉莉一直致力于美丽和健康
18	爱茉莉一直致力于美丽和
20	爱茉莉一直致力于美丽

Arita Heiti · Bold
10pt 이상으로 쓰는 것을 권장하며 8pt 아래로는 쓰지 않는다.
10 pt or larger is recommended, but do not use a size smaller than 8 pt.

A는 한글과 로마자 모두 아리따 계열을 사용해 굵기, 기준선 등이 안정적으로
어우러진다. B, C, D, E는 아리따 돋움, 아리따 부리와 어울리는 글꼴을 나열했다.
Example A has a balanced combination of elements such as weight and baseline
because Arita fonts have been used for both Korean and the Latin letters.
Examples B, C, D, and E display a list of other typefaces that match Arita Dotum
and Arita Buri for various uses.

마몽드 꽃초 씨씨 크림
Complete Care Cream

Example A.
Arita Dotum · Light 18pt 글자사이 Letter Space 0
Arita Sans · Light 18pt 글자사이 Letter Space 10

마몽드 꽃초 씨씨 크림
Complete Care Cream

Example B.
Arita Dotum · SemiBold 18pt 글자사이 Letter Space 0
Frutiger 55 · Roman 18pt 글자사이 Letter Space -10

마몽드 꽃초 씨씨 크림
Complete Care Cream

Example C.
Arita Dotum · SemiBold 18pt 글자사이 Letter Space 0
Fedra Sans · Normal 18pt 글자사이 Letter Space -20

한율 서리태 안티에이징
Seo Ri Tae Antiaging

Example D.
Arita Dotum · Bold 18pt 글자사이 Letter Space 0
Goudy Oldstyle · Bold 18pt 글자사이 Letter Space 0

한율 서리태 안티에이징
Seo Ri Tae Antiaging

Example E.
Arita Dotum · Bold 18pt 글자사이 Letter Space 0
Palatino · Bold 18pt 글자사이 Letter Space 0

아리따 흑체와 로마자 글꼴
Arita Heiti and Latin Alphabet Typefaces

A는 한글과 로마자 모두 아리따 흑체를 사용해 굵기, 기준선 등이 안정적으로
어우러진다. B, C, D, E는 아리따 흑체와 어울리는 글꼴을 나열했다.
Example A has a balanced combination of elements such as weight and baseline
because Arita Heiti has been used for both Korean and the Latin characters.
Examples B, C, D, and E display a list of other typefaces that match Arita Heiti
for various uses.

夜间锁水修护面膜
Water Sleeping Pack

Example A.
Arita Heiti · Medium 18pt 글자사이 Letter Space 0

夜间锁水修护面膜
Water Sleeping Pack

Example B.
Arita Heiti · Medium 18pt 글자사이 Letter Space 0
Arita Sans · Medium 17.5pt 글자사이 Letter Space 0

夜间锁水修护面膜
Water Sleeping Pack

Example C.
Arita Heiti · Bold 18pt 글자사이 Letter Space 0
Myriad · SemiBold 17.5pt 글자사이 Letter Space 0

夜间锁水修护面膜
Water Sleeping Pack

Example D.
Arita Heiti · Bold 18pt 글자사이 Letter Space 0
Fedra Sans · Medium 17.5pt 글자사이 Letter Space -10

夜间锁水修护面膜
Water Sleeping Pack

Example E.
Arita Heiti · Medium 18pt 글자사이 Letter Space 0
Gotham · Book 17.5pt 글자사이 Letter Space 0

A, B처럼 아리따 돋움을 함께 사용하면 도드라짐 없는 자연스러운 판짜기를 할 수 있다. C, D는 아리따 부리와 어울리면서 색다른 느낌을 준다. When Arita Dotum is used with Chinese typefaces, as in A and B, it is possible to create natural typesetting without being discernible. Examples C and D are harmonized with Arita Buri and create a different impression at the same time.

라네즈 워터 슬리핑 팩
夜间锁水修护面膜

Example A.
Arita Dotum · Bold 18pt 글자사이 Letter Space 0
FZ LanTingHei · DemiBold 17.5pt 글자사이 Letter Space 20

라네즈 워터 슬리핑 팩
夜间锁水修护面膜

Example B.
Arita Dotum · Medium 18pt 글자사이 Letter Space 0
Noto Sans CJK SC · DemiLight 17.5pt 글자사이 Letter Space 20

라네즈 워터 슬리핑 팩
夜间锁水修护面膜

Example C.
Arita Buri · Bold 18pt 글자사이 Letter Space 0
FZ YaSong · DemiBold 17.5pt 글자사이 Letter Space 20

라네즈 워터 슬리핑 팩
夜间锁水修护面膜

Example D.
Arita Buri · Bold 18pt 글자사이 Letter Space 0
HY JinKai · Regular 18.5pt 글자사이 Letter Space 20

A, B처럼 아리따 돋움을 함께 사용하면 도드라짐 없는 자연스러운 판짜기를 할 수 있다. C, D는 아리따 부리와 어울리면서 색다른 느낌을 준다. When Arita Dotum is used with Japanese typefaces, as in A and B, it is possible to create natural typesetting without being discernible. Examples C and D are harmonized with Arita Buri and also create a different impression.

설화수 자정미백수
雪花秀の滋晶美白水

Example A.
Arita Dotum · Medium 18pt 글자사이 Letter Space 0
Hiragino Kaku Gothic · W3 17.5pt 글자사이 Letter Space 0

설화수 자정미백수
雪花秀の滋晶美白水

Example B.
Arita Dotum · Medium 18pt 글자사이 Letter Space 0
Kozuka Gothic · Regular 17.5pt 글자사이 Letter Space 0

설화수 자정미백수
雪花秀の滋晶美白水

Example C.
Arita Buri · Bold 18pt 글자사이 Letter Space 0
TsukuAMDMin · 17pt 글자사이 Letter Space 0

설화수 자정미백수
雪花秀の滋晶美白水

Example D.
Arita Buri · Medium 18pt 글자사이 Letter Space 0
Kyoukasho · Regular 17.5pt 글자사이 Letter Space 0

바탕 생각 【글꼴 디자인 철학】

아리따는 2004년부터 개발을 시작해 개별 글꼴이
완성될 때마다 일반인에게 공개하고 무료로
사용할 수 있도록 했습니다. 아모레퍼시픽은 아리따가
기업 전용 글꼴의 역할뿐 아니라 대중에게 널리 알려져
문화 나눔의 가치가 널리 공유되기를 바랍니다.

➡ p.82 나눔의 가치

A Fundamental Idea 【Typeface Design Philosophy】

The development of Arita began in 2004,
and individual fonts have been released to the
public and distributed free of charge whenever
each font is completed. Amorepacific hopes that
Arita fonts not only serve as corporate fonts,
but also become widely known to the public and
promote the value of sharing.

➡ p.82 The Value of Sharing

아리따 철학

아모레퍼시픽은 '아름다움은 세상을 변화시키는 선물이다'라는
기업 철학을 바탕으로 건강한 아름다움을 세상과 나누기 위해
노력해왔습니다. 아리따는 고운 글씨를 널리 심고 꽃피우기 위한
긴 여정입니다. 아리따가 아름드리나무가 되어 여럿이 사용하고 함께
나누어 더욱 빛나기를 희망합니다.

Arita Philosophy

Based on its corporate philosophy of "Beauty is a gift to change
the world," Amorepacific has been striving to share a healthy
sense of beauty with the world. Developing Arita has been a long
journey to plant and then witness the blossoming of beautiful
types. It is our hope that Arita grows like an enormous tree,
shining ever-brighter as it becomes more widely used.

정정옥립
A Slim and Slender Beauty

꽃과 나무가 하늘을 향해 곧게 뻗은 모습처럼 반듯하고 아름답다.
This represents a flower blooming and a tree standing tall,
just as a woman appears slim and beautiful.

자연미려
A Natural Beauty

푸른 산과 전원, 초원, 강 등 자연이 매우 아름답다.
Green mountains, rivers, vast plains and
the countryside are blissfully beautiful.

기운생동
Lively and Vigorous Charm

글씨나 그림이 지닌 기품, 품격, 정취가 생생하게 약동하다.
Works of calligraphy and paintings exude elegance, dignity,
and a delicate feel to them.

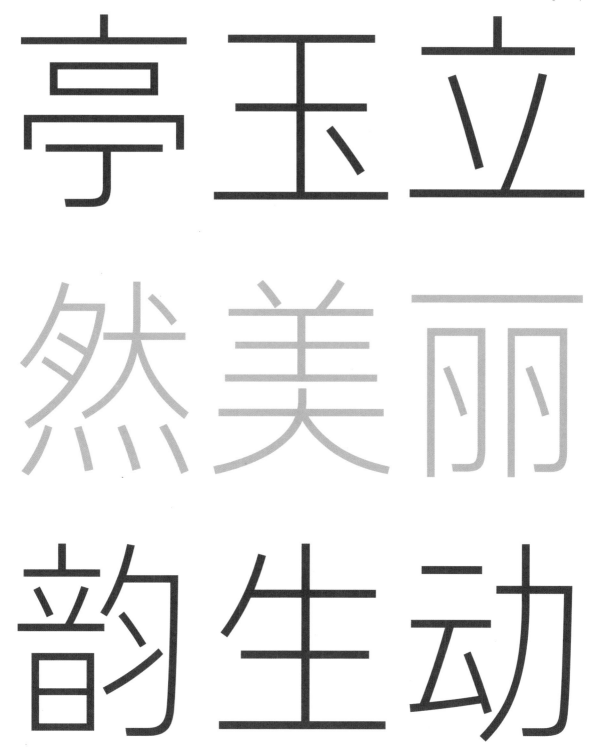

亭玉立

然美丽

韵生动

삐침【전통과 낯선 형태】

아리따 흑체의 필획에는 중국 한나라 예서隸書체를
바탕으로 디자인한 현대적 요소를 적극적으로
반영했습니다. 갈고리, 점, 삐침 등 기존 글꼴에서
반복되던 요소를 글자 판독에 영향을 주지 않는 범위에서
과감하게 정리했습니다. 이처럼 군더더기 없는
간결한 필획은 글자의 형태를 돋보이도록 합니다.

➡ p.238 아리따 흑체·류위

Ppichim【Traditions and Odd Shapes】

Arita Heiti strokes reflect the modern elements
of the writing style referred to as lishu from
China's Han Dynasty. We made a bold effort to
clean up the elements of old fonts, such as hooks,
dots, and *ppichim*, to the extent that they do not
affect legibility. Such simple, neat strokes flatter
the shape of every individual letter.

➡ p.238 Arita Heiti·Liu Yu

1. 세로굽갈고리 제거 Removed hook

2. 창갈고리 제거 Removed hook

3. 수직세로점 Vertical dot

4. 세로굽갈고리 제거 Removed hook

5. 출각 제거 Removed protruding-foot

6. 완만한 평널 Smooth flat stroke

아리따 흑체 글꼴 검수 워크숍 회의록에서, 2016. 1. 25
From the minutes of Arita Heiti Typeface Evaluation Workshop, Jan. 25, 2016

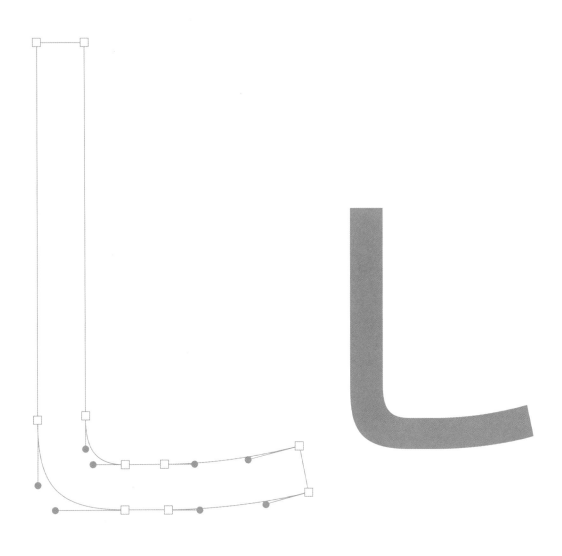

완만한 곡선

아리따 돋움의 필획은 함축성과 간결함이 특징입니다. 필획이 꺾이는 각도와 굽은 선이 과하지 않고 완만하며 부드럽습니다. 아리따 흑체 또한 아리따 돋움의 미감美感을 적용해 가능한 한 적은 수의 점을 이어 곡선을 표현했습니다.

Smooth Curve

Strokes of Arita Dotum are characterized by connotation and simplicity. The angles and curved lines of strokes are not excessive, but actually smooth. We applied the aesthetic sense of Arita Dotum to Arita Heiti, of which curved lines were expressed by connecting as small a number of dots as possible.

아리따 흑체 글꼴 검수 워크숍 회의록에서, 2016. 1. 25
From the minutes of Arita Heiti Typeface Evaluation Workshop, Jan. 25, 2016

받침, 갈고리, 올림, 꺾임

같은 필획이라도 낱자에 따라 형태가 다릅니다. 아리따 흑체는 필획의
받침, 갈고리, 올림, 꺾임의 형태가 변하더라도 시각적으로 일관성이
있도록 다듬었습니다.

Stroke's Support, Hook, Ridge, Break Changes

Even if it is a stroke in the same meaning, it has different
shape depends on the syllabic block. Arita Heiti has been refined
to provide visual consistency even as the shape of the stroke's
support, hook, ridge, and break changes.

속공간【네모 속의 균형감】

속공간은 글자의 표정을 보여주는 중요한 요소입니다.
아리따는 속공간을 균형 있게 다듬고자 했습니다.
글자크기, 줄기 수, 굵기에 따라 상대적인 비례를
유지하도록 끊임없이 보완해 최적의 속공간을 찾았습니다.

➡ p.114 글자 표정 이야기

Counter【Balance in Squares】

The counter is a critical element that shows an
impression of a letter. We wanted to refine
equally balanced counters for Arita fonts.
We continuously supplemented each counter
to maintain relative proportion depending on
the size, number of strokes, and weight of the
glyphs and found the optimal counters.

➡ p.114 The Story of the Typeface Look

아리따 산스 속공간

일반적인 산세리프 sans serif 글꼴의 속공간은 대칭 구조를 이루지만
아리따 산스의 속공간은 비대칭 구조입니다. 글자 폭이 좁은 대신
속공간을 크고 시원하게 해 아리따 산스만의 우아함과 역동성을 동시에
표현하고자 했습니다.

Arita Sans Counter

The counter of a typical Sans Serif typeface is symmetrical, while
the counter of Arita Sans is asymmetrical. Despite the narrow
width of the letters, we wanted to express the elegance and
dynamism of Arita Sans at the same time by making the counter
large and wide.

아리따 돋움 속공간

아리따 돋움은 사각의 자면을 최대한 효과적으로 활용해 속공간을
디자인하고자 했습니다. 판짜기 테스트를 여러 번 진행해 글자크기가
작아질 때 자음과 모음 사이가 뭉쳐보이지 않도록 다듬었습니다.

Arita Dotum Counter

For Arita Dotum, we intended to use the square space for
each letter as effectively as possible to design the counters.
We've run several typesetting tests and refined the consonants
and vowels so that they don't seem stuck together when the
letters get smaller.

아리따 부리 속공간

아리따 부리의 속공간은 아리따 돋움과 비슷한 인상을 주도록
디자인했습니다. 속공간이 커지면 아리따 돋움과 인상이 비슷해지고
속공간이 작아지면 인상이 달라져 상대적 균형을 맞추고자 했습니다.

Arita Buri Counter

Arita Buri's counter was designed to make an impression similar
to Arita Dotum. The larger the counter, the more similar the
impression of the two fonts, while the smaller the counter, the
more different the impression, so we tried to balance it relatively.

아리따 흑체 속공간

'중궁中흠'은 서예에서 글자 구조를 분석하고 훈련하는 방법인
'구궁九흠'에서 나온 개념으로 구궁의 중심 구역을 가리킵니다.
본래 한자 흑체는 중궁이 좁은 편이나 디지털시대가 되면서 화면에서
글자가 잘 보이도록 중궁을 넓히는 방향으로 바뀌었습니다.

아리따 흑체는 흑체가 본래 지닌 자연스러운 손글씨의 아름다움을
담고자 중궁을 다시 좁혔습니다. 중궁이 좁아지면서 여백이 넓어져
그에 따른 필획의 놓임과 교차하는 부분을 더 세밀하게 조정해 글꼴이
자연스러우면서 단정하게 보이도록 했습니다.

Arita Heiti Counter

Zhonggong is a concept derived from jiugong, a method of analyzing and training the character structure of calligraphy, referring to the central part of jiugong. Originally, Heiti fonts for Chinese characters tend to have narrow zhonggong, but in the digital age, they were changed to expand zhonggong so that the characters could have good readability on the screen.

Arita Heiti narrowed zhonggong again to capture the beauty of natural handwriting in Heiti fonts. As zhonggong narrows, blank space expands. Accordingly, the placement and intersections of strokes were further refined to make the font look natural and tidy.

씨앗 【차나무의 생장과 닮은 아리따】

아리따 프로젝트에서 가장 많이 나온 단어는 '씨앗'입니다.
아리따를 멋지었던 열여섯 해는 '아리따'라는 고운 글씨의
씨앗을 심어 꽃피우고 널리 나누는 여정이었습니다.
글꼴을 만드는 과정에서의 수많은 고찰은 현대 한글꼴
연구의 중요한 단서가 되었고, 참여 디자이너는 글꼴 전문
디자이너로 성장해 또 다른 나눔을 실천하고 있습니다.

➔ p.62 글꼴 디자인 철학

Seeds 【Arita and the Growth of Tea Trees】

The most common word in the Arita project is
"seed." The 16 years that we designed Arita were
a journey to plant the seeds of refined writing,
to blossom and spread them all over. Many
considerations in the process of developing
the Arita typeface have become an essential
clue to modern Hangeul typeface studies, and
participating designers have grown to become
professional type designers, giving back to society
through their talents.

➔ p.62 Typeface Design Philosophy

2005년 아리따 돋움 한글을 시작으로 로마자와 한자에
이르기까지 아리따가 자라난 과정은 차나무의 생장과
닮았습니다. 차나무는 키가 작습니다. 봄이면 화려한 꽃 대신
여린 잎으로 존재감을 드러냅니다. 하지만 땅 위의
소박한 모습과 달리 아래의 뿌리는 매우 거대합니다.
차나무의 키보다 세 배 이상 자라는 그 뿌리는 땅은 물론
바위까지 뚫는 강인한 생명력을 지니고 있습니다.
제대로 뿌리 내린 차나무는 땅의 자양분을 잘 흡수해
1년에 열 번까지 찻잎을 수확할 수 있다고 합니다.
아리따 또한 많은 분의 애정을 자양분으로 어느덧 한글,
로마자, 중국의 한자까지 향기롭게 그 영역을 넓혔습니다.

「아리따 흑체 글꼴보기집」 서경배 대표이사 회장 서문

The process of growing Arita fonts from Korean Arita Dotum
(2005) to Latin and Chinese characters resembles the growth of
tea trees. The tea tree is short. In spring, it reveals its presence
with soft leaves rather than colorful flowers. However, unlike
the humble appearance on the ground, the tea roots are very
large. The root of the tea tree, which is more than three times
longer than the height of the tree, shows a strong vitality to
penetrate the ground as well as the rock. The well-rooted tea
trees can harvest tea leaves up to ten times a year thanks to the
well-absorbed nutrients of the ground. The Arita typeface has
also been expanded its area with fragrance to Korean, Latin and
Chinese characters thanks to many people's support.

Arita Heiti Type Specimen Preface by Chairman & CEO Suh Kyungbae

인상【요조숙녀】

아리따의 이미지는 공자가 애독한 300여 수의 시를 모아 엮은 『시경詩經』의 첫 번째 시 「관저關雎」에 등장하는 '요조숙녀'에서 비롯했습니다. 아리따는 단아하고 지적인 멋을 풍기는 요조숙녀의 인상을 글꼴에 담았습니다. 아리따의 부드럽게 휜 글자줄기는 손글씨의 움직임을 반영한 것이며 유연하고 간결한 형태에서는 아리따 고유의 아름다움을 느낄 수 있습니다.

→ p.96 한글꼴을 위한 용어

Impression【A Modest, Virtuous, Young Lady】

Arita's image originates from "窈窕淑女" (a modest, virtuous, young lady) a word from the first piece "Guan ju" in the *Classic of Poetry* which is comprised of more than 300 poems that Confucius himself loved to read. Arita has the impression of such a young lady who is elegant and intelligent. Arita's softly stemmed letters reflect the movement of handwriting, and you can feel the beauty of Arita fonts in their flexible and concise forms.

→ p.96 Terms for Korean Typefaces

동백꽃

동백꽃은 혹독한 추위를 견디며 아름답게 피어납니다. 아모레퍼시픽이
추구하는 '건강한 아름다움'은 동백꽃처럼 강인하고 단아한
아름다움입니다. 아리따는 아모레퍼시픽의 뿌리인 동백의 이미지를
떠올리며 품격있는 글꼴을 만들고 나누었습니다.

Camellia

Camellias blooms beautifully, withstanding the harsh cold.
Amorepacific's "healthy beauty" is as strong and elegant as a
camellia. Arita created and shared a classy typeface, recalling the
image of a camellia, the root of Amorepacific.

저작권【나눔의 가치】

아리따는 기업 전용 글꼴이자 누구나 사용할 수 있도록
배포하는 나눔 글꼴로서, 아름다움의 가치를 사회와
나누고자 하는 아모레퍼시픽의 정신이 담겨 있습니다.
단, 제작물에는 '이 제작물은 아모레퍼시픽의
아리따 글꼴을 사용해 디자인되었습니다.'라는 정보를
표기해야 합니다. 바른 저작권 문화를 통해 나눔의
가치를 널리 실현할 수 있습니다.

Copyrights【The Value of Sharing】

Arita is a corporate typeface as well as a font
family free to the public. It contains Amorepacific's
spirit to share the value of beauty with society.
However, when Arita is used for a production,
it requires to mark proper information by
adding "This product (publication) was designed
using Amorepacific's Arita typeface" in it.
Through fair copyright culture, we can realize
the value of sharing widely.

아리따 글꼴 사용 조건 및 안내
아리따 글자체의 지식재산권은 모두 주식회사
아모레퍼시픽(이하, "아모레퍼시픽")에 있습니다. 아리따
글자체는 무료로 사용할 수 있으며 본 사용규정 안내
전문을 포함하여 재배포하실 수 있습니다. 정확한 사용
조건은 아래 라이선스 전문을 참고하시기 바랍니다.

사용 제한 및 조건
1. 아리따 글자체는 인쇄나 출판, 영상, 웹, 모바일 등에
자유롭게 사용할 수 있습니다. 단, (1) CI 및 BI로의
사용, (2) 아모레퍼시픽과 동종 사업(화장품/생활용품/
건강식품 등의 생산, 판매)을 영위하기 위한 사용(기업
사이트 및 제품 용기와 단상자, 사용설명서를 포함한
모든 패키지에 사용 등), (3)불법, 반사회적 또는
비윤리적 콘텐츠 등 아모레퍼시픽의 이미지 훼손이
우려되는 사용 일체는 금지되며 사용시 이에 대한 책임을
물을 수 있습니다.

2. 아리따 글자체를 수정하거나 다른 포맷으로 변형하여
사용하는 것은 엄격하게 금지됩니다.

3. 아리따 글자체는 폰트 소프트웨어 또는 개별
구성요소인 폰트 자체로 유료로 판매할 수 없습니다.

4. 아리따 글자체는 전체나 부분 여부에 상관 없이
저작권자 안내와 본 라이선스 규정 내용을 포함하는
경우(독립 텍스트 파일, 가독성이 있는 헤더 혹은 유저가
용이하게 열람 가능한 텍스트 파일 혹은 이진파일,
내 기계가 읽을 수 있는 메타데이터 형태 등)에는 다른
소프트웨어와 함께 묶이거나 재배포가 가능합니다.

5. 아리따 글자체는 저작권자인 아모레퍼시픽의
명시적 서면 허가가 있는 경우를 제외하고는 아리따
글자체 명칭 또는 저작권자의 이름을 사용자의 홍보 및
마케팅을 위한 목적으로 사용할 수 없습니다.

6. 아리따 글자체가 사용된 인쇄물, 광고물(온라인 포함)
이미지 등은 아모레퍼시픽이 홍보 목적을 위해 활용할
수 있습니다. 이를 원치 않는 사용자는 언제든지 당사에
요청하실 수 있습니다.

라이선스 종료
본 라이선스는 상기 조건 중 일부라도 부합되지 않으면
무효가 될 수 있습니다.

이용에 대한 책임
아모레퍼시픽은 아리따 글자체의 사용 또는 기타
아리따 글자체의 취급과 관련하여 발생하는 어떠한
책임도 가지지 않습니다.

License for Arita fonts
Permission is hereby granted, free of charge, to use Arita
Fonts for any purposes e.g. printing, publishing, video,
web and mobile, subject to the following conditions:

Restrictions and conditions of use
1. Arita Fonts cannot be used in relation with the
followings:
- to create CI and BI
- to create any content relating to the same field of
business as Amorepacific Corporation, i.e. production
and sales of cosmetics, household items and health
supplement food. This includes all contents related to
companies' websites, all types of packaging such as
product containers, boxes and user guides
- to be used in ways which might defame the reputation
of Amorepacific Corporation such as illegal, antisocial or
unethical contents. Such usage may be held accountable.

2. Modification of Arita Fonts and/or conversion into
other formats are strictly prohibited.

3. Neither the Font Software nor any of its individual
components may be sold by itself.

4. Arita Fonts Software may be bundled, redistributed
and/or sold with any software, provided that each copy
contains the above copyright notice and this license.
These can be included either as stand-alone text files,
human-readable headers or in the appropriate machine-
readable metadata fields within text or binary files as
long as those fields can be easily viewed by the user.

5. The name of Arita Fonts itself or the Copyright Holder
of Arita Fonts shall not be used to promote, endorse
or advertise, except to explicit written consent of
Amorepacific Corporation.

6. Amorepacific Corporation can freely use any printed
materials and advertising images (including online)
using the Arita Fonts for promotional purposes. Users
against such use may request the same at any time.

Termination
This license becomes null and void if any of the above
conditions are not met.

Disclaimer
In no event shall the copyright holder be liable for any
claim, damages or other liability, including any general,
special, indirect, incidental, or consequential damages,
whether in an action of contact, tort or otherwise, arising
from, out of the use or inability to use the font software
or from other dealings in the font software.

짜기【어울림을 위한 과정】

아리따는 지속적인 판짜기 테스트와 검수 워크숍을 진행해 글꼴을 다듬었습니다. 모임꼴별로 모아 판짜기를 해보고, 서로 다른 언어의 글꼴이 잘 어울릴 수 있도록 섞어짜기 워크숍도 했습니다. 글자를 파생할 때마다 판짜기 워크숍을 열어 글꼴의 완성도를 최대한 높이고자 했습니다.

➜ p.54 바르고 쉬운 쓰임

Typesetting【Process for Harmony with Arita】

The Arita typeface has been refined through continuous typesetting tests and evaluation workshops. We put typefaces together in groups and typeset together, and let fonts in different languages mixed so that they become well harmonized together. Whenever we develop derivatives of fonts, we held typesetting workshops to improve their completeness to the fullest.

➜ p.54 Easy and Correct Usage

가까나다따라마바빠사싸아자짜차카타파하

ABCDEFGHIJKLMNOPQRSTUVWXYZ

abcdefghijklmnopqrstuvwxyz 0123456789

.,;:!?''""……——(){}[][]「」『』〈〉《》«»

12pt

아모레퍼시픽은 아시아 고유의 문화와 서구의
기술이 조화를 이룬 새로운 아름다움을
꿈꾸었습니다. 최초의 히트 브랜드 'ABC 식물성
포마드'에서 최초의 한방 화장품 설화수,
그리고 아시아의 가치가 농축된 글로벌 브랜드
AMOREPACIFIC까지, 아모레퍼시픽은 도전과

16pt

아모레퍼시픽은 아시아 고유의 문화와
서구의 기술이 조화를 이룬 새로운
아름다움을 꿈꾸었습니다. 최초의
히트 브랜드 'ABC 식물성 포마드'에서
최초의 한방 화장품 설화수, 그리고

18pt

아모레퍼시픽은 아시아 고유의 문화와
서구의 기술이 조화를 이룬 새로운
아름다움을 꿈꾸었습니다. 최초의
히트 브랜드 'ABC 식물성 포마드'에서
최초의 한방 화장품 설화수, 그리고
아시아의 가치가 농축된 글로벌 브랜드
AMOREPACIFIC까지, 아모레퍼시픽은
도전과 창조정신으로 아시아의 미를
새롭게 만들어 왔습니다. 그 결과,

Arita Buri Medium

가까나다따라마바빠사싸아자짜차카타파하

ABCDEFGHIJKLMNOPQRSTUVWXYZ

abcdefghijklmnopqrstuvwxyz 0123456789

.,:;!?''""…――(){}[]「」『』❶〈〉《》‹›

18pt

아모레퍼시픽은 아시아 고유의 문화와
서구의 기술이 조화를 이룬 새로운
아름다움을 꿈꾸었습니다. 최초의
히트 브랜드 'ABC 식물성 포마드'에서
최고의 한방 화장품 설화수, 그리고
아시아의 가치가 농축된 글로벌 브랜드
AMOREPACIFIC까지, 아모레퍼시픽은
도전과 장조정신으로 아시아의 미를
새롭게 만들어 왔습니다. 그 결과,

12pt

아모레퍼시픽은 아시아 고유의 문화와 서구의
기술이 조화를 이룬 새로운 아름다움을
꿈꾸었습니다. 최초의 히트 브랜드 'ABC 식물성
포마드'에서 최고의 한방 화장품 설화수,
그리고 아시아의 가치가 농축된 글로벌 브랜드
AMOREPACIFIC까지, 아모레퍼시픽은 도전과

16pt

아모레퍼시픽은 아시아 고유의 문화와
서구의 기술이 조화를 이룬 새로운
아름다움을 꿈꾸었습니다. 최초의
히트 브랜드 'ABC 식물성 포마드'에서
최고의 한방 화장품 설화수, 그리고

가까나다따라마바빠사싸아자짜차카카타파하

ABCDEFGHIJKLMNOPQRSTUVWXYZ

abcdefghijklmnopqrstuvwxyz 0123456789

.,;!?''""…‥——(){}[]「」『』【】〈〉《》«»

18pt

아모레퍼시픽은 아시아 고유의 문화와
서구의 기술이 조화를 이룬 새로운
아름다움을 꿈꾸었습니다. 최초의
히트 브랜드 'ABC 식물성 포마드'에서
최고의 한방 화장품 설화수, 그리고
아시아의 가치가 농축된 글로벌
브랜드 AMOREPACIFIC까지,
아모레퍼시픽은 도전과 창조정신으로
아시아의 미를 새롭게 만들어

12pt

아모레퍼시픽은 아시아 고유의 문화와 서구의
기술이 조화를 이룬 새로운 아름다움을
꿈꾸었습니다. 최초의 히트 브랜드 'ABC 식물성
포마드'에서 최고의 한방 화장품 설화수,
그리고 아시아의 가치가 농축된 글로벌 브랜드
AMOREPACIFIC까지, 아모레퍼시픽은 도전과

16pt

아모레퍼시픽은 아시아 고유의 문화와
서구의 기술이 조화를 이룬 새로운
아름다움을 꿈꾸었습니다. 최초의
히트 브랜드 'ABC 식물성 포마드'에서
최고의 한방 화장품 설화수, 그리고

Arita Sans · Medium 20pt
글줄사이 Interline Space 30
글자사이 Letter Space 0

One's manner of speaking is a measure of one's level of sophistication. That said, refined manner of speaking is the essence of true beauty. If we say a corporate identity is the face of a company typographic identity is their manner of speaking. Amorepacific developed Arita, a Korean typeface and began to tailor the way the company speaks. Not only the way it speaks, the company has also been pursuing a beautiful spirit, by sharing the typeface with the public. In January 2012, alongside with the improved Korean version, Arita Dotum 3.0, Amorepacific is proud to introduce Arita Sans, an English version of the typeface.

Arita envisioned a new beauty that combines Asian culture and Western technologies in perfect harmony. From its first hit brand ABC Pomade to its unparalleled oriental medicine-based Sulwhasoo and Arita, a global brand that captures the essence of Asian values, Arita spirit of challenge and creativity has reshaped Asia's beauty. As a result, Arita has, since its inception in 1945, been showered with love and trust from customers to become the most esteemed beauty company

Arita envisioned a new beauty that combines Asian culture and Western technologies in perfect harmony. From its first hit brand ABC Pomade to its unparalleled oriental medicine-based Sulwhasoo and Arita, a global brand that captures the essence of Asian values, Arita spirit of challenge and creativity has reshaped Asia's beauty. As a result, Arita has, since its inception in 1945, been showered with love and trust from customers to become the most esteemed beauty

Arita envisioned a new beauty that combines Asian culture and Western technologies in perfect harmony. From its first hit brand ABC Pomade to its unparalleled oriental medicine-based Sulwhasoo and Arita, a global brand that captures the essence of Asian values, Arita spirit of challenge and creativity has reshaped Asia's beauty. As a result, Arita has, since its inception in 1945, been showered with love and trust from customers to become the most esteemed beauty

Arita envisioned a new beauty that combines Asian culture and Western technologies in perfect harmony. From its first hit brand ABC Pomade to its unparalleled oriental medicine-based Sulwhasoo and Arita, a global brand that captures the essence of Asian values, Arita spirit of challenge and creativity has reshaped Asia's beauty. As a result, Arita has, since its inception in 1945, been showered with love and trust from customers to become the most esteemed beauty

Arita envisioned a new beauty that combines Asian culture and Western technologies in perfect harmony. From its first hit brand ABC Pomade to its unparalleled oriental medicine-based Sulwhasoo and Arita, a global brand that captures the essence of Asian values, Arita spirit of challenge and creativity has reshaped Asia's beauty. As a result, Arita has, since its inception in 1945, been showered with love and trust from customers to become

Arita Heiti·Light 14pt
글줄사이 Interline Space 26
글자사이 Letter Space 0

爱茉莉太平洋集团一直遵循的发展，2004年，韩国 AritaDotum 文字体得到世界范围的认可，其卓越以有田三出的始。这里是历史得出的字

Arita Heiti·Medium 14pt
글줄사이 Interline Space 26
글자사이 Letter Space 0

体作为一种创新尝试开发一种名为 AritaSans 的韩文字体，极细并试图让优雅的设计的企业的15客户至到排版遍布许多的1亚洲美人的

Arita Heiti·Bold 14pt
글줄사이 Interline Space 26
글자사이 Letter Space 0

典范。2017年，爱茉莉太平洋集团正试图通过更广行进我们这个小成朝着想客体的黑字球全达平洋如果你中国和阿丽达太平洋世界，茉莉了，通的沟的开始为亚爱始亚

爱茉莉太平洋为了宣传企业形象，实践文化分享，自2005年起着手开发「阿丽达」字体。目前为止，爱茉莉太平洋已成功开发韩文字体「Arita Dotum」、「Arita Buri」和英文字体「Arita Sans」。接下来希望通过开发「阿丽达黑体」，为中国文化的发展献上微薄之力并巩固企业的文化基础。「Arita」取自中国《诗经》第一首诗「关雎」中的一句「窈窕淑女」，意思是知性而美丽的女性。「阿丽达黑体」蕴含着爱茉莉太平洋所追求的现代女性之美。字体的稳固结构和向外舒展的笔画表现了拥有深厚内在和优美姿态的女性形象，笔画末尾的手写字体增添了自然的美。我们是在以现代的方式重新解析秦国小篆和汉朝隶书的过程中发现了这样的美。所有阿丽达字体均可在爱茉莉太

추임【한글꼴을 위한 용어】

아리따 부리는 한글 글꼴 최초로 이름에 '부리'를 붙여
새로운 본문용 글꼴의 첫발을 내디뎠습니다. 또 닿자
'니은(ㄴ)' '디귿(ㄷ)'에서 글자 맺음 부분을 쳐올린 모양을
'추임'이라고 이름 붙였습니다. 아리따를 발전시키는
과정에서 그동안 논의되지 않은 다양한 한글꼴 용어가
탄생했습니다. 한국의 문화 감성을 바탕으로 글꼴 형태를
설명하는 고유 용어를 고민하며 붙여나갔습니다.

➡ p.160 아리따 돋움·한재준

Chuim【Terms for Korean Typefaces】

Arita Buri took the first step of a new body font
adding the word "buri" for the first time in
Korean typeface design. It also adopted the term
"chuim" for the edge of a stroke in *nieun* (ㄴ) and
digeut (ㄷ). In the process of developing Arita,
new and diverse Korean font terms—which have
never been discussed before—were coined.
Based on the cultural sensibility of Korea, we
addressed and created the original terms that
describe shapes of fonts.

➡ p.160 Arita Dotum·Han Jaejoon

글꼴 얼개 【아리따 돋움, 아리따 부리】
'얼개'의 사전적 의미는 '어떤 사물이나 조직의 전체를 이루는 짜임새나 구조'로, 아리따 돋움과 부리의 관계를 정의하는 용어로 '얼개'를 사용했다.
아리따 부리 회의록에서, 2012. 6

남매 글자 【아리따 돋움, 아리따 부리】
아리따 돋움과 부리는 DNA는 같아도 형태는 다른 관계를 표현하기 위해 '남매 글자'라는 말을 사용했다. 남매 글자라는 정의로 아리따 부리의 형태를 디자인하는 영역이 넓어졌고, 글자의 굵기 외에도 스타일, 용도의 변화를 통한 다양한 확장을 이야기할 수 있었다.
류양희 인터뷰에서, 2019. 2

부리 【아리따 부리】 ⇔ 민부리, 산세리프, 무츤선체无衬线体
'부리'는 꺾인 필획의 시작 부분을 이르는 말로 서양의 세리프serif, 중국의 츤선체衬线体와 비슷한 표현이다. '부리'와 '민부리'는 서양의 '세리프'와 '산세리프'처럼 형태로 글꼴을 구분하는 방식의 이름이다. 한글의 본문용 글자는 보통 용도에 따라 명조체와 고딕체 혹은 바탕체와 돋움체로 대표된다. 아리따 돋움과의 연결성을 고려하면 당연히 '아리따 바탕'이라고 해야 한다고 생각할 수도 있었다. 그러나 장기적으로 글꼴가족을 확장할 계획이 있었기 때문에 아리따 부리라고 이름을 지었다. 아리따 부리는 최초로 글꼴 이름에 '부리'라는 용어를 붙여 새로운 본문용 글꼴의 첫발을 디뎠다.
류양희 인터뷰에서, 2019. 2

손맛 표현 【아리따 돋움】
'손맛 표현'은 글자줄기의 부드러운 곡선을 이르는 말이다. 아리따 돋움은 기존의 딱딱하고 직선적인 느낌의 돋움체에서 벗어나 '기역(ㄱ)' '치읓(ㅊ)' '히읗(ㅎ)' 'ㅠ' 등의 휘어진 줄기가 돋보이도록 손맛을 살린 것이 특징이다.
아리따 돋움 발표 자료에서, 2012. 1

추임 【아리따 돋움】
닿자 '니은(ㄴ)' '디귿(ㄷ)'에서 살짝 추켜올린 맺음을 '추임'이라고 부르자고 제안했다. 판소리 등에서 흥을 돋우기 위해 쓰는 '얼씨구' '좋다' 같은 추임새에서 따왔다. 추임새를 하는 기분으로 글자를 쳐올린 모양이라는 뜻이었다.
한재준 메일 기록에서, 2006. 4

파임 【아리따 돋움】 = 트임
잉크 트랩이라는 용어를 줄기 이음 부분을 파낸다는 의미의 '파임'으로 바꾸었다. 아리따 돋움에서 '시옷(ㅅ)' '지읒(ㅈ)' '치읓(ㅊ)' 줄기 이음의 뭉침 현상을 없애기 위해 파임을 적용했다.
한재준 메일 기록에서, 2006. 4

Structure of Typeface 【Arita Dotum, Arita Buri】
The dictionary meaning of "structure" is "the way in which the parts of something are organized or arranged into a whole." We used "structure" as the term defining the relationship between Arita Dotum and Buri.
From the Proceedings of meetings on Arita Buri, Jun 2012

Sibling Typefaces 【Arita Dotum, Arita Buri】
To describe the relationship between Arita Dotum and Buri, which have the same DNA but different shapes, the term "sibling typefaces" was used. Due to this definition, we could broaden the realm of Arita Buri design, and we were able to deal with various extensions through changes in style and usage as well as the weight of the letters.
From an interview with Ryu Yanghee, Feb. 2019

Buri 【Arita Buri】 ⇔ Minburi, Sans Serif, 无衬线体
"Buri" refers to the beginning of a stroke in Hangeul, a term similar to "serifs" in the Western languages and 衬线体 in Chinese. "Buri" and "minburi" show how typefaces are classified according to their shapes just as serif and san serif do in Latin typefaces. Fonts for the body text in Hangeul are usually represented by fonts such as Myeongjo and Gothic, Batang, and Dotum, depending on their intended use. Considering its relation with Arita Dotum, this typeface for the body text could naturally be named "Arita Batang." However, we named it Arita Buri because we were planning to extend the type family on a long-term basis. Arita Buri became the first typeface for the body text that used the term "buri" for its name.
From an interview with Ryu Yanghee, Feb. 2019

Handwriting Expression 【Arita Dotum】
"Handwriting expression" refers to the smooth curve of the stem in letters. Arita Dotum is characterized by the fact that it is free from the existing stiff and masculine Dotum font features, and that it enhances the impression of handwriting to make curved stems of letters such as giyeok (ㄱ), chieut (ㅊ), hieut (ㅎ), and and yu (ㅠ) stand out.
From the presentation materials on Arita Dotum, Jan. 2012

Chuim 【Arita Dotum】
I proposed to call a slight uplifting finish of nieun (ㄴ) and digeut (ㄷ) as "chuim." It is derived from a Korean word chuimsae (expressions) such as "eolssigu (bravo!)" and "jotta (great!)", both of which are used to add more amusement to pansori, a traditional Korean epic chant, and other performances. It was used to mean that strokes were lifted in the spirit of chuimsae.
From an email from Han Jaejoon, Apr. 2006

Paim 【Arita Dotum】 = Teuim
I changed the term ink trap to a Korean word "paim" that means scraping out the seam of stems. Arita Dotum adopted paim to eliminate the lumping of the stems of siot (ㅅ), jieut (ㅈ), and chieut (ㅊ).
From an email from Han Jaejoon, Apr. 2006

코드【아리따 글리프 일람】

한글 글꼴을 하나 만드는 데 적게는 2,780자, 많게는 11,172자의 글자가 필요합니다. 아리따 돋움과 부리는 모든 한글에 사용할 수 있도록 11,172자로 만들었으며 아리따 산스와 흑체를 만들어 쓰임을 넓혔습니다. 아리따는 한글, 로마자, 한자뿐 아니라 기호활자까지 본문글꼴로 사용하는 데 불편함이 없는지 고민하며 채워나갔습니다.

➡ p.154 타임라인

Code【Arita Glyph List】

It takes from 2,780 characters to 11,172 characters to create a single Hangeul typeface. Arita Dotum and Buri were made of 11,172 characters each so that they could mark all the Korean letters, and we made Arita Sans and Heiti to expand the use of Arita. Arita was completed as we continuously cared about any inconveniences in using all parts of the typeface— including Hangeul, Latin alphabet, Chinese characters and symbols—for the body text.

➡ p.154 Timeline

가	각	갂	갃	간	갅	갆	갇	갈	갉	갊	갋	갌	갍	갎	갏
U+ac00	U+ac01	U+ac02	U+ac03	U+ac04	U+ac05	U+ac06	U+ac07	U+ac08	U+ac09	U+ac0a	U+ac0b	U+ac0c	U+ac0d	U+ac0e	U+ac0f
까	깍	깎	깏	깐	깑	깒	깓	깔	깕	깖	깗	깘	깙	깚	깛
U+ae4c	U+ae4d	U+ae4e	U+ae4f	U+ae50	U+ae51	U+ae52	U+ae53	U+ae54	U+ae55	U+ae56	U+ae57	U+ae58	U+ae59	U+ae5a	U+ae5b
나	낙	낚	낛	난	낝	낞	낟	날	낡	낢	낣	낤	낥	낦	낧
U+b098	U+b099	U+b09a	U+b09b	U+b09c	U+b09d	U+b09e	U+b09f	U+b0a0	U+b0a1	U+b0a2	U+b0a3	U+b0a4	U+b0a5	U+b0a6	U+b0a7
다	닥	닦	닧	단	닩	닪	닫	달	닭	닮	닯	닰	닱	닲	닳
U+b2e4	U+b2e5	U+b2e6	U+b2e7	U+b2e8	U+b2e9	U+b2ea	U+b2eb	U+b2ec	U+b2ed	U+b2ee	U+b2ef	U+b2f0	U+b2f1	U+b2f2	U+b2f3
따	딱	딲	딳	딴	딵	딶	딷	딸	딹	딺	딻	딼	딽	딾	딿
U+b530	U+b531	U+b532	U+b533	U+b534	U+b535	U+b536	U+b537	U+b538	U+b539	U+b53a	U+b53b	U+b53c	U+b53d	U+b53e	U+b53f
라	락	띾	랛	란	랝	랞	랟	랄	랅	랆	랇	랈	랉	랊	랋
U+b77c	U+b77d	U+b77e	U+b77f	U+b780	U+b781	U+b782	U+b783	U+b784	U+b785	U+b786	U+b787	U+b788	U+b789	U+b78a	U+b78b
마	막	맦	맧	만	맩	맪	맫	말	맭	맮	맯	맰	맱	맲	맳
U+b9c8	U+b9c9	U+b9ca	U+b9cb	U+b9cc	U+b9cd	U+b9ce	U+b9cf	U+b9d0	U+b9d1	U+b9d2	U+b9d3	U+b9d4	U+b9d5	U+b9d6	U+b9d7
바	박	밖	밗	반	밙	밚	받	발	밝	밞	밟	밠	밡	밢	밣
U+bc14	U+bc15	U+bc16	U+bc17	U+bc18	U+bc19	U+bc1a	U+bc1b	U+bc1c	U+bc1d	U+bc1e	U+bc1f	U+bc20	U+bc21	U+bc22	U+bc23
빠	빡	빢	빣	빤	빥	빦	빧	빨	빩	빪	빫	빬	빭	빮	빯
U+be60	U+be61	U+be62	U+be63	U+be64	U+be65	U+be66	U+be67	U+be68	U+be69	U+be6a	U+be6b	U+be6c	U+be6d	U+be6e	U+be6f
사	삭	삮	삯	산	삱	삲	삳	살	삵	삶	삷	삸	삹	삺	삻
U+c0ac	U+c0ad	U+c0ae	U+c0af	U+c0b0	U+c0b1	U+c0b2	U+c0b3	U+c0b4	U+c0b5	U+c0b6	U+c0b7	U+c0b8	U+c0b9	U+c0ba	U+c0bb
싸	싹	싺	싻	싼	싽	싾	싿	쌀	쌁	쌂	쌃	쌄	쌅	쌆	쌇
U+c2f8	U+c2f9	U+c2fa	U+c2fb	U+c2fc	U+c2fd	U+c2fe	U+c2ff	U+c300	U+c301	U+c302	U+c303	U+c304	U+c305	U+c306	U+c307
아	악	앆	앇	안	앉	않	앋	알	앍	앎	앏	앐	앑	앒	앓
U+c544	U+c545	U+c546	U+c547	U+c548	U+c549	U+c54a	U+c54b	U+c54c	U+c54d	U+c54e	U+c54f	U+c550	U+c551	U+c552	U+c553
자	작	잒	잓	잔	잕	잖	잗	잘	잙	잚	잛	잜	잝	잞	잟
U+c790	U+c791	U+c792	U+c793	U+c794	U+c795	U+c796	U+c797	U+c798	U+c799	U+c79a	U+c79b	U+c79c	U+c79d	U+c79e	U+c79f
짜	짝	짞	짟	짠	짡	짢	짣	짤	짥	짦	짧	짨	짩	짪	짫
U+c9dc	U+c9dd	U+c9de	U+c9df	U+c9e0	U+c9e1	U+c9e2	U+c9e3	U+c9e4	U+c9e5	U+c9e6	U+c9e7	U+c9e8	U+c9e9	U+c9ea	U+c9eb
차	착	챆	챇	찬	챉	챊	챋	찰	챍	챎	챏	챐	챑	챒	챓
U+cc28	U+cc29	U+cc2a	U+cc2b	U+cc2c	U+cc2d	U+cc2e	U+cc2f	U+cc30	U+cc31	U+cc32	U+cc33	U+cc34	U+cc35	U+cc36	U+cc37
카	칵	칶	칷	칸	칹	칺	칻	칼	칽	칾	칿	캀	캁	캂	캃
U+ce74	U+ce75	U+ce76	U+ce77	U+ce78	U+ce79	U+ce7a	U+ce7b	U+ce7c	U+ce7d	U+ce7e	U+ce7f	U+ce80	U+ce81	U+ce82	U+ce83
타	탁	탂	탃	탄	탅	탆	탇	탈	탉	탊	탋	탌	탍	탎	탏
U+d0c0	U+d0c1	U+d0c2	U+d0c3	U+d0c4	U+d0c5	U+d0c6	U+d0c7	U+d0c8	U+d0c9	U+d0ca	U+d0cb	U+d0cc	U+d0cd	U+d0ce	U+d0cf
파	팍	팎	팏	판	팑	팒	팓	팔	팕	팖	팗	팘	팙	팚	팛
U+d30c	U+d30d	U+d30e	U+d30f	U+d310	U+d311	U+d312	U+d313	U+d314	U+d315	U+d316	U+d317	U+d318	U+d319	U+d31a	U+d31b
하	학	핚	핛	한	핝	핞	핟	할	핡	핢	핣	핤	핥	핦	핧
U+d558	U+d559	U+d55a	U+d55b	U+d55c	U+d55d	U+d55e	U+d55f	U+d560	U+d561	U+d562	U+d563	U+d564	U+d565	U+d566	U+d567

아리따 돋움 글리프 일람
아리따 돋움은 한글 11,172자, 로마자와 숫자 94자, 기호활자 989자로 이루어져 있습니다.

Arita Dotum Glyph List
Arita Dotum consists of 11,172 Hangeul characters, 94 Latin alphabet letters and figures, and 989 symbols.

∂	Δ	€	∏	Σ	‐	–	—
U+2202	U+2206	U+20ac	U+220f	U+2211	U+2212	U+2013	U+2014
"	#	$	%	&	'	()
U+0022	U+0023	U+0024	U+0025	U+0026	U+0027	U+0028	U+0029
2	3	4	5	6	7	8	9
U+0032	U+0033	U+0034	U+0035	U+0036	U+0037	U+0038	U+0039
B	C	D	E	F	G	H	I
U+0042	U+0043	U+0044	U+0045	U+0046	U+0047	U+0048	U+0049
R	S	T	U	V	W	X	Y
U+0052	U+0053	U+0054	U+0055	U+0056	U+0057	U+0058	U+0059
b	c	d	e	f	g	h	i
U+0062	U+0063	U+0064	U+0065	U+0066	U+0067	U+0068	U+0069
r	s	t	u	v	w	x	y
U+0072	U+0073	U+0074	U+0075	U+0076	U+0077	U+0078	U+0079
√		¡	¢	£	¥	¦	§
U+221a	U+00a0	U+00a1	U+00a2	U+00a3	U+00a5	U+00a6	U+00a7

∂	Δ	€	Π	Σ	–	—	—	'	'	‚	"	"	„		!
U+2202	U+2206	U+20ac	U+220f	U+2211	U+2212	U+2013	U+2014	U+2018	U+2019	U+201a	U+201c	U+201d	U+201e	U+0020	U+0021
"	#	$	%	&	'	()	*	+	,	-	.	/	0	1
U+0022	U+0023	U+0024	U+0025	U+0026	U+0027	U+0028	U+0029	U+002a	U+002b	U+002c	U+002d	U+002e	U+002f	U+0030	U+0031
2	3	4	5	6	7	8	9	:	;	<	=	>	?	@	A
U+0032	U+0033	U+0034	U+0035	U+0036	U+0037	U+0038	U+0039	U+003a	U+003b	U+003c	U+003d	U+003e	U+003f	U+0040	U+0041
B	C	D	E	F	G	H	I	J	K	L	M	N	O	P	Q
U+0042	U+0043	U+0044	U+0045	U+0046	U+0047	U+0048	U+0049	U+004a	U+004b	U+004c	U+004d	U+004e	U+004f	U+0050	U+0051
R	S	T	U	V	W	X	Y	Z	[\]	^	_	`	a
U+0052	U+0053	U+0054	U+0055	U+0056	U+0057	U+0058	U+0059	U+005a	U+005b	U+005c	U+005d	U+005e	U+005f	U+0060	U+0061
b	c	d	e	f	g	h	i	j	k	l	m	n	o	p	q
U+0062	U+0063	U+0064	U+0065	U+0066	U+0067	U+0068	U+0069	U+006a	U+006b	U+006c	U+006d	U+006e	U+006f	U+0070	U+0071
r	s	t	u	v	w	x	y	z	{	\|	}	~	‡	≤	∞
U+0072	U+0073	U+0074	U+0075	U+0076	U+0077	U+0078	U+0079	U+007a	U+007b	U+007c	U+007d	U+007e	U+2021	U+2264	U+221e
√		¡	¢	£	¥	¦	§	¨	©	ª	«	¬		®	¯
U+221a	U+00a0	U+00a1	U+00a2	U+00a3	U+00a5	U+00a6	U+00a7	U+00a8	U+00a9	U+00aa	U+00ab	U+00ac	U+00ad	U+00ae	U+00af
°	±	²	³	´	µ	¶	·	¸	¹	º	»	¼	½	¾	¿
U+00b0	U+00b1	U+00b2	U+00b3	U+00b4	U+00b5	U+00b6	U+00b7	U+00b8	U+00b9	U+00ba	U+00bb	U+00bc	U+00bd	U+00be	U+00bf
À	Á	Â	Ã	Ä	Å	Æ	Ç	È	É	Ê	Ë	Ì	Í	Î	Ï
U+00c0	U+00c1	U+00c2	U+00c3	U+00c4	U+00c5	U+00c6	U+00c7	U+00c8	U+00c9	U+00ca	U+00cb	U+00cc	U+00cd	U+00ce	U+00cf
Ð	Ñ	Ò	Ó	Ô	Õ	Ö	×	Ø	Ù	Ú	Û	Ü	Ý	Þ	ß
U+00d0	U+00d1	U+00d2	U+00d3	U+00d4	U+00d5	U+00d6	U+00d7	U+00d8	U+00d9	U+00da	U+00db	U+00dc	U+00dd	U+00de	U+00df
à	á	â	ã	ä	å	æ	ç	è	é	ê	ë	ì	í	î	ï
U+00e0	U+00e1	U+00e2	U+00e3	U+00e4	U+00e5	U+00e6	U+00e7	U+00e8	U+00e9	U+00ea	U+00eb	U+00ec	U+00ed	U+00ee	U+00ef
ð	ñ	ò	ó	ô	õ	ö	÷	ø	ù	ú	û	ü	ý	þ	ÿ
U+00f0	U+00f1	U+00f2	U+00f3	U+00f4	U+00f5	U+00f6	U+00f7	U+00f8	U+00f9	U+00fa	U+00fb	U+00fc	U+00fd	U+00fe	U+00ff
fi	fl	·	˘	‰	™	˛	Ω	˝	ı	Ł	ł	^			
U+fb01	U+fb02	U+2022	U+02d8	U+2030	U+2122	U+02db	U+2126	U+02dd	U+0131	U+0141	U+0142	U+02c6			
Œ	œ	‹	›	Š	š	∫	ˇ	Ÿ	…	Ž	ž	≥	ƒ	⁄	≈
U+0152	U+0153	U+2039	U+203a	U+0160	U+0161	U+222b	U+02c7	U+0178	U+2026	U+017d	U+017e	U+2265	U+0192	U+2044	U+2248
π	≠	◊	†												
U+03c0	U+2260	U+25ca	U+2020												

아리따 산스 글리프 일람

아리따 산스는 로마자 52자, 로마자 확장 50자, 기호활자 86자로
이루어져 있습니다.

Arita Sans Glyph List

Arita Sans consists of 52 characters from the Latin alphabet,
50 extended characters from the Latin alphabet, and 86 symbols.

괋	괌	괍	괎	괏
U+ac0b	U+ac0c	U+ac0d	U+ac0e	U+ac0f

괛	개	객	꺆	갯
U+ac1b	U+ac1c	U+ac1d	U+ac1e	U+ac1f

갫	갬	갭	갮	갯
U+ac2b	U+ac2c	U+ac2d	U+ac2e	U+ac2f

갻	갼	갽	갾	갿
U+ac3b	U+ac3c	U+ac3d	U+ac3e	U+ac3f

걋	걌	걍	걎	걏
U+ac4b	U+ac4c	U+ac4d	U+ac4e	U+ac4f

걟	걠	걡	걢	걣

가 각 갂 갃 간 갅 갆 갇 갈 갉 갊 갋 갌 갍 갎 갏
U+ac00 U+ac01 U+ac02 U+ac03 U+ac04 U+ac05 U+ac06 U+ac07 U+ac08 U+ac09 U+ac0a U+ac0b U+ac0c U+ac0d U+ac0e U+ac0f

까 깍 깎 깏 깐 깑 깒 깓 깔 깕 깖 깗 깘 깙 깚 깛
U+ae4c U+ae4d U+ae4e U+ae4f U+ae50 U+ae51 U+ae52 U+ae53 U+ae54 U+ae55 U+ae56 U+ae57 U+ae58 U+ae59 U+ae5a U+ae5b

나 낙 낚 낛 난 낝 낞 낟 날 낡 낢 낣 낤 낥 낦 낧
U+b098 U+b099 U+b09a U+b09b U+b09c U+b09d U+b09e U+b09f U+b0a0 U+b0a1 U+b0a2 U+b0a3 U+b0a4 U+b0a5 U+b0a6 U+b0a7

다 닥 닦 닧 단 닩 닪 닫 달 닭 닮 닯 닰 닱 닲 닳
U+b2e4 U+b2e5 U+b2e6 U+b2e7 U+b2e8 U+b2e9 U+b2ea U+b2eb U+b2ec U+b2ed U+b2ee U+b2ef U+b2f0 U+b2f1 U+b2f2 U+b2f3

따 딱 딲 딳 딴 딵 딶 딷 딸 딹 딺 딻 딼 딽 딾 딿
U+b530 U+b531 U+b532 U+b533 U+b534 U+b535 U+b536 U+b537 U+b538 U+b539 U+b53a U+b53b U+b53c U+b53d U+b53e U+b53f

라 락 띾 띿 란 랁 랂 랃 랄 랅 랆 랇 랈 랉 랊 랋
U+b77c U+b77d U+b77e U+b77f U+b780 U+b781 U+b782 U+b783 U+b784 U+b785 U+b786 U+b787 U+b788 U+b789 U+b78a U+b78b

마 막 맊 맋 만 맍 많 맏 말 맑 맒 맓 맔 맕 맖 맗
U+b9c8 U+b9c9 U+b9ca U+b9cb U+b9cc U+b9cd U+b9ce U+b9cf U+b9d0 U+b9d1 U+b9d2 U+b9d3 U+b9d4 U+b9d5 U+b9d6 U+b9d7

바 박 밖 밗 반 밙 밚 받 발 밝 밞 밟 밠 밡 밢 밣
U+bc14 U+bc15 U+bc16 U+bc17 U+bc18 U+bc19 U+bc1a U+bc1b U+bc1c U+bc1d U+bc1e U+bc1f U+bc20 U+bc21 U+bc22 U+bc23

빠 빡 빢 빣 빤 빥 빦 빧 빨 빩 빪 빫 빬 빭 빮 빯
U+be60 U+be61 U+be62 U+be63 U+be64 U+be65 U+be66 U+be67 U+be68 U+be69 U+be6a U+be6b U+be6c U+be6d U+be6e U+be6f

사 삭 삮 삯 산 삱 삲 삳 살 삵 삶 삷 삸 삹 삺 삻
U+c0ac U+c0ad U+c0ae U+c0af U+c0b0 U+c0b1 U+c0b2 U+c0b3 U+c0b4 U+c0b5 U+c0b6 U+c0b7 U+c0b8 U+c0b9 U+c0ba U+c0bb

싸 싹 싺 싻 싼 싽 싾 싿 쌀 쌁 쌂 쌃 쌄 쌅 쌆 쌇
U+c2f8 U+c2f9 U+c2fa U+c2fb U+c2fc U+c2fd U+c2fe U+c2ff U+c300 U+c301 U+c302 U+c303 U+c304 U+c305 U+c306 U+c307

아 악 앆 앇 안 앉 않 앋 알 앍 앎 앏 앐 앑 앒 앓
U+c544 U+c545 U+c546 U+c547 U+c548 U+c549 U+c54a U+c54b U+c54c U+c54d U+c54e U+c54f U+c550 U+c551 U+c552 U+c553

자 작 잒 잓 잔 잕 잖 잗 잘 잙 잚 잛 잜 잝 잞 잟
U+c790 U+c791 U+c792 U+c793 U+c794 U+c795 U+c796 U+c797 U+c798 U+c799 U+c79a U+c79b U+c79c U+c79d U+c79e U+c79f

짜 짝 짞 짟 짠 짡 짢 짣 짤 짥 짦 짧 짨 짩 짪 짫
U+c9dc U+c9dd U+c9de U+c9df U+c9e0 U+c9e1 U+c9e2 U+c9e3 U+c9e4 U+c9e5 U+c9e6 U+c9e7 U+c9e8 U+c9e9 U+c9ea U+c9eb

차 착 찪 찫 찬 찭 찮 찯 찰 찱 찲 찳 찴 찵 찶 찷
U+cc28 U+cc29 U+cc2a U+cc2b U+cc2c U+cc2d U+cc2e U+cc2f U+cc30 U+cc31 U+cc32 U+cc33 U+cc34 U+cc35 U+cc36 U+cc37

카 칵 칶 칷 칸 칹 칺 칻 칼 칽 칾 칿 캀 캁 캂 캃
U+ce74 U+ce75 U+ce76 U+ce77 U+ce78 U+ce79 U+ce7a U+ce7b U+ce7c U+ce7d U+ce7e U+ce7f U+ce80 U+ce81 U+ce82 U+ce83

타 탁 탂 탃 탄 탅 탆 탇 탈 탉 탊 탋 탌 탍 탎 탏
U+d0c0 U+d0c1 U+d0c2 U+d0c3 U+d0c4 U+d0c5 U+d0c6 U+d0c7 U+d0c8 U+d0c9 U+d0ca U+d0cb U+d0cc U+d0cd U+d0ce U+d0cf

파 팍 팎 팏 판 팑 팒 팓 팔 팕 팖 팗 팘 팙 팚 팛
U+d30c U+d30d U+d30e U+d30f U+d310 U+d311 U+d312 U+d313 U+d314 U+d315 U+d316 U+d317 U+d318 U+d319 U+d31a U+d31b

하 학 핚 핛 한 핝 핞 핟 할 핡 핢 핣 핤 핥 핦 핧
U+d558 U+d559 U+d55a U+d55b U+d55c U+d55d U+d55e U+d55f U+d560 U+d561 U+d562 U+d563 U+d564 U+d565 U+d566 U+d567

아리따 부리 글리프 일람
아리따 부리는 한글 11,172자, 로마자와 숫자 94자, 기호활자 1,028자, 추가자 2자로 이루어져 있습니다.

Arita Buri Glyph List
Arita Buri consists of 11,172 Hangeul characters, 94 characters and figures from the Latin alphabet, 1,028 symbols, and 2 additional characters.

俱	俳	俸	俺	俾	倀	倆	倉
U+4ff1	U+4ff3	U+4ff8	U+4ffa	U+4ffe	U+5000	U+5006	U+5009
候	倚	倜	借	倡	倥	倦	倨
U+5019	U+501a	U+501c	U+501f	U+5021	U+5025	U+5026	U+5028
倾	偃	假	偈	偉	偌	偎	偏
U+503e	U+5043	U+5047	U+5048	U+5049	U+504c	U+504e	U+504f
偷	偻	债	偿	傀	傅	傈	傍
U+5077	U+507b	U+507e	U+507f	U+5080	U+5085	U+5088	U+508d
催	傭	傲	傳	傴	債	傷	傺
U+50ac	U+50ad	U+50b2	U+50b3	U+50b4	U+50b5	U+50b7	U+50ba
僖	僚	僞	僥	僦	僧	僨	僬
U+50d6	U+50da	U+50de	U+50e5	U+50e6	U+50e7	U+50e8	U+50ec
億	儆	儇	會	儉	儋	儐	儒
U+5104	U+5106	U+5107	U+5108	U+5109	U+510b	U+5110	U+5112
儻	儼	儿	兀	允	元	兄	充
U+513b	U+513c	U+513f	U+5140	U+5141	U+5143	U+5144	U+5145
兕	兖	党	兜	兢	入	內	全
U+5155	U+5156	U+515a	U+515c	U+5162	U+5165	U+5167	U+5168

一 丁 七 万 丈 三 上 下 丌 不 与 丐 丑 专 且 丕
U+4e00 U+4e01 U+4e03 U+4e07 U+4e08 U+4e09 U+4e0a U+4e0b U+4e0c U+4e0d U+4e0e U+4e10 U+4e11 U+4e13 U+4e14 U+4e15

世 丘 丙 业 丛 东 丝 丞 丢 两 严 並 丧 丨 个 丫
U+4e16 U+4e18 U+4e19 U+4e1a U+4e1b U+4e1c U+4e1d U+4e1e U+4e22 U+4e24 U+4e25 U+4e26 U+4e27 U+4e28 U+4e2a U+4e2b

丬 中 丰 串 临 丶 丸 丹 为 主 丽 举 丿 乃 久 乇
U+4e2c U+4e2d U+4e30 U+4e32 U+4e34 U+4e36 U+4e38 U+4e39 U+4e3a U+4e3b U+4e3d U+4e3e U+4e3f U+4e43 U+4e45 U+4e47

么 义 之 乌 乍 乎 乏 乐 乒 乓 乔 乖 乘 乙 乜 九
U+4e48 U+4e49 U+4e4b U+4e4c U+4e4d U+4e4e U+4e4f U+4e50 U+4e52 U+4e53 U+4e54 U+4e56 U+4e58 U+4e59 U+4e5c U+4e5d

乞 也 习 乡 书 乩 买 乱 乳 乾 亂 了 予 争 事 二
U+4e5e U+4e5f U+4e60 U+4e61 U+4e66 U+4e69 U+4e70 U+4e71 U+4e73 U+4e7e U+4e82 U+4e86 U+4e88 U+4e89 U+4e8b U+4e8c

亍 于 亏 云 互 亓 五 井 亘 亚 些 亞 亟 亠 亡 亢
U+4e8d U+4e8e U+4e8f U+4e91 U+4e92 U+4e93 U+4e94 U+4e95 U+4e98 U+4e9a U+4e9b U+4e9e U+4e9f U+4ea0 U+4ea1 U+4ea2

交 亥 亦 产 亨 亩 享 京 亭 亮 亲 亳 亵 人 亻 亿
U+4ea4 U+4ea5 U+4ea6 U+4ea7 U+4ea8 U+4ea9 U+4eab U+4eac U+4ead U+4eae U+4eb2 U+4eb3 U+4eb5 U+4eba U+4ebb U+4ebf

什 仁 仂 仃 仄 仅 仆 仇 仉 今 介 仍 从 仑 仓 仔
U+4ec0 U+4ec1 U+4ec2 U+4ec3 U+4ec4 U+4ec5 U+4ec6 U+4ec7 U+4ec9 U+4eca U+4ecb U+4ecd U+4ece U+4ed1 U+4ed3 U+4ed4

仕 他 仗 付 仙 全 仞 仟 仡 代 令 以 仨 仪 仫 们
U+4ed5 U+4ed6 U+4ed7 U+4ed8 U+4ed9 U+4edd U+4ede U+4edf U+4ee1 U+4ee3 U+4ee4 U+4ee5 U+4ee8 U+4ee9 U+4eeb U+4eec

仰 仲 仳 仵 件 价 任 份 仿 企 伉 伊 伍 伎 伏 伐
U+4ef0 U+4ef2 U+4ef3 U+4ef5 U+4ef6 U+4ef7 U+4efb U+4efd U+4eff U+4f01 U+4f09 U+4f0a U+4f0d U+4f0e U+4f0f U+4f10

休 众 优 伙 会 伛 伞 伟 传 伢 伤 伥 伦 伧 伪 伫
U+4f11 U+4f17 U+4f18 U+4f19 U+4f1a U+4f1b U+4f1e U+4f1f U+4f20 U+4f22 U+4f24 U+4f25 U+4f26 U+4f27 U+4f2a U+4f2b

伯 估 伲 伴 伶 伸 伺 似 伽 佃 但 佇 位 低 住 佐
U+4f2f U+4f30 U+4f33 U+4f34 U+4f36 U+4f38 U+4f3a U+4f3c U+4f3d U+4f43 U+4f46 U+4f47 U+4f4d U+4f4e U+4f4f U+4f50

佑 体 何 佗 佘 余 佚 佛 作 佝 佞 佟 你 佣 佤 佥
U+4f51 U+4f53 U+4f55 U+4f57 U+4f58 U+4f59 U+4f5a U+4f5b U+4f5c U+4f5d U+4f5e U+4f5f U+4f60 U+4f63 U+4f64 U+4f65

佧 佩 佬 佯 佰 佳 佴 佶 佻 佼 佾 使 侃 侄 來 侈
U+4f67 U+4f69 U+4f6c U+4f6f U+4f70 U+4f73 U+4f74 U+4f76 U+4f7b U+4f7e U+4f7f U+4f83 U+4f84 U+4f86 U+4f88

侉 例 侍 侏 侑 侔 侖 侗 供 依 侠 侣 侥 侦 侧 侨
U+4f89 U+4f8b U+4f8d U+4f8f U+4f91 U+4f94 U+4f96 U+4f97 U+4f9b U+4f9d U+4fa0 U+4fa3 U+4fa5 U+4fa6 U+4fa7 U+4fa8

侩 侪 侬 侮 侯 侵 便 促 俄 俅 俊 俎 俏 俐 俑 俗
U+4fa9 U+4faa U+4fac U+4fae U+4faf U+4fb5 U+4fbf U+4fc3 U+4fc4 U+4fc5 U+4fca U+4fce U+4fcf U+4fd0 U+4fd1 U+4fd7

俘 俚 俛 保 俞 俟 俠 信 俣 俦 俨 俩 俪 俭 修 …
U+4fd8 U+4fda U+4fdc U+4fdd U+4fde U+4fdf U+4fe0 U+4fe1 U+4fe3 U+4fe6 U+4fe8 U+4fe9 U+4fea U+4fed U+4fee

아리따 흑체 글리프 일람
아리따 흑체는 간체자 6,763자, 번체자 2,114자, 국제 기호 1,103자, 대체 글리프glyph 13자, CJKChinese-Japanese-Korean 호환용 한자 383자로 이루어져 있습니다.

Arita Heiti Glyph List
Arita Heiti consists of 6,763 simplified characters, 2,114 traditional characters, 1,130 international symbols, 13 alternative glyphs, and 383 CJK Compatibility Ideographs.

탐색【볍씨를 만드는 노력】

아리따 부리는 본문용 글꼴의 미덕인 '보편성'과 기업용
글꼴의 필요성인 '개성' 사이에서 균형을 맞추기 위해
여러 차례 논의했습니다. 그리고 '새로운 탐색'이라 불린
6차와 7차 회의를 계기로 현재의 형태가 되었습니다.
본문용 글꼴은 매일 먹는 쌀밥과 같습니다. 새로운
쌀 품종을 개발하듯 아리따를 만들었습니다. '아리따'는
다양한 쌀로 밥을 지어 맛을 보는 것과 같은 과정으로
오랜 시간을 거쳐 탄생했습니다.

➜ p.24 형태에 관해

Exploration【Efforts for Improvement】

For Arita Buri, we discussed on several occasions
about finding a balance between "universality,"
the virtues of body fonts, and "individuality,"
which is the need for corporate fonts. At the sixth
and seventh meetings, which were called the "New
Exploration," we then came upon the current
form of Arita Buri. Fonts for the body text are
like cooked rice we eat every day, and we created
Arita as if we were developing a new species
of rice. Arita was born through a long process
of improvement—similar to cooking rice with
various types of rice and testing different tastes.

➜ p.24 About Arita's Form

기존 안
Existing Proposal

Handgloves

첫 번째 시안
First Draft

Handgloves

두 번째 시안
Second Draft

Handgloves

세 번째 시안
Third Draft

Handgloves

아리따 산스 시안 파생
아리따 산스는 기존의 안을 바탕으로 같은 굵기와 너비의 세 가지
시안을 파생했습니다. 손글씨의 영향을 받아 부드럽고 우아한 표정을
지닌 첫 번째 시안을 바탕으로 줄기와 맺음을 더욱더 둥글게 하며
완성해나갔습니다.

Deriving Arita Sans Drafts
Arita Sans was derived from three draft designs of the same
weights and width based on an existing proposal. Based on draft
A, which had a soft and elegant look influenced by handwriting,
the typeface was completed by rounding the stems and edges of
the letters.

나랏말이달

아모레설화

A-2

나랏말이달

B-1

아모레설화

A-3

나랏말이달

C-1

아모레설화

B-1

나랏말이달

D-1

아모레설화

B-2

나랏말이달

E-1

아모레설화

B-3

나랏말이달

자연사람기

자연사람기

B-1

자연사람기

B-1

자연사람기

C-1

자연사람기

C-1

자연사람기

A-2

아모레설화

B-2

자연사람기

아리따 부리 시안 파생

아리따 부리는 여덟 개의 시안 방향 가운데 첫 번째 시안에서 전체
방향과 이미지를 정하고 두 번째 시안에서 글자 구조와 이음보 모양,
'이응(ㅇ)' 모양을 정했습니다. 세 번째 시안에서는 필기 순서를 반영한
획의 모양과 '지읒(ㅈ)' 모양을 정했습니다.

Deriving Arita Buri Drafts

We came up with the overall direction and image of the typeface
in the first draft for Arita Buri. In the second draft, we devised
the letter structure, the shape of the rim, and the "ieung (ㅇ)"
shape. In the third draft, we decided on the forms of the strokes,
reflecting the order of constructing letters, and finally settled on
the "jieut (ㅈ)" shape.

자연사람기

자연사람기

B-1

자연사람기

B-1

자연사람기

C-1

자연사람기

C-1

자연사람기

A-2

자연사람기

B-2

자연사람기

자연사람기

아름설화수

B-1

자연사람기

B-1

아름설화수

C-1

자연사람기

다섯 번째 시안에서는 시각흐름선을 정했습니다. 최종안은 일곱 번째와
여덟 번째 시안에서 새로운 시도를 했다가 다시 여섯 번째 시안으로
돌아가 결정했습니다. 총 서른두 개의 스케치 가운데 여섯 번째 시안의
C-1을 바탕으로 아리따 부리가 만들어졌습니다.

Then, in the fifth draft, we determined the visual flow line.
We made some new attempts with seventh and eighth drafts,
but went back to the sixth draft to decide on the final design.
Out of 32 sketches in total, Arita Buri was created based on
C-1 of the sixth draft.

永流狼蔼安

永流狼蔼安

D-1

吟诗悦者闪

A-2

永流狼蔼安

A-2

永流狼蔼安

E-1

吟诗悦者闪

B-1

吟诗悦者闪

E-2

吟诗悦者闪

B-2

吟诗悦者闪

E-3

吟诗悦者闪

C-1

吟诗悦者闪

E-4

吟诗悦者闪

F-1

吟诗悦者闪

吟诗悦者闪

悦诗吟容盛

F-2

吟诗悦者闪

C-1

吟诗悦者闪

E-4-2

悦诗吟容盛

G-1

吟诗悦者闪

C-2

吟诗悦者闪

E-4-2

悦诗吟容盛

G-2

吟诗悦者闪

E-4

吟诗悦者闪

H-1

吟诗悦者闪

아리따 흑체 시안 파생

초기 시안 단계에서는 열여섯 명의 디자이너가 참여해 열다섯 종의
시안을 파생했습니다. 그중 글자폭이 좁고 구조가 단단한 'E-4 시안'을
바탕으로 아리따 흑체가 만들어졌습니다. 기존 흑체와 달리 갈고리를
간소화하고 점을 꼭지의 형태로 바꾸었으며, 필획 공간을 여유롭게 하는
방향으로 보완했습니다.

Deriving Arita Heiti Drafts

In the early drafting stage of the project, 16 designers came
up with 15 different drafts. From this, Arita Heiti was created
based on the E-4 draft, which is narrow in width and has
a solid structure. Unlike the existing Heiti font, the hook was
simplified and the point was changed into the shape of a tap,
while the space for strokes was complemented by becoming
more spacious.

표정 【글자 표정 이야기】

아리따는 아모레퍼시픽이 추구하는 '건강한 아름다움'을 모티브로 단아하고 지적인 멋이 풍기는 아시아의 현대적인 여성상을 담아낸 글꼴입니다. 아리따의 네 가지 글꼴은 남매 글꼴답게 닮았으면서도 저마다의 개성을 지니고 있습니다. 돋움은 '정직하고 올바른', 산스는 '강인하고 부드러운', 부리는 '우아하고 단아한', 흑체는 '섬세하고 단단한' 표정의 글꼴입니다.

Look 【The Story of the Typeface Look】

Arita features a modern Asian female image, featuring graceful and intellectual beauty through the motif of Amorepacific's "healthy beauty." The four typefaces of Arita resemble one another, just like siblings, but each one has its own personality. Dotum has an honest and upright look; Sans is soft and strong; Buri is elegant and graceful; and Heiti is delicate and robust.

바람에도 흔들리지 않는
뿌리 깊은 나무 같습니다.
부드러워 보이지만
기본을 그대로 지키고 있어
외유내강이 느껴집니다.

김현미, 삼성디자인교육원(SADI) 교수

It's like a deep-rooted tree that
doesn't waver in the wind. It looks soft,
but it keeps the basics intact so that
you can feel its internal strength even
with a gentle appearance.

Kim Hyunmi, Professor of SADI (Samsung Art and Design Institute)

아리따 산스를 자세히 보면
기품있는 선과 둥근 형태를 볼 수 있습니다.
이러한 형태는 여성의 품위뿐 아니라
강인하고 자신감 있는 인상을 줍니다.

피터 베르휠, 글꼴 디자이너

If you take a closer look at Arita Sans,
you'll find a graceful line and a round shape.
This gives the impression of strong and proud,
as well as feminine dignity.

Peter Verheul, Type Designer

아리따에는 자연스럽고
은근하게 표현하는
사람과 같은 매력이 있습니다.

김기조, 그래픽 디자이너

Arita has the charm of a person
who expresses themselves in
a natural and subtle way.

Kim Kijo, Graphic Designer

멀리서 보면 티끌 하나 없는
한 장의 백지 같지만 가까이에서 보면
필획과 도형이 화폭에 넘쳐나는 멋.
한 마디로 유정작태柔情綽態입니다.

쉬에빙엔薛冰焰, 중국 난징예술학원南京艺术学院 교수

From a distance, it looks like a blank sheet
without a speck of dust, but when examined
from a closer perspective, strokes and
shapes are overflowing on the canvas.
In short, it's a slight, sweet-hearted figure.

Xue Bingyan, Professor of China Nanjing University of the Arts

자이융밍翟永明 시집 『여인女人』에서
드러나는 소녀의 애절함, 부드러움,
섬세함과 놀라울 정도로 일치합니다.
즉, 현대 동아시아 여성의 다양한
내면을 반영한다고 할 수 있습니다.

우판吳帆, 중국 베이징중앙미술학원北京中央美术学院 교수

It's strikingly similar to a girl's sorrow,
tenderness and delicacy, like in
Zhai Yongming's book of poems, *Lady*.
It reflects the many different inner sides
of a modern East Asian woman.

Wu Fan, Professor of China Central Academy of Fine Arts (CAFA)

활용【일상에서 만난 아리따】

우리는 일상 속에서 자연스럽게 아리따와 만납니다.
서점에 들러서 본 책에도, 주말에 들른 전시장에도, 매일 보는
스마트폰에도 아리따가 있습니다. 기업 아이덴티티 전용
글꼴의 역할뿐 아니라 나눔의 가치를 공유해온 아리따는
글꼴가족의 범위를 확장하고 그 쓰임의 폭을 넓혀왔습니다.

➡ p.18 아리따 가족 구성

Usage【Arita in Everyday Life】

We encounter Arita in our daily lives. You can see
Arita in bookstores, in galleries and museums,
and on the screens of smartphones that you
look at every day. Arita not only performs the
function of creating a corporate identity, but also
captures the value of sharing. It has expanded
the scope of font families and their usage.

➡ p.18 Arita Family Composition

『안토니오 타부키 선집』, 문학동네, 2013
An Anthology of Antonio Tabucchi's Works, Munhakdongne, 2013

페르난두 페소아의
마지막 사흘 어떤 정신착란

안토니오 타부키 선집 7
김운찬 옮김

Antonio Tabucchi
Gli ultimi tre giorni di
Fernando Pessoa.
Un delirio

인문 서가에 꽂힌 작가들 ┃ 안토니오 타부키 선집 7

안토니오 타부키 선집 7

인문 서가에 꽂힌 작가들 ┃ 안토니오 타부키 선집 7

Antonio Tabucchi
Notturno Indiano

페르난두 페소아의 마지막 사흘

문학동네

안토니오 타부키 선집 6

인문 서가에 꽂힌 작가들 ┃ 안토니오 타부키 선집 6

Antonio Tabucchi
Requiem

인도 야상곡

문학동네

인문 서가에 꽂힌 작가들 ┃ 안토니오 타부키 선집 4

Antonio Tabucchi
Sogni di sogni

레퀴엠 어떤 참가

문학동네

인문 서가에 꽂힌 작가들 ┃ 안토니오 타부키 선집 1

꿈의 꿈

문학동네

『도시, 생태학적 풍경』, 사진예술사, 2018
Cities, their Ecological Landscape, Sajinyesul, 2018

도시,
생태학적
풍경

—

Cities,
their Ecological
Landscape

—

김경숙
Kyungsook Kim

불의 강

유년의 뜰

바람의 넋

불꽃놀이

새

오정희 컬렉션
소설집

오정희 컬렉션
소설집

오정희 컬렉션
소설집

오정희 컬렉션
소설집

오정희 컬렉션
장편소설

문학과지성사

문학과지성사

문학과지성사

문학과지성사

문학과지성사

| EPITONE PROJECT |

: 때론, 혼자만의 시간이 필요하니까요.
: 때론, 같이 있어도 외로울 때가 있으니까요.

유월의 고독회
이화여고 100주년기념관 화암홀
2019년 6월15일 - 7월7일 매주 토,일

『우리 선시 삼백수』, 문학과지성사, 2017
300 Buddhist Poems from Korea, Moonji Publishing, 2017

우리
선시
삼백수

문학과지성사

우리
선시
삼백수

재료의 산책

여름의 일기

재료의 산책

봄의 일기

요나 지음

재료의 산책

겨울의 일기

요나 지음

재료의 산책

가을의 일기

요나 지음

이제 다른 길이 열리겠다

박수진　최근 은 탈의 환경을 중심으로 여성주의 목소리가 높아지고, 이에 관해 관심을 갖고 공부해야겠다는 공감대가 형성되고 있다는 인상을 받아요. 저 또한 그렇고요. 반면 이 프로젝트에서의 제 역할에 대해서는 자격스럽기도 했습니다. 우리 두 사람은 여자대학 교에서 학생들을 가르친다는 특징이 있는데, 제 경우 평소 그 부분을 많이 인식하며 교육에 임하진 못했거든요.

이재원　이 프로젝트에 대한 제안이 왔을 때, 지 역시 박수진 선생님과 마찬가지로 제 역할에 대해 고민했죠. 되돌아보면 지는 꽤 오랫동안 미국에서 살았기 때문에 비교적 젠더 문제에 관해서 자유로웠어요. 내가 여성이라거나 저 사람이 성소수자라는 인식을 하지 않은 채 그냥 인간적인 관계를 맺었던 것 같아요. 젠더 역할 구분이 명확한 한국 사회에 살기 시작하면서 여성 혹은 이슈에 더 많이 노출된 것 같아요. 지는 여대에서 여성 디자이너들을 배출하는 데 힘쓰지만, 사실상 필드를 보면 상대적으로 여성 디자이너 수가 적죠. 장기적으로 시니어 레벨까지 활동하는 여성 디자이너으로 비율도 낮고요. 즉, 여성이 디자이너라는 직업을 장기적으로 지속하는 게 어려운 거죠. 우리가 사회 구조적인 차원에서 여성에 대한 차별을 고려하지 않고, 개인의 실력 부족으로 '살아남기'가 안 된다고 인식하는 것이 일반적이에요.

자연스럽게 사용하는 말에도 남성의 편견이 비롯된 성차별이 많죠. 특히 남성이 여성의 외모를 언급하고, 평가하는 것과 칭찬이든 비하하는 그것을 당연시하는 것도 성차별이에요. 그것도 공적 영역에서 말이죠. 일반적으로 여성은 외모 및

『우리 균도』, 후마니타스, 2015
Our Gyundo, Humanitasbook, 2015

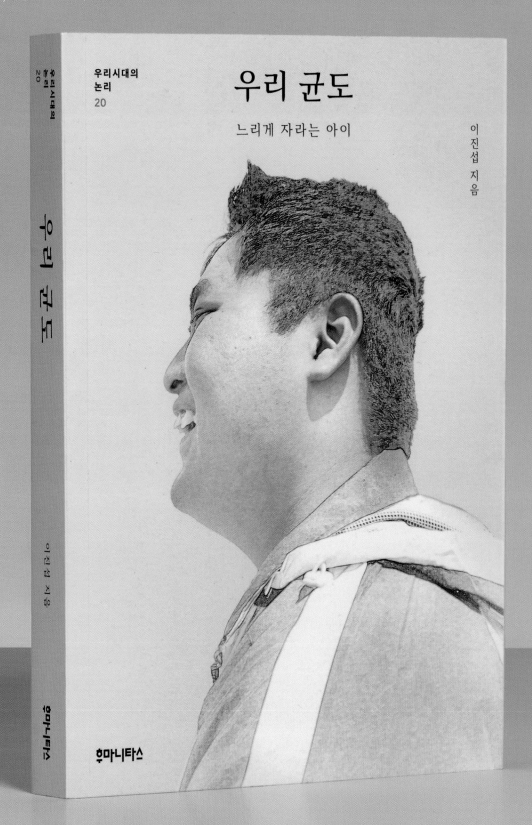

우리시대의
논리
20

우리 균도

느리게 자라는 아이

이진섭 지음

우리시대의 논리 20

우리 균도

이진섭 지음

후마니타스

A Designer's Pride as a Social Leader and Cultural Innovator

Interview with Hong Sung-taek

When I was a graduate student at Hongik University, I took one of Professor Ahn Sang-soo's undergraduate courses because he was already [...] the time. After completing [...] e, he asked me if I was [...] working on the *Seoul* [...] or me, it was obviously [...] r, so I gladly accepted [...] t was the starting point [...] ught I was only helping [...] t-time basis, but as AG [...] grow, I was hired on as [...] mployee that same year. [...] had the chance to con- [...] with Professor Ahn.

You started working at Ahn Graphics the same year it was founded. In an interview with *Monthly Design* magazine in

On Creativity and Fresh Spring Water Running Down a Mountain

Interview with Ahn Sang-soo

AG's original name was AHN GRAPH-ICS & BOOK PUBLISHERS. From the start, it was a publishing company. It was February 8, 1986 that I completed the nominal transfer after buying a publisher's license from the existing company, Korea Moonye. I felt that design services had certain limitations at the time and that someone needed to publish more content. The money my new company saved on design services was spent on publishing. Together, the *Asian Art Motifs from Korea* series, which was our first project, and the following book, *Seoul City Guide*, cost us KRW 100 million in total. That was a lot of money, so we were forced to take out loans to pay for it all.

We conceived of *Seoul City Guide* all on our own. With the 1988 Seoul Summer Olympics fast approaching, there wasn't a proper English guide to introduce Seoul to visitors. Thus, we thought a city guide to Seoul was necessary. Hong Sung-taek and Kim Hye-ran worked on the project, while taking advice from a number of experts, including the present-day director of the Seoul Museum of History, Dr. Kang Hong-bin. After we published the book, KBS offered to introduce it on their 9 o'clock news show, so I went down to the broadcasting station with a press release. It was while talking to a producer that the president of KBS spotted me. He was an acquaintance of mine, so after greeting me he asked what I was doing there. That's when I gave him a copy of *Seoul City Guide*. Later, he went on to become president of the Korea Tourism Organization (KTO) and called me to say the KTO wanted to publish the

Seoul City Guide (1986) and Asian Art Motifs from Korea series (1986–2004) played a pivotal role in getting the name Ahn Graphics out there, both in Korea and overseas. In fact, each series was relatively large in terms of its scope for a new company to publish. How did these big book projects ever come about?

[...] u were [...] is that AG [...] ees or so. [...] n an almost [...] project

수채화에
빠지다

작은 그림에서 시작해
나만의 작품까지

윤인애 지음

미진사

오픈 디자인

바스 판 아벌·뤼카스 에버르스
로얼 클라선·피터 트록슐러 엮음

배수현·김현아 옮김

EN
SIGN
OW

안그라픽스

디자인 독점의 시대는 끝났다

완성된 결과물만 보면 누가 만들더라도 차이가 없다.
바스 판 아벌(Bas van Abel, Waag Society), 뤼카스 에버르스(Lucas Evers, Waag Society),
로얼 클라선(Roel Klaassen, Premsela)

오픈 디자인은 모든 사람에게, 모든 것에 변화를 가져올 것이다.
폴 앳킨슨(Paul Atkinson, Sheffield Hallam University)

디자이너들은 사회적 방식의 창작이 약속하는 혜택을 누릴 수 있게 됐다.
앤드루 카츠(Andrew Katz, Moorcrofts LLP)

웹셀러 작가는 다른 많은 예술가에 비해 더 많이 벌기는 하겠지만,
베스트셀러 작가에 비하면 사회적으로 용인될 만한 정도의 차이다.
요스트 스미어스(Joost Smiers, Hogeschool voor de Kunsten Utrecht)

창작이 생산자의 문 앞에서 가로막히지 않도록 할 방법을 찾아야 한다.
로넨 카두신(Ronen Kadushin, Hochschule für Technik und Wirtschaft)

오늘날 평균 서양인은 빅토리아 여왕이 집권 당시 소유한 것보다
더 많은 물건을 사용할 수 있다.
요리스 라르만(Joris Laarman, Joris Laarman Lab)

예술 학교 출신이 아니라 보통 사람과의 대화에서 나오는 창의적
아이디어를 발전시키고자 한다.
레니 라마커르스(Renny Ramakers, Droog Design)

창작 과정에 참여하고 그 안에서 전문성을 깨닫게 되는 행위는
사람들이 자발적으로 나설 수 있도록 자신감을 준다.
피터르 얀 스타퍼르스(Pieter Jan Stappers & Co, Technische Universiteit Delft)

오픈 디자인은 우리가 복잡하고 예측할 수 없는 네트워크 속에서
정체성과 선택 같은 어려운 문제에 대처하기 위한 방법을 찾을 수 있도록
영감을 줄 것이다.
딕 레이컨(Dick Rijken, De Haagse Hogeschool)

던져야 할 올바른 질문은 어떤 과정이 최고의 디자인으로 이어질까가 아니다.
근본적인 물음은 훨씬 더 간단한 것, 바로 무엇이 공정하고 공평한가이다.
토미 라이티오(Tommi Laitio, Demos Helsinki)

모든 사람이 디자인에 참여하는 세상에서 디자인은 우리의 일상이 될 것이다.
대니얼 석(Daniel Saakes, KAIST)

http://www.opendesignnow.org

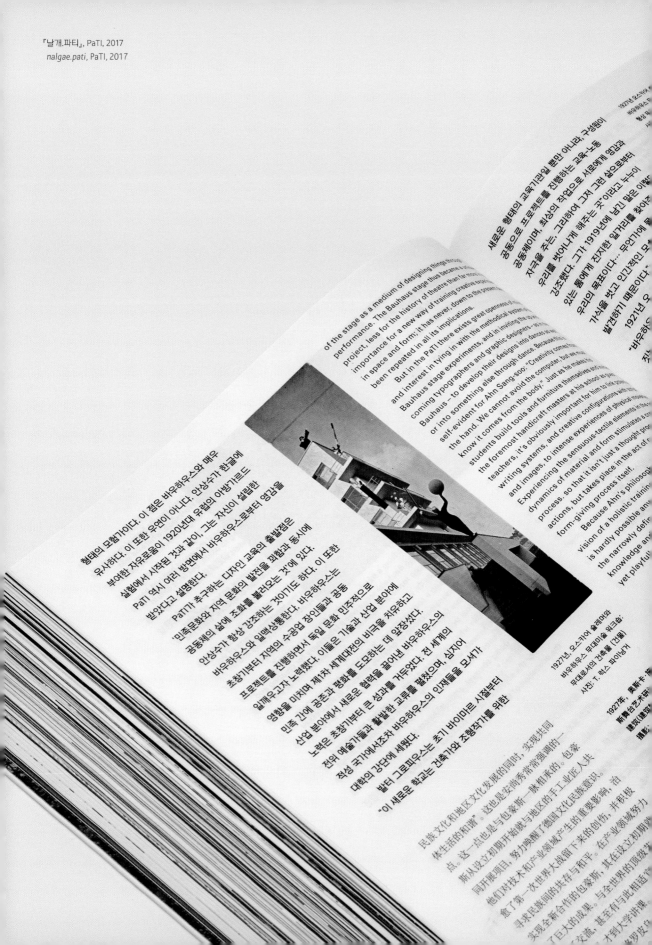

「날개.파티」, PaTI, 2017
nalgae.pati, PaTI, 2017

형태의 모험가이다. 이 점은 바우하우스와 매우 유사하다. 이 또한 우연이 아니다. 안상수가 한글에 부여한 자유로움이 1920년대 유럽의 아방가르드 실험에서 시작된 것과 같이, 그는 자신이 설립한 PaTI 역시 여러 방면에서 바우하우스로부터 영감을 받았다고 설명한다.

PaTI가 추구하는 디자인 교육의 출발점은 '민족문화와 지역 문화의 발전을 꾀함과 동시에 공동체의 삶에 조화를 불러오는 것'에 있다. 이 또한 안상수가 항상 강조하는 것이기도 하다. 바우하우스는 바우하우스와 일맥상통한다. 바우하우스는 초창기부터 지역의 수공업 장인들과 공동 프로젝트를 진행하면서 독일 문화 민주적으로 일깨우고자 노력했다. 이들은 기술과 산업 분야에 민족 간의 공존과 평화를 도모하는 데 앞장섰다. 전 세계의 산업 분야에서 새로운 협력을 끌어낸 바우하우스의 노력은 초창기부터 큰 성과를 거두었으며, 심지어 전 위 예술가들과 활발한 교류를 펼쳤으며, 심지어 모셔가 적성 국가에서조차 바우하우스의 인재들을 모셔가 대학의 강단에 세웠다.

"이 새로운 학교는 초기 바이마르 시절부터 발터 그로피우스는 건축가와 조형작가를 위한

of the stage as a medium of designing things through performance. The Bauhaus stage thus became a vital project, less for the history of theatre than far more for importance for a new way of training creative expression in space and form; it has never, down to the present been repeated in all its implications.

But in the PaTI there exists great openness and interest in tying in with the methodical systems and Bauhaus stage experiments, and in inviting the young coming typographers and graphic designers – as it Bauhaus – to develop their designs into dances is self-evident for Ahn Sang-soo: "Creativity comes from coming typographers and graphic designers or into something else through dance. Because they self-evident for Ahn Sang-soo: "Creativity comes the hand. We cannot avoid the computer, but we know it comes from the body." Just as he makes his students build tools and furniture themselves and the foremost handicraft masters at his school is good teachers, it's obviously important for him to link typ writing systems, and creative configurations with and images, to intense experiences of physical move Experiencing the sensuous-tactile elements in the dynamics of material and form stimulates a crea process, so that it isn't just a thought process actions, but takes place in the act of c form-giving process itself.

Because Ahn's philosoph vision of a holistic training is hardly possible anyw the narrowly defin knowledge and yet playfull

1927년, 오스카어 슐레머와
바우하우스 무대미술 워크숍:
무대작품의 건축물(건물)
사진: T. 룩스 파이닝거

1927年，奥斯卡·
斯新舞台艺术研
建筑(建筑)
摄影:

民族文化和地区文化发展的同时，实现共同
体生活的和谐。这也是与包豪斯一脉相承的一
点。这一点也是安尚秀始终常常强调的。包豪
斯从设立初期开始就与地区的手工业匠人共
同开展项目，努力唤醒了德国文化民族意识，治
他们对技术和产业领域产生的重要影响，并积极
愿了第一次世界大战留下来的创伤，在产业领域努力
寻求民族间的共存与和平。在设立初期就实现了
实现全新合作的包豪斯，与全世界的匠级才
巨大的成果。基至有与此相适
交流，才来到大学讲坛

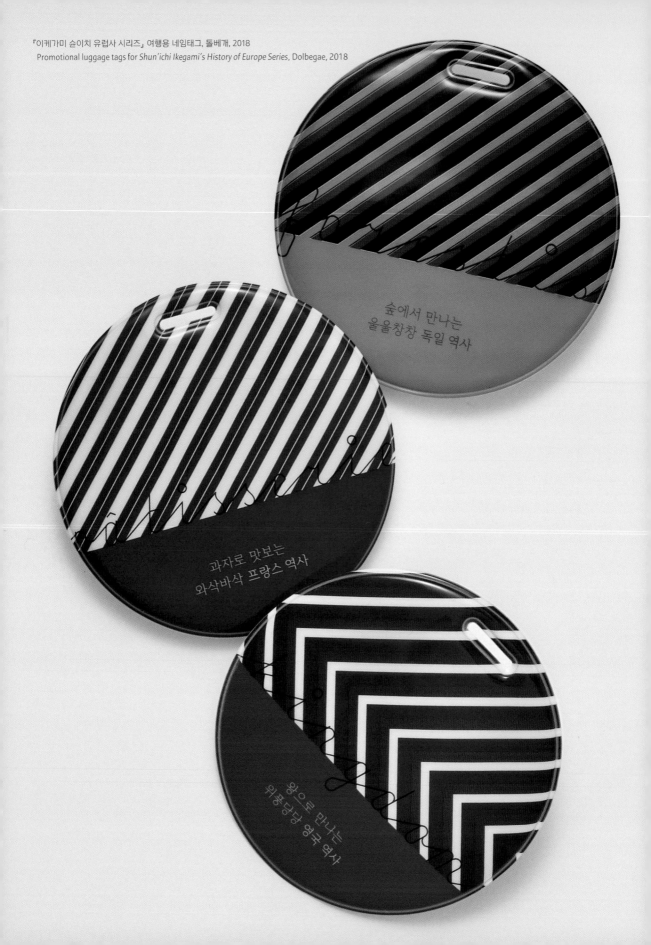

『이케가미 슌이치 유럽사 시리즈』 여행용 네임태그, 돌베개, 2018
Promotional luggage tags for *Shun'ichi Ikegami's History of Europe Series*, Dolbegae, 2018

숲에서 만나는
울울창창 독일 역사

과자로 맛보는
와삭바삭 프랑스 역사

왕으로 만나는
위풍당당 영국 역사

『타이포그래픽 디자인』, 안그라픽스, 2014
Typographische Gestaltung, Ahn Graphics, 2014

타이포그래픽 디자인

Typographische Gestaltung

ag | 안그라픽스

타이포그래픽 디자인

얀 치홀트 지음 안진수 옮김

《탬》 2호, 안그라픽스, 2017
Tel, vol. 2, Ahn Graphics, 2017

2017 VOLUME 2

PaTI 소식 웹사이트, 7호, PaTI, 2018
Website for PaTI News, 7, PaTI, 2018

8월 소식

파티 방문과 워크숍

서울문화재단과 뤼징런 페이퍼로그에서 파티를 방문했다.
또한 강원도 원주에 있는 상지여고 학생들이 파티를 방문해
파티에서 기획한 워크숍에 참여했다.

합정지구 웹사이트
Website for Hapjungjigu

'합정지구'는 젊은 문화예술창작자들이 전시, 프로그램, 교육, 비평가, 출판 등 여러 가지 형태의 문화 예술 활동을 통해 스스로의 삶을 조직하고, 동료들과의 긴밀한 협업관계를 개척하기 위한 비영리예술 나아갈 수 있는 길을 개척하기 위한 비영리예술 공간이다.

2015년 2월에 개관한 이래로, 20대부터 50대까지 다양한 연령대의 작가, 비평가, 기획자들을 소개하며 우리에게 필요한 컨텐츠를 위한 기회를 넓혀왔다. 이러한 기획들은 이제 막 시작하는 청년작가들과 잠깐의 시간 동안 잊혀지거나 적절한 방식을 만들지 못한 중/장년작가들이 만나고 아우러질 수 있론이고, 다양한 연령층과 관심사들이 자리가 되었다. 전시 외에도 비정기적으는 형태를 모색하는 자리가 되었다. 참여 작가와의 대화, 여러 외부 인사를 초청한 공개 강연, 합정지구의 프로그램은 작가와 기획가지 주제의 세미나와 워크숍도 진행된다. 참여 예술가요한 부분이다. '합정지구'의 전시와 연구조로 운영되며, 예술가자들의 자발적이고 다양한 연대를 통해 지금 시대에서 "함께들과 함께 창작과 연대를 통해 지금 시대에서 실천하는 것을 목표로 한다. 살아가는 방법"을 연구하고 실천하는 것을 목표로 한다.

합정지구 연혁
Chronology

2018
전시 Exhibition
2.2 ~ 2.25 《공백이 가득한 행성 A planet fi
회: 서다슴 / 참여작가: 박신영, 송승은》
3.3 ~ 3.25 《살람》 《기획: 이진실 / 참
4.13 ~ 5.11 박진아

베르너 사세
문화 인류학자

세종은 한국어라는 특정한 언어의 발음을 정확하게
반영할 수 있는 문자 체계를 만들었습니다.

수선화

Narcissus

水仙花

아모레퍼시픽 원료식물원에서는
마몽드 플로랄 하이드로크림의 꽃
수선화를 식재 관찰하고
있습니다.

Mamonde

1950	에이비씨	ABC
1960	코티	COTY
	오스카	OSCAR
	아모레	AMORE
	부루버드	BLUE BIRD
	하이톤	HI-TONE
1970	타미나	TAMINA
	미보라	MIBORA
	부로아	BUROA
1980	지.지.	G.G.
	나그랑	NAGRAND
	리바이탈	REVITAL
	탐스핀	TAMSPIN
	순정	SOONJUNG
	미로	MEERO
1990	레쎄	L'ESSAI
	설화수	SULWHASOO
2000	아모레퍼시픽	AMOREPACIFIC

카운셀러 가방

1980~90년대

DIRECTORY & MAP

돗통시 Pigpen-cum-Toilet

제주의 가정마다 하나씩 있던 돗통시는 돼지를 기르는 우리와
화장실을 합쳐놓은 공간이다. 돼지를 돗통시에 키워 인분을 처리하고,
그곳에서 나온 퇴비를 다시 밭에 뿌려 이용하는 방법은 제주만의
지혜로운 농법이다.

Every household on Jeju used to feature a combination of
a pigpen and a traditional toilet. Pigs were raised in a pigpen
attached to the toilet and fed with human waste. The remainder
of the waste was used as a fertilizer for the soil. It was an eco-
friendly agricultural technique unique to Jeju.

Car No.1-7
1~7号车厢　1~7호차

ライナー券に 記載の号車 の乗車口まで お進みくだ さい。

Go to the entrance of the car shown on your Liner ticket.

라이너권에 기재된 호차의 승차구로 가시기 바랍니다.

请到 Liner 券上所记载的车厢号的 上车门。

スカイ ライナー
skyliner

船橋・日暮里・上野 方面
for Funabashi, Nippori, Ueno

モーニング ライナー
Morningliner

8号車

Car No.8

8号车厢　　　8호차

아리따 여정【타임라인】

2004년 아리따 돋움을 시작으로 16년 동안 이어진
아리따 프로젝트는 세상에 고운 글자 씨앗을 심고 가꾸고
꽃피우는 여정이었습니다. 한글, 로마자, 한자가 태어났고
열여덟 종에 35,115자의 글자가 가족이 되었습니다.
아리따 가족은 100년을 바라보는 글꼴로 앞으로도
그 여정을 계속할 것입니다.

Arita's Journey【Timeline】

Beginning with Arita Dotum, the Arita project,
which was initiated in 2004 and lasted for
16 years, was a journey of planting, cultivating
and blooming seeds of fine types in the world.
Meanwhile, Hangeul, Latin alphabet letters, and
Chinese characters were born, together becoming
a family of 18 fonts and 35,115 characters.
The Arita typeface family will continue its journey
into the future to grow into typefaces that can be
used and loved by people everywhere.

2004	2005	2006	2007

11월 November
기획 및 자료 조사
Planning and research

6월 June
글자꼴의 방향성과
글꼴 이름으로 '아리따' 확정
Decided on "Arita" as the name
of the typeface and the overall
direction it would take

11월 November
「타이포그래피 아이덴티티를 위한 글자꼴 아리따」
논문 발표
Publication of the academic paper
"Arita: Typeface for Typographic Identity"

아리따 돋움 Arita Dotum

1월 January
아리따 돋움 미디엄, 세미볼드
개발 시작
Launch of Arita Dotum Medium
& SemiBold development

2월 February
글자 표정 결정
Decision reached on the look of
the characters

8월 August
글자높이 체계 확정
Finalization of the height system
글자사이 체계 확정
Finalization of the character
spacing system
낱말사이 체계 확정
Finalization of the word
spacing system
비례너비 체계 확정
Finalization of the proportional
space system
한글 2,350자 파생
Deriving the 2,350 characters
used in Hangeul

2월 February
글자 검수, 문장 조판 테스트
Evaluation of characters &
typesetting test

4월 April
한글 11,172자 파생
Deriving the 11,172 characters
used in Hangeul

10월 October
1차 나눔: 아리따 돋움
미디엄, 세미볼드
The 1st Round of Free
Dissemination: Arita Dotum,
Medium, and SemiBold

1월 January
아리따 돋움 라이트, 볼드 개발 시작
Launch of Arita Dotum Light and
Bold's development

12월 December
2차 나눔: 아리따 돋움 라이트, 볼드
The 2nd Round of Free
Dissemination: Arita Dotum
Light and Bold

10월 October
아리따 3.0 논의
Discussions about Arita 3.0

1월 January
아리따 돋움 씬 개발 시작
Launch of Arita Dotum Thin's
development

12월 December
아리따 3.0 개발 완료
Completion of Arita 3.0's
development

아리따 산스 Arita Sans

1월 January
아리따 산스 씬, 라이트, 미디엄,
세미볼드, 볼드 개발 시작
Launch of Arita Sans Thin,
Light, Medium, SemiBold, and
Bold's development

아리따 글씨

Arita Writing

2004

2020

18

35,115

100

2016	2017	2018	2019

1월 January
아리따 글꼴 인지도 조사
Survey on people's awareness of
the Arita typeface

3월 March
IF디자인어워드 2016 수상
Recipient of an IF Design Award
2016
CA디자인어워드 2016 수상
Recipient of a CA Design Award
2016

5월 May
아리따 흑체 라이트, 볼드 개발 시작
Launch of Arita Heiti Light and
Bold's development

6월 June
6차 나눔: 아리따 흑체 미디엄
The 6th Round of Free
Dissemination: Arita Heiti
Medium

5월 May
7차 나눔: 아리따 흑체 라이트, 볼드
The 7th Round of Free
Dissemination: Arita Heiti
Light and Bold
아리따 흑체 프레스키트 발행
Publication of the Arita Heiti
Press Kit

8월 August
아리따 흑체 프레스키트로
레드닷디자인어워드 2017 수상
Recipient of a Red Dot Design
Award 2017 for the Arita Heiti
Press Kit

12월 December
「아리따 흑체를 통해 본 중문 글자체
개발 과정」논문 발표
Publication of an academic paper
titled "The Development Process
of Chinese Character Type
through Arita Heiti"

2월 February
IF디자인어워드 2018 수상
Recipient of an IF Design Award
2018
CA디자인어워드 2018 수상
Recipient of a CA Design Award
2018

6월 June
「아리따 중문 리서치 2.0」 발행
Publication of *Arita Chinese
Reserch 2.0*

한재준【아리따 돋움】

글꼴 디자이너. 1세대 한글 디자이너로 홍익대학교
미술대학을 졸업하고 동 대학원에서 시각 디자인을
전공했다. '문자추상' 작업을 계기로 한글의 현실과 새로운
가능성에 관심을 두고 한글 디자인을 사회적인 관점으로
점차 확대해왔다. 한글 기계화의 선구자 공병우 박사에게
디자인을 배웠고 '공한체' '한체' 등을 개발했다.
아리따 돋움의 총괄 디렉터로 참여했다.

Han Jaejoon【Arita Dotum】

Han Jaejoon is one of the first generation of
Korean type designers. He graduated from Hongik
University's College of Art, and then received his
master's degree in Visual Design at the same
university. Using the Letter Abstract series as a
starting point, he has maintained an interest
in the current status and new possibilities of
Hangeul, and gradually expanded his design of
Hangeul from a social point of view. He learned
design from Dr. Gong Byungwoo, a pioneer of
Hangeul mechanization, and then developed
Gonghan and Han typefaces. He also participated
in the Arita Dotum project as executive director.

2012	2013	2014	2015

1월 January
『타이포그래피 매뉴얼』 발행
Publication of *Typography Manual*

아리따 부리 Arita Buri

2월 February
아리따 부리 미디엄, 세미볼드
개발 시작
Launch of Arita Buri Medium
and SemiBold's development

1월 January
3차 나눔: 아리따 돋움 씬,
라이트, 미디엄, 세미볼드, 볼드
업그레이드 버전
The 3rd Round of Free
Dissemination: Arita Dotum
Thin and the upgraded versions
of Arita Dotum Light, Medium,
SemiBold, and Bold

2월 February
4차 나눔: 아리따 부리 미디엄,
세미볼드
The 4th Round of Free
Dissemination: Arita Buri
Medium and SemiBold

6월 June
아리따 부리 헤어라인, 라이트,
볼드 개발 시작
Launch of Arita Buri HairLine,
Light, and Bold's development

12월 December
5차 나눔: 아리따 부리 헤어라인,
라이트, 볼드
The 5th Round of Free
Dissemination: Arita Buri
HairLine, Light, and Bold

3월 March
아리따 부리 '한율' 브랜드
글꼴로 적용
Adoption of Arita Buri as the
typeface for the Hanyul brand

8월 August
아리따 부리 프레스키트 발행
Publication of the Arita Buri
Press Kit
아리따 부리 프레스키트로 레드닷
디자인어워드 커뮤니케이션부문
베스트오브더베스트 수상
Recipient of the Red Dot:
Best of the Best award in the
Communication category for
the Arita Buri Press Kit

아리따 흑체 Arita Heiti

1월 January
3차 나눔: 아리따 산스 씬, 라이트,
미디엄, 세미볼드, 볼드
The 3rd Round of Free
Dissemination: Arita Sans
Thin, Light, Medium, SemiBold,
and Bold
아리따 포스터 전시
Arita Poster Exhibition
디자인 포럼 개최
Host of a Design Forum
아리따 산스 프레스키트 발행
Publication of the Arita Sans
Press Kit

7월 July
아리따 산스 프레스키트로
레드닷디자인어워드 커뮤니케이션
부문 우수상 수상
Recipient of a Red Dot Design
Award in the Communication
category for the Arita Sans
Press Kit

8월 August
『아리따를 위한 중문 글꼴 리서치』
발행
Publication of *Research on
Chinese Typefaces for Arita*

6월 June
중국 글꼴회사 한이, 중국
베이징중앙미술학원과의 협업 제안
Proposal of a collaboration with
Hanyi and the Beijing Central
Academy of Fine Arts

11월 November
아리따 한자 글꼴 개발을
위한 워크숍
Workshop for the development
of Arita Chinese characters

5월 May
아리따 흑체 미디엄 개발 시작
Launch of Arita Heiti Medium's
development

아리따 돋움 프로젝트에 어떤 계기로 참여하게 되었고
맡은 역할은 무엇이었는가?

안상수 선생님과의 인연으로 시작했고 그를 가까이에서 도왔다.
안상수 선생님과 하는 일은 새롭고 재미있으며 편안하다.
그는 함께 일하는 사람을 두근거리게 한다. 아모레퍼시픽이
글꼴 개발에 특별한 관심이 있다는 것에도 끌렸다.

아리따 돋움의 자문, 디렉팅의 기준은 무엇이었는가?

새롭고 의미 있고 편리하며 널리 사랑받는 글꼴을 생각했다.
기준은 당연히 아모레퍼시픽이었다. 생각나는 것은
무엇이든 말했다.

프로젝트 진행 과정은 어떠했는가?

자료 조사를 충분히 하고 비교 검증, 자유 토론 등을 거치며
디자인 방향을 구체화했다. 다양한 정보와 근거를 통해
디자인을 조금씩 발전해갔다. 명쾌하고 자유로운 분위기였다.

아리따 돋움의 콘셉트는 어떻게 정했는가?

아모레퍼시픽의 경영 철학을 바탕으로 했다. 오래가는
아름다움, 특히 어제의 아름다움을 존중하며 내일의 아름다움을
추구한다는 점을 중요하게 보았다. 각자가 떠올리는 방향과
이미지를 인물이나 사물, 낱말로 구체화했다. 작은 것
하나하나에 정성을 기울이면 큰 것을 이룰 수 있다고 믿었다.

프로젝트 이름을 '아리따'로 짓게 된 배경은 무엇인가?
글꼴과는 어떤 연관성이 있는가?

'아리따'라는 이름을 지은 과정은 안상수 선생님이 답해야 가장
정확할 것이다. 그가 처음 '아리따'라는 이름을 꺼낸 순간 딱
어울리는 이름이라고 생각했다. 뜻도 어감도 좋았다. 성공적인
상징 이름이 될 것 같았다. 이름을 잘 지으면 프로젝트를
공유하고 구체화하는 데 큰 도움이 된다. 공통된 이미지로
구체화할 수 있어 작업이 훨씬 수월해진다. 꼴, 뜻, 소리가
어울리면 소통이 편해지는 것과 같은 이치이다. '아리따'라는
이름에는 이러한 어울림의 철학이 잘 드러나 있다.

What made you take part in the Arita Heiti project,
and what was your role?

My connection with Ahn Sangsoo, the head of the Paju
Typography Institute (PaTI), led me to the project,
and I closely assisted with his work. Work with Ahn is
always new, fun and comfortable, and people feel a
sense of anticipation when working with him. I was
also fascinated by the fact that Amorepacific has been
interested in developing typefaces.

What were your criteria in consulting with and
directing the Arita Dotum project?

I was thinking of a new, meaningful and more convenient
typeface that would be widely loved. Of course, expressing
Amorepacific's identity was an essential part of the
equation. I openly discussed anything that came to mind
during the development process.

What was the process of conducting the project like?

We created the direction of the design through ample
data research, comparative verification, and open
discussions. We gradually developed designs based on
various kinds of information and evidence. In fact,
the entire process was carried out in an atmosphere
where everybody was able to share their thoughts clearly
and freely.

How was the concept of Arita Dotum decided upon?

It was based on the management philosophy that
Amorepacific has pursued for years. In particular,
we paid attention to the fact that the company respects
long-lasting beauty, and pursues tomorrow's beauty
while respecting yesterday's beauty. Each participant in
the project conjured up different directions and images
of the project by specifically expressing them through
people, objects, and words. We believed that something
great could be achieved if we put our hearts and soul into
even the smallest things.

Tell us about the background and the process behind
the name Arita. What is the connection between the
name "Arita" and the typeface itself?

When it comes to the naming process, it would be
most appropriate for Mr. Ahn to answer the question.
I thought it was a perfect name when Ahn first brought
out the word "Arita." Its meaning and tone were all
perfect. I thought it would be a successful symbolic
name. Proper naming usually helps in a significant
way to share and give shape to a design project. Work
gets much easier when a specific and shared image
for the project is created among colleagues. It is like
communication will be convenient when the form,
meaning, and the sound of an expression are harmonized.
The word "Arita" is an excellent manifestation of the
eoullim (harmony) philosophy.

아리따는 기업 아이덴티티 영역의 새로운 장을 여는 문화 이미지 아이덴티티로서, 타이포그래픽 아이덴티티^{TI, Typographic Identity} 개념을 처음 적용한 글꼴이다. 아리따 돋움은 기존 기업용 글꼴과 어떤 점이 다른가?

갈수록 더 친근해지는 글꼴이길 바랐다. 보는 아름다움만이 아니라 체험하는 아름다움을 생각했다. 그래서 사람들이 직접 사용하는 과정이 중요했다. 이것이 제목용이 아닌 본문용으로 접근한 배경이다. 빨리 가기보다는 천천히 오래가는 친구가 되길 바랐다. 서두르지 않고 천천히. 이것이 더 큰 힘이 될 것으로 생각했다. 내가 처음 썼는지는 모르겠지만, 이때 타이포그래픽 아이덴티티라는 표현을 사용했다. 아모레퍼시픽 고유의 표정과 시각적 목소리, 말씨의 체계를 만들고자 했다.

국내 기업 전용 글꼴이 제목용 수준에 머물러 있을 때 아리따는 본문용으로 제작해야 한다고 이야기했다. 아리따 돋움이 본문용 글꼴이 되기까지의 과정은 어떠했는가?

군손질 없이 편리하고 쓸모 있으면서 누가 다루더라도 짜임새 있는 판면으로 구성되는 글꼴을 추구했다. 이미지 차별화를 넘어 바른 쓰임을 강조했다. 그 가운데 하나의 성과라면 마이너스 자간이라는 어리석은 환경을 깨끗이 쓸어낸 일이다. 과정을 되돌아보면 앞으로가 더 중요하다는 생각이 든다. 현재 부족한 점을 꼼꼼히 채워나가야 한다. 그래야 살아남는다. 그것이 오래가는 아름다움일 것이다.

아리따 돋움의 최종안을 결정한 기준은 무엇이었는가? 디자인 과정에서 어떠한 점에 주목해 기준을 마련했는가?

음식에 비유하자면 본문용 글꼴은 쌀밥과 같다. 아무리 먹어도 질리지 않는 균질한 식감과 맛이 있어야 한다. 여러 조건이 있었지만, 특히 글줄의 흐름선을 강조했다. 한글 활자꼴이 풀어야 할 가장 큰 숙제로, 부분과 전체를 함께 고려했다.

아리따 돋움은 조화로운 판짜기를 위한 비례너비 글꼴이다. 아리따 부리 또한 비례너비의 원칙에 따라 개발했다. 비례너비 글꼴을 만들게 된 이유와 과정은 어떠했는가?

가로짜기 디지털시대에 고정너비를 벗어나는 것은 자연스러운 선택이었다. '니' '빼'처럼 줄기 수가 많이 차이 나는 글자꼴을 고정너비에 가두는 일은 어리석지 않은가? 현재의 기술과 사용 환경에 머무르지 않고 한 발짝 더 앞으로 가기 위한 결단이었다.

Arita is the first typeface to adopt the typographic identity (TI) concept, one which embraces cultural image identity and opens a new chapter for corporate identity (CI). What is the most significant difference between Arita Dotum and traditional corporate fonts?

We expected Arita to be an increasingly friendly typeface. Therefore, we were not just thinking about something beautiful to look at, but also about a beauty to experience. That is why the process which people use for themselves was crucial. It is also one of the reasons why we approached it from the perspective of the body text, not the title. We wanted it to be a "friend" in a long-standing relationship; slowly, not in a hurry. I thought this would be a greater force. I don't know if I was the first person to use this expression, but I used "typographic identity" in the past. We wanted to create the look, visual voice, and language system unique to Amorepacific.

While most Korean corporate fonts usually remain focused on the title, you said Arita should be made for the body. Tell us about the process of Arita becoming the body typeface.

We sought a typeface that would be convenient and useful, with no need for extra trimming, one which would be shown in a neat typeset no matter who handles it. That's why I emphasized the correct use of the typeface beyond image differentiation. One of our achievements is that we clearly removed the unreasonable environment of negative letter-spacing in Arita. Looking back, I think the future process is more important. By carefully improving the present condition of Arita, it can survive. That would be the enduring beauty of the typeface.

What criteria did you use to determine the final design of Arita Dotum? In the course of designing it, what did you pay attention to in preparing such criteria?

To compare it to food, the font for the body is like rice; it requires a homogeneous texture and taste that you can't get enough of. There were many conditions in making this font, but we especially emphasized the flow line of the text. It is one of the biggest tasks to accomplish for the typeface of Hangeul, so we considered both the parts and the whole of the font.

Arita Dotum is a proportional typeface for harmonious typesetting. Arita Buri was also developed following its principle of proportional space. How and why did you create the proportional fonts?

In today's digital age of horizontal writing, it was a natural approach to get out of the mindset of fixed-width fonts. Wouldn't it be absurd to keep characters, which have a different number of vertical lines, such as "니" and "빼," within a fixed horizontal space? It was a decision not to be limited to current technology or usage environment, but instead to take a step forward.

'추임' '파임' '트임' 등 한글 디자인 용어를 바로잡는 것이 중요하다고 이야기했다. 새로운 용어를 제안하게 된 계기는 무엇인가?

얼과 말과 글과 꼴을 하나의 이치로 이어보려는 것이다. 이치를 따르면 세상이 밝아진다. 그런 정신을 따른 것이다. 오래전 일이라 기억이 희미하지만, 추임은 살짝 추켜올린 맺음을 구분해서 부르기 위해 제안했던 것 같다. 판소리 등에서 흥을 돋우기 위해 쓰는 '얼씨구' '좋다' 같은 '추임새'에서 따왔다. 추임새를 하는 기분으로 글자를 쳐올린 모양이라는 뜻이었다. 파임이나 트임도 막히지 않게 트거나 파낸 부분이니까 잉크 트랩이라는 표현보다 이해하기 쉬울 것으로 생각했다.

한글 용어의 사용이 한국 글꼴 디자인 분야에서 어떤 역할을 할 수 있다고 보는가?

전문 분야가 발달하면 새로운 용어가 생길 수밖에 없다. 체계와 문화가 다른 말을 무턱대고 빌려 쓰기만 하면 이해와 소통이 어려워진다. 말의 뿌리와 갈래를 알고 쓰면 이해가 쉽고 더 정교하게 소통할 수 있다. 글꼴이 단단하면 디자인도 단단해진다. 글꼴 관련 용어를 바로잡는 일도 디자인의 기본을 다지는 일이다.

아리따 돋움은 긴 검수 기간을 거쳤다. 검수 기준과 그 과정에서 어려웠던 점은 무엇인가?

여러 기준이 있지만, 무엇보다 부분과 전체를 동시에 보는 것이 중요했다. 규칙과 질서가 일정해야 하고 되도록 단순한 방향으로 마무리해야 했다. 일정 기간 디자이너와 호흡을 맞추는 일이 민감하고 까다로웠다.

아리따 돋움을 개발하면서 아리따 가족이 확장되어야 한다고 이야기했다. 돋움, 부리, 산스, 흑체가 개발된 현재 상황에서 아리따 글꼴 확장에 대해 어떻게 생각하는가?

글꼴 확장에 새로운 접근이 필요하다. 시대는 이미 한 차원 다른 확장 체계를 요구하고 있다. 지금의 글꼴가족 체계를 뛰어넘어야 한다. 특히 로마자의 틀에서 벗어나야 한다. 한글의 특성을 살리고 이끌어가며 더 편리하고 쓸모 있는 디자인 방향으로 가야 한다.

마지막으로 아리따 돋움 프로젝트를 몇 가지 주제어로 말한다면?

또 하나의 돋움, 도전, 젊음, 배려, 새로움. 아리따움.

You said it is vital to correct the terms in Hangeul typeface design, such as *chuim* (a raised shape at the end of a stroke) and *paim* (ink trap). What made you come up with new terms?

It is an attempt to connect people's spirits, language, and the shapes of letters in a single logic. I followed the idea that the world will become brighter when we come into union with reason. It was a long time ago, so I don't exactly remember this, but I think I suggested *chuim* to refer to a slightly raised edge of a stroke. It is derived from the Korean word *chuimsae* (expressions), such as *"eolssigu* (bravo!)" and *"jotta* (great!)," both of which are used to add more amusement to *pansori*, a traditional Korean epic chant, and other performances. It was used to mean that strokes were lifted in the spirit of *chuimsae*. I thought *"paim* (slight dip)" and *"teuim* (slit)" would be easier to understand than ink traps.

What role can Korean terms play in the field of Korean typeface design?

Advances in the field of expertise inevitably create new terms. However, if you blindly borrow words from different languages and cultures, it makes understanding and communication difficult. If you use terms based on the knowledge of their roots and language branches, you can understand them more easily and communicate using them. Correcting terms related to typefaces is also a way to lay the foundation for design.

Arita Dotum went through a long evaluation period. What were the criteria and challenges during the process?

There were many criteria, but above all it is essential to look at the part and the whole at the same time. Rules and order for the typeface should be consistent, and the project had to be completed in the simplest way possible. Collaborating with designers for a certain period was quite sensitive and tricky.

While developing Arita Dotum, you said the Arita family should be expanded. So far, Arita Dotum, Buri, Sans, and Heiti have been developed. What is your opinion about the expansion of the Arita typeface at this point?

We need a new approach to the expansion of the typeface. Changes in the times are already calling for another level of expansion. It needs to move beyond the current typeface family system. In particular, Korean type design must break away from the framework of the Latin alphabet. We need to move in a more convenient and useful direction while promoting and enhancing the characteristics of Hangeul.

Lastly, describe Arita Dotum in a few keywords.

They include another kind of rising (*dotum*): challenges, youth, consideration, novelty, and beauty.

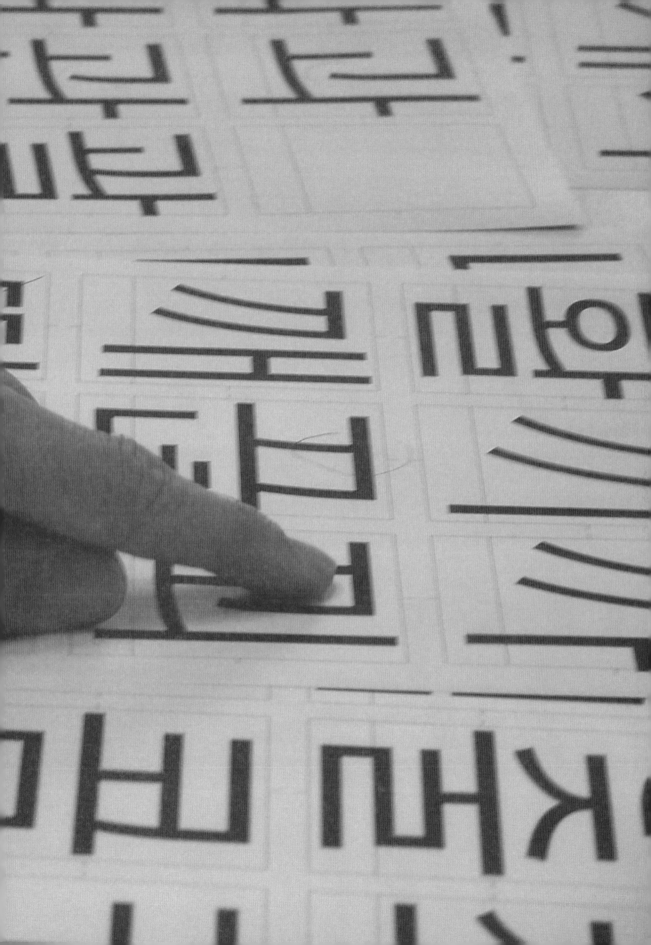

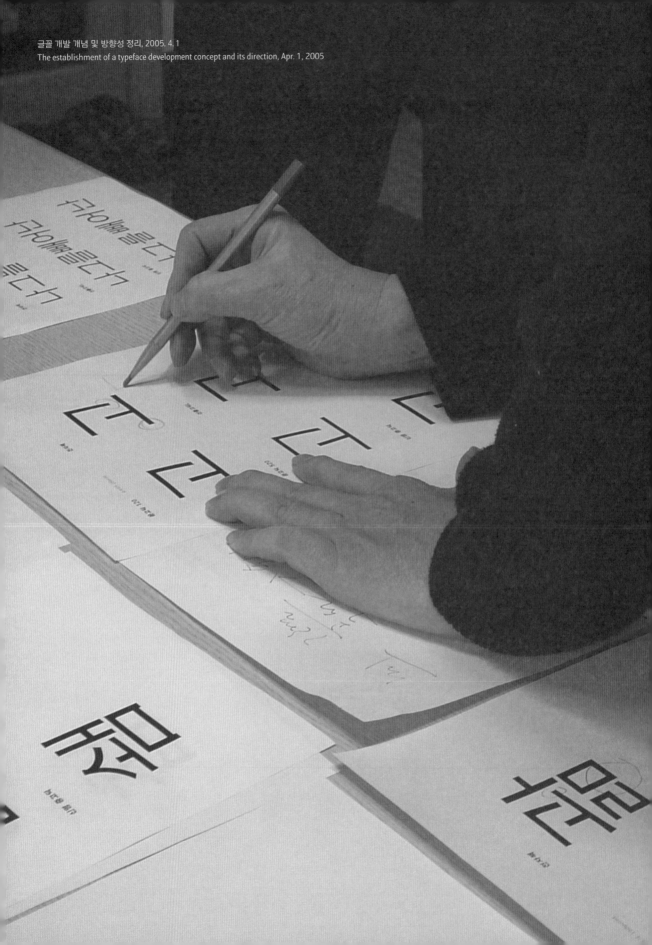

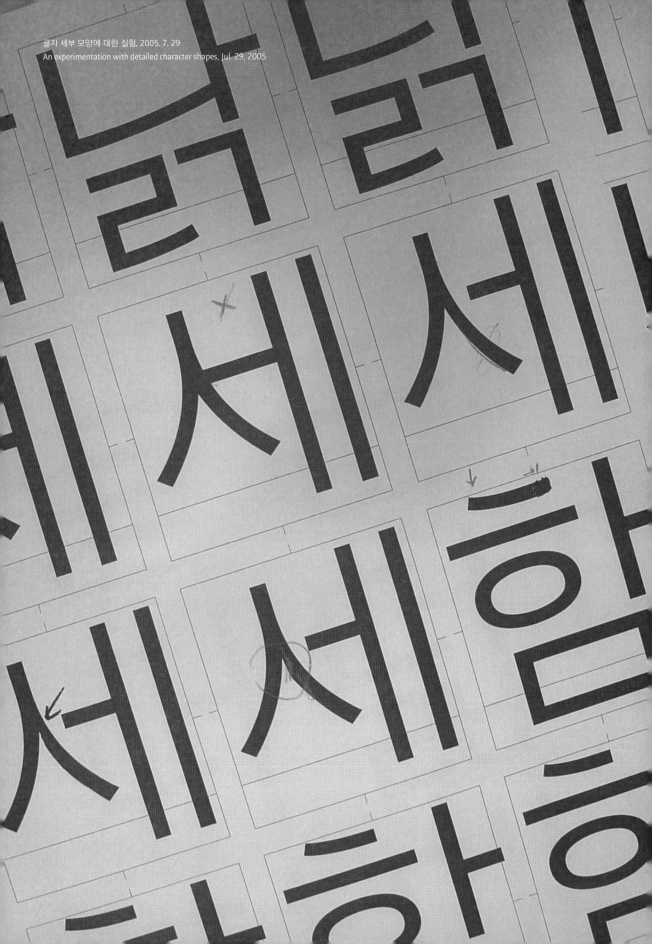

글자 세부 모양에 대한 실험, 2005. 7. 29
An experimentation with detailed character shapes, Jul. 29, 2005

...용 워터가 생동감 있는 피

부드럽게 정돈해 주는 워터 프리

자연의 풍부한 미네랄 성분을 함유

생명력 넘치는 피부 활력을 전달

보타니컬 토너입니다 추출물이 피

와 고산지대에서 자라는 야생화 추

게 진정시키면서 균형 있고 편안하

녁 세안 후 적당량을 화장솜에 덜어

꼼히 닦아내듯이 사용합니다 피부

파라옥시안식향산에스텔 페녹시

용인시 기흥읍 영덕리

쌍닿자의 이음에 대한 논의, 2005. 7. 29
A discussion on the joint between double consonants, Jul. 29, 2005

이용제【아리따 돋움】

글꼴 디자이너. 홍익대학교와 동 대학원에서 시각 디자인을
전공했으며, 한글 디자인으로 박사 학위를 받은 첫 번째
디자이너이다. 방일영문화재단 한글 글꼴 창작지원으로
2006년 세로쓰기용 글꼴 '꽃길체'를, 2014년 텀블벅
후원을 통해 '바람체'를 발표했다. 현재 한글을 연구하고
디자인하는 '활자공간'을 운영하고 있다. 아리따 돋움의
책임 디자이너로 참여했다.

Lee Yongje【Arita Dotum】

Type Designer Lee Yongje studied Visual Design at
Hongik University and the same graduate school,
and was the first designer to receive a Ph.D. in
Korean typeface design. Lee created the Kkotgil
typeface for vertical writing with the support
of the Bang Il-young Foundation in 2006, and
then released the Baram typeface with support
from Tumblbug (a platform for the creative arts)
crowdfunding. Lee now operates a company
called Type-space for studying and designing
Hangeul. He participated in the Arita project as
a senior designer.

아리따 돈움 프로젝트에 어떤 계기로 참여하게 되었고
맡은 역할은 무엇이었는가?

안상수 선생님이 프로젝트를 기획했고, 같이 일을 하고 있어
자연스럽게 합류했다. 박사 과정 때로 기억하는데 역할은
디자이너였다. 안상수 선생님과 한재준 선생님이 직접 글자를
그리지는 않았다. 안상수 선생님은 총괄 디렉터였고, 한재준
선생님은 공동 디렉터의 역할도 했지만 공식적으로는 검수
역할이었다. 방향에 대한 회의는 모두 함께했지만, 내 역할은
글자를 그리는 일이었고 글자 확장은 '활자공간'의 직원들과
함께했다. 아리따 돈움은 좋은 프로젝트였다. 오랜 시간이 지난
지금도 이렇게 이야기를 정리하는 것을 보면 대단하다고 느낀다.
해외에도 이와 비슷한 사례는 없을 것 같다. 이런 프로젝트에
참여해 영광이다.

아리따 돈움은 아리따 글꼴 프로젝트의 시작이었고
디자인적으로 새로운 시도를 많이 했다. 아리따 돈움은
어떤 글꼴인가?

당시 진행했던 연구 성격의 프로젝트와 비교하면 상용화와
특정인의 요구를 모두 염두에 두어야 했던 아리따 프로젝트에서
특별히 새로운 시도를 했다고 말하기는 어려울 것 같다.
아리따는 기업에 납품해야 했기 때문에 현실과 타협한 점도
많다. 그럼에도 유지했던 부분은 비례너비와 윗선을 가지런하게
하는 것이었다. 또한 잉크 트랩과 같이 활자에서 디지털로
넘어오면서 사라지고 간과된 부분을 조금 더 정교하게 표현하기
위해 많은 시도를 했다. 덧붙여 아리따 돈움 프로젝트를
진행할 당시에는 쿼크엑스프레스^{QuarkXpress}와 아래한글에서
비례너비 글꼴이 지원되지 않았다. 그래서 당시 두 개의 버전을
만들었는데 비례너비 글꼴이 지원되면서 자연스럽게 사라졌다.

What made you take part in this project and
what was your role in it?

Ahn Sangsoo planned the project, and I naturally joined it
because I was working with him at the time. I remember
when I was doing my Ph.D. I was a designer back then.
Ahn and Han Jaejoon didn't personally draw characters.
Ahn was the director of the entire process, while Han
served as the co-director, but they officially oversaw the
whole process. All of the people involved took part in the
meetings on the direction of the project, but I did the
drawing, and the expansion of the typeface was done
with the staff of a company called Type-space. Arita
Dotum was a great project. It's great to see the story of
the project recorded in this book today, even if it was
finished years ago. I am honored to have been able to
participate in such a project.

Arita Dotum, which was the beginning of the
Arita project, made many new forays into type design.
Can you tell us about Arita Dotum?

It's difficult to say if we made many new forays in
particular for the Arita project when compared to the
research projects we were working on at the time.
Honestly, we had to commercialize the typeface while
satisfying a specific client. With Arita, the design of
the typeface was compromised because of practical
requirements, as it had to be delivered to a company on a
certain date. Nevertheless, we kept the proportional space
and the straight upper line. In addition, many attempts
were made to more precisely express the disappearing
and overlooked parts in the digital age—like ink traps.
On top of that, the proportional typeface was not
supported in QuarkXpress and Hangeul (HWP) software
when we were working on Arita Dotum. Thus, we made
two different versions at the time, but one naturally
disappeared, as the proportional typeface became
compatible with both of those software programs.

'아리따'는 사랑스럽고 아리따운 여성이라는 의미를 담고 있다.
이 의미를 어떻게 글꼴에 담았는가?

질문에서 '사랑스럽고 아리따운 여성'이라고 했는데 '건강함'이
빠졌다. '건강한 여성미'를 강조했고 '여성성'과 '건강함'을
어떻게 표현하면 좋을지 고민했다. 여성성을 담기 위해 획을
휘어지게 그려 손맛을 표현했고 건강함을 표현하기 위해 획을
이어붙여 결구를 단단하게 그렸다. 하지만 획을 이어붙이다 보니
조형적 문제와 글자의 오독 문제가 생겨 예외 사항을 나열하며
다듬어나갔다. 그때는 '사랑스러움'이라는 단어보다는
'건강함'이라는 단어를 더 많이 떠올렸다. 이미지로 삼은 여성은
'곱고 순종적인 여성'이 아닌 '건강하고 당당한 여성'이었다.
여성과 건강함이 최종적으로 '아름다움'이라는 말로 귀결되었다.

아리따 돋움의 제작 과정은 어떠했는가?
다른 한글 글꼴 제작과 어떤 점이 달랐는가?

글꼴 제작 과정은 비슷했지만 더 심도 있는 시간을 보냈다. 많은
사람이 모여 형식적인 논의를 한 것이 아니라 모두가 새로운 것을
만들고자 노력했다. 회의의 밀도가 아주 높았다. 가끔 강연에서
앞으로도 아리따 같은 프로젝트는 없을 것 같다고 이야기한다.
보통 글꼴 개발은 형식적인 과정이 많은데 이 프로젝트는 그렇지
않았다. 당시 사용성 평가에서 다들 좋게만 말해 아쉬웠다.
최근의 아리따 사용성 평가를 보면 이제는 "너무 좋아요."가
아닌 "장점은 있지만, 아쉬운 점은 어떤 부분이다."라고 한다.
이러한 평가가 훨씬 객관적인 것 같다. 개인적으로는 아리따를
쓰지 않는다. 작업은 재미있게 했지만, 10년 전 작업을 보며
"와! 잘했다."라고 말하기는 어렵다. 계속 다듬고 싶어도
쉽게 고칠 수 있는 작업이 아니기에 괴로워서 보지 않는다.
이렇게 흥미로운 프로젝트가 또 있다면 참여하겠지만,
전용 글꼴 개발을 하지 않는 이유 가운데 하나는 내 마음대로
계속 손댈 수 없기 때문이다.

"Arita" means a lovely and beautiful woman. How did
you capture the meaning of this in the typeface itself?
You mentioned "lovely and beautiful," but "healthy" was
missing. For the design, a "healthy female beauty" was
emphasized, and we thought long and hard about how
to express "femininity" and "healthiness." I drew curved
strokes to imply femininity, and the joining parts of
strokes were drawn tight in order to express healthiness.
However, there were problems with the formation of
the characters and issues that caused the letters to
be misread, so they were refined while pouring over
exceptional cases of design. When I think of that time,
I dealt with the word "healthiness" more than the
word "loveliness." The woman we imagined was healthy
and confident, not pretty and obedient. For me, the
concepts of "women" and "healthiness" added up to the
keyword "beauty."

What was the production process of Arita Dotum like?
How was it different from the production process of
other Hangeul typefaces?
The production process was basically the same, but
we spent an in-depth length of time developing it.
It was not that many people got together just for
perfunctory discussions; everybody worked hard to come
up with something new. We had very productive and
substantive meetings. There are times I think that there
could never be another project like Arita in the future.
Font development usually includes a lot of superficial
processes, but this project was different. At the time,
however, I didn't like the fact that everyone gave only
positive reviews during the usability test. A recent
usability test for Arita shows that people don't simply
say "It's really good." Instead, they say "It has many
merits but needs some improvement in…" I think this
is much more objective. Personally, I don't use Arita.
It was fun to work on, but it's hard to say that what
I did 10 years ago was really great. Although I want to
keep refining the typeface, it's not something I can
easily improve, so I would rather avoid thinking about.
If another exciting project comes along, I would be
happy to take part in it. However, one of the reasons for
me not to develop an exclusive typeface for a specific
client is that I probably wouldn't be able to modify it to
my own content.

아리따 돋움은 곧은 기역(ㄱ), 줄기의 휨, 마지널존^{marginal zone}, 쌍닿자 이음의 형태 등이 특징이다. 글꼴 형태를 그릴 때 가장 중점을 두었던 점은 무엇인가?
가장 중점을 두었던 점은 고르고 가지런하게 보이도록 하는 것이다. 지금은 다르게 생각하는 부분도 많지만, 당시에는 시각적 균질함보다 물질적 균질함에 더 초점을 맞추었던 것 같다. 그래서 비례너비, 탈네모꼴, 잉크 트랩을 시도했고 공간 배분을 고르게 해야겠다는 생각이 강했다. 실제로 아리따 돋움으로 판짜기를 하면 농도가 굉장히 고르다. 개인적으로는 곧은 기역(ㄱ)을 반대했다. 필법에 맞지 않고 공간 배분이 어렵다는 이유였고 오랜 시간 논쟁했다. 결국 안상수 선생님의 결정에 따라 곧은 기역(ㄱ)으로 진행되었고, 그것으로 생기는 문제를 줄이는 것에 중점을 두었다. 실제로 기역(ㄱ) 닿자 때문에 굉장히 고생했다. '가' '각'의 너비와 글자 면적을 비교해보면 일반적으로 그리는 방식과는 다르게 그려져 있다. 일반적인 방식으로 그리면 글자가 매우 작아졌다. 그래서 첫 닿자를 앞으로 빼고 글자여백을 좁게 하는 등 여러 수단과 방법을 동원해 그렸다. 좋은 활자는 어떠해야 한다는 것에 대한 내 생각과 선생님들이 바라보는 관점이 같았기 때문에 어려움과 낯섦은 있었지만 충분히 수용해서 그릴 수 있었다. 그런데 지금은 생각이 많이 변해 또 다르다.

미디엄^{medium}과 세미볼드 두 종으로 시작해 라이트, 볼드를 개발하고 마지막에 씬까지, 총 다섯 종의 굵기로 개발했다. 어떠한 관점에서 굵기를 정하고 어떠한 순서로 진행했는가?
가장 중점을 둔 점은 용도이다. 열 개 이상으로 확장할 수 있는 프로젝트는 아니었기 때문에 어디에 쓸 것인지 논의하고 적합한 굵기를 찾았다. 보통 물리적인 굵기 기준을 세우면 글꼴가족을 겹쳤을 때 계조가 자연스럽게 나온다. 그런데 아리따 돋움을 비교해보면 차이가 있다. 겹쳤을 때 예쁜 것보다 어디에 쓸 것인지가 더 중요했다.

글꼴가족 가운데 특별하게 공을 들인 글꼴이 있는가?
'미디엄'이다. 많이 다듬었기 때문이다.

The main features of Arita Dotum are the straight *giyeok* (ㄱ), the bending of stems, the marginal zone, and the form of joint double consonants. What was the most crucial aspect in drawing these character shapes?
What we focused on most was to make them look even and clean-cut. Even today, I have many different ideas about how it should have been done, but at the time I focused more on physical homogeneity than on visual homogeneity. For that reason, I tried proportional space, a non-square frame font, and ink traps. I strongly believed in even space distribution. Actually, typesetting with Arita Dotum makes the concentration of the text very even. Personally, I opposed the introduction of the "straight *giyeok* (ㄱ)." We debated this for a long time because the straight *giyeok* did not fit the style of the font's strokes and made it difficult to allocate space in typesetting. However, we proceeded with the straight *giyeok* in the end, as Ahn Sangsoo had made a final decision on the subject. We then focused on reducing resulting problems. In fact, it was arduous to deal with the consonant "*giyeok* (ㄱ)." When you compare the width and space for "가" and "각," you'll find the letters are designed differently than usual. When you draw them in the usual way, the letters become very small. That's why I adopted various means and methods to address this, such as moving the first consonant forward and narrowing the margin of the letters. Although it was difficult and unfamiliar to design the new typeface, it turned out well because my thoughts about what a good typeface should be and the two directors' point of view were the same. That being said, my opinions have changed so much since then.

You have developed a total of five types of weight systems, including Medium and Semibold, followed by Light and Bold, and finally Thin. From what point of view did you set the weights and in what order did you proceed with them?
At the time, the main focus was the usage. Since it was impossible to extend them into more than 10 types, we discussed where to use the fonts and found the appropriate weights. In general, setting physical standards naturally creates gradation when superimposing font families. However, it's different with Arita Dotum. The usages of fonts were more important than making them look pretty when superimposed.

Is there a font from the font family you paid particular attention to?
It's Medium, and that's because I spent a lot of time and effort on its refinement.

가장 애착이 가거나 어려웠던 낱글자는 무엇인가?

기역(ㄱ)이다. 애착보다는 애증에 가깝다. 이 형태를 어떻게
해야 쓰기 좋을까 많이 고민했다. 아리따 돋움을 그릴 때 의도와
뜻은 다 이해되었지만, 형태에 동의하지 못했다. 공간이 맞지
않아 생기는 문제가 많았는데 방향이 정해져 있었기 때문에
고생을 많이 했다. 말 그대로 애증이다. 힘들었지만 개인적으로
고민할 수 있는 지점이 생겼다.

**아리따 돋움은 조화로운 판짜기를 위한 비례너비 글꼴이다.
아리따 부리 또한 비례너비의 원칙에 따라 개발되었다.
비례너비 글꼴을 만들게 된 이유는 무엇인가?**

고르게 보이는 것이 좋은 활자의 기준인 시기였다. 그것이
디자인적으로 자연스럽게 드러난 모습이 비례너비이다. 특별한
의도가 있었던 것은 아니었다. 두 선생님에게 배우고 그동안
이야기를 나누어왔기 때문에 나에게는 당연한 방향이었다.

글꼴 디자인은 아날로그와 디지털 방식이 함께 진행되었는가?

스케치는 하지 않았다. 손으로 그린 기억은 없고 바로
디지털로 작업했다.

**아리따 돋움은 4.0까지 업그레이드 과정을 거쳤다.
글꼴 디자인에서 업그레이드는 어떠한 의미가 있는가?
과정상의 어려움은 없었는가?**

업그레이드 과정은 어렵지 않았고 계속 발전시키는 것이
좋았다. 당시에는 그런 문화가 없었다. 더 낫게 다듬고 매만지는
과정이었기 때문에 힘들지 않았다. 다행이었고 참 좋았다.

What was the most preferred or challenging character?
It was *giyeok* (ㄱ). I had a love/hate relationship with it.
I was concerned about how to make this shape useful for
a long time. When designing Arita Dotum, both intention
and meaning were understandable, but I didn't agree
on its shape. There were a lot of problems caused by the
mismatch of space. It was very challenging because the
direction of the project was decided upon before I started
work on it. Literally, it left me with love and hatred. It was
hard, but I came about a topic to think about seriously
from a personal point of view.

**Arita Dotum is a proportional typeface for
harmonious typesetting. Arita Buri was also developed
following the principle of proportional space.
Tell us about why you created the proportional typeface.**
Back then, it was essential that good typefaces appear
evenly. The natural expression of it in design is
proportional space. There was no special intention about
adopting proportional space, but it was an easy direction
for me to follow while talking with and learning from the
two directors.

**Did the typeface design combine analogue and
digital methods?**
I didn't make sketches. I moved straight to digital work.

**Arita Dotum has been upgraded to 4.0. What does an
upgrade mean in typeface design, and what difficulties
did you face during the upgrading process?**
The upgrading process was not complicated, and
I enjoyed upgrading it on a continuous basis. At the time,
nobody was designing a typeface like this. Yet it wasn't
hard because it's just a process of refining and making
touch-ups to make it better. I enjoyed the entire process.

아리따 돋움을 디자인하면서 실험적이거나
도전적인 면이 있었는가?

아리따 돋움 프로젝트는 글꼴에 기업의 정체성을 반영하는 것을
고민해본 첫 번째 프로젝트였다. 성공인지 실패인지는 시간이
지나면 다시 평가받겠지만, 개인적으로는 좋은 점과 아쉬운 점이
모두 있다. 건강한 여성미를 어떻게 글자체에 표현하면 좋을지
많이 고민한 것은 좋은 경험이었다. 2018년『글짜씨 16: 타입
디자인』에「한글 글자체의 인상」이라는 글을 쓴 것도 아리따
돋움 작업의 영향이었던 것 같다. 아리따 돋움 프로젝트를
진행하면서 '아모레퍼시픽'을 생각했을 때 떠오르는 인상이
무엇인지 계속 고민했다. 이러한 과정은 흔치 않다. 지금도 한 달
내외로 글꼴을 기획해달라는 요청을 받는다. 아리따는 그렇지
않은 좋은 사례였다.

아리따 글꼴은 누구에게나 무료로 배포하고 사용하는
나눔 글꼴이다. 아리따 돋움이 기업용 글꼴 생태계에서
어떤 역할을 하기 바라는가?

기업용 글꼴 제작의 좋은 사례로 남기를 바랐고 그렇게 남았다.
바람을 더한다면, '이런 좋은 사례가 있었다.'가 아니라 '여전히
좋은 사례이다.'였으면 좋겠다. 2020년에도 '요즘 이런 사례가
없다.'라고 말할 수 있으면 좋겠다. 또 글꼴 디자인 활동에 좋은
영향을 주길 바란다. 누군가 좋은 작업을 보여줘야 따라오는
사람들이 생긴다.

마지막으로 아리따 돋움 프로젝트를 한마디로 표현한다면?

새로운 도전.

What was the experimental and challenging part of the
Arita Dotum project as a type designer?

The Arita Dotum project was the first of its kind to
consider reflecting corporate identity on a typeface.
Success and failure will be assessed over time, but from
my own point of view, there were both good and bad
aspects. I thought a lot about how to express healthy
feminine beauty in the typeface, and it was a good
experience for me. In 2018, I wrote an essay titled "The
Impression of Hangeul Typefaces" to *LetterSeed 16:
Type Design*, which, I feel, was influenced by the Arita
Dotum project. While conducting the project, I kept
thinking about what impressions were coming to mind
when people think about Amorepacific. Scrutinizing
a process like this is rare. Even these days, some clients
ask me to complete a typeface design project within
a month or so. Arita was a perfect example where we had
a reasonable timeframe to complete the project.

Arita typefaces are distributed free of charge so that they
can be used by anyone. What role do you expect Arita
Dotum to play in the field of corporate typefaces?

Obviously I hoped it would become something to aspire
to, and it has already become a beacon of light for the
type design community. What I want more is that Arita
Dotum will not simply be remembered as an excellent
example of the past, but continue to be a leading typeface
for future designers. I also wish people would call it "an
extraordinary example" in 2020. Hopefully, it will have
a positive impact on overall typeface design activities.
When someone shows top activities and results, others
will follow.

Lastly, describe Arita Dotum in one phrase.

A new challenge.

차별화 요소 및 변화 체계 검토, 2005. 7. 1
Reviewing differentiation factors and the framework for change, Jul. 1, 2005

촛물이 피부를 부드럽

편안하게 가꿔 줍니다

글자 실험 및 시안 검토, 2005. 7. 1
Character experiments and draft reviews, Jul. 1, 2005

세세세세
지생워터

미셸 드 보어 【아리따 산스】

그래픽 디자이너. 네덜란드 로테르담에서
하이테크놀러지 higher technologies 와 순수 예술을 공부했다.
스튜디오둠바 Studio Dumbar 에서 크리에이티브 디렉터를
역임하고 2014년 데타오그룹 DeTao Group 의 자회사인
드보어앤드왕스튜디오 De Boer & Wang Studio 를 설립했다.
네덜란드 경찰청의 비주얼 아이덴티티, 덴마크 우정국의
타이포그래픽 아이덴티티를 디자인했다. 아리따 산스의
총괄 디렉터로 참여했다.

Michel de Boer 【Arita Sans】

Graphic Designer. Michel de Boer studied at the
Academy of Fine Arts and Higher Technologies
in Rotterdam. After assuming the role of creative
director at Studio Dumbar, he founded De Boer &
Wang Studio, a subsidiary of the DeTao Group. He
designed the visual identity of the Dutch National
Police, as well as the typographic identity of the
Denmark Post Office, and participated in the Arita
Sans project as executive director.

아리따 산스는 어떤 프로젝트였는가?
프로젝트에서 맡은 역할은 무엇이었는가?

아리따 산스는 여러 면에서 어려운 프로젝트였다. 첫째로
아모레퍼시픽은 글꼴을 만들어 일반에 배포하면서 자신들의
이미지를 사회에 표현하고자 했다. 둘째로 기존의 아리따
돋움과 조화를 이루면서 독특한 글꼴을 만들어야 했다.
이 프로젝트에서 안그라픽스 그리고 나의 좋은 친구 안상수와
밀접하게 협업할 수 있어 대단히 기뻤다. 크리에이티브
디렉터로서 나의 역할은 뛰어난 전문성을 지닌 팀을 꾸리는
것이었다. 사전 조사와 이전 경험에 비추어 봤을 때, 피터
베르휠Peter Verheul이 가장 적합한 디자이너였다. 피터는 훌륭한
글꼴 디자이너이자 이 프로젝트에 맞는 성격을 지니고 있었다.
먼저 믿을만했고 뛰어난 적응력으로 융통성 있게 프로젝트를
발전시킬 수 있는 사람이었다. 프로젝트 마지막에는 네덜란드
출신의 디자이너, 유스트 반 로섬Just van Rossum이 참여해 기술적인
측면을 세밀하게 조정하는 작업을 도왔다.

아리따 산스 작업에서는 어떤 점을 중심으로 디렉팅했는가?
2011년 1월 25일에 보낸 메일에서 작업을 시작하기 전
몇 가지 점을 짚었다고 했는데 무엇이었는가?

뛰어난 디자인은 뛰어난 리서치에서 시작한다. 리서치 자료를
분석해 좋은 전략을 세우려고 했다. 이러한 과정에서 '어떻게'가
아니라 '왜'라는 질문에 답할 수 있었다. 2011년 1월 25일에
이 '왜'와 관련된 중요한 질문들을 메일로 보냈다. 상황을
이해하고 비판적인 자세를 갖는 것이 가장 중요하다. 만약
우리가 미리 이 질문의 답을 찾지 않았다면 추측할 수밖에
없었을 것이다. 디자인 과정에서 가정과 추측에 의존하는 것은
매우 위험하다.

The Arita Sans project was challenging in several aspects.
Firstly, Amorepacific shows its social character by funding
this project, which enabled us to design a particular
typeface and to present this font to society. Secondly, the
challenge for our team was to create a unique font, which
is in balance with the existing Korean (Dotum) typeface.
It was a great pleasure to work on this project in close
collaboration with the Ahn Graphics team and my good
friend Ahn Sangsoo. In my role as Creative Director,
I established a team with specific expertise. After some
research, I found type designer Peter Verheul the right
person for me due to my earlier experience with him.
Besides being a good type designer, I find him also fit for
this specific project, having the right mental character,
being a reliable person and last but not least being
flexible and adaptable to elevate the project. Just van
Rossum assisted us at the end of the project doing a more
technical finetuning job.

In the process of designing Arita Sans, what did you
focus on to direct the project? In an email written on
January 25, 2011, you pointed out a few significant
points before starting work.
That's right. Good design starts by default with
good research. We analysed the material from our
research which enabled us to define a good strategy.
In this way we were able to answer the important
question "why we do something" more than only
what and how we do it. My email on January 25, 2011
addresses those important questions being relevant
before we started. Understanding the situation and being
critical is most important. If we don't find those answers
in advance, then we need to guess. Needless to say,
relying on assumptions and guessing is very risky in the
design process.

아리따 산스의 자문과 디렉팅 과정은 어떠했는가?
다른 로마자 제작 방식과 다른 점이 있었다면 무엇이었는가?
아리따 산스의 제작 과정은 치열했다. 아모레퍼시픽 브랜드의
핵심 가치를 담고 아리따 돋움과 조화시키기 위해 안그라픽스와
긴밀하게 소통했다. 피터와 나는 앞서 말한 가치를 구현하고
글꼴의 품질을 높이기 위해 자주 만났다. 수많은 자문을 거치고
이후 확장하게 될 로마자 이탤릭Italic과 세리프 글꼴을 위해
몇 가지 초기 실험을 진행하며 프로젝트를 확장했다. 당시의
결정이 결과에 어떤 영향을 줄지 알 수 없어 예기치 못한 문제를
피하기 위해 안전하게 몇 가지 테스트를 진행하고 작업했다.

아모레퍼시픽이라는 브랜드와 글꼴을 어떻게 연결 지을지
질문과 답변을 주고받은 것이 인상적이었다. 아리따 글꼴이
다른 기업 전용 글꼴과 다른 점은 무엇인가?
나는 아리따 산스 글꼴이 아모레퍼시픽의 정신을 반영해야
한다고 했다. 그렇게 해야 글꼴이 독특하면서 브랜드와
완벽하게 맞아떨어진다. 그러면 그 글꼴은 기존의 글꼴과
차별성이 생긴다. 확장된 글꼴을 만들 때도 마찬가지였다.

아리따 프로젝트의 '건강한 아름다움' '현대 여성'과 같은
주제어를 어떻게 반영했는가?
그에 대한 대답은 아리따 산스 글꼴에 있다. 아리따 산스를
자세히 보면 우아한 선과 둥근 형태가 여성의 품위뿐 아니라
강인함과 자신감 있는 느낌을 준다. 아리따 산스는 현대적
글꼴로서 유행을 타지 않는 자연스러운 아름다움으로 오래도록
남을 것이라고 확신한다.

'아리따운 여성'이라는 주제어가 디자인 수정 과정에서 단서가
될 것이라고 했다. 이 주제어가 글꼴에 어떻게 구현되었는가?
'아리따운 여성'은 안그라픽스에서 제시한 주제어였다.
'아리따움'은 아모레퍼시픽이 제품과 서비스를 통해
제안하고자 하는 아름다움이다. 그래서 이 주제어는 글꼴의
특징을 표현하는 데 중요했다. 그 방향에 맞게 아리따 산스를
디자인했다. 한글 글꼴인 아리따 돋움과도 조화롭다.

How was the process of consultation and direction?
Did you make it in a way similar to other Latin typefaces?
If it was different, what made it different?
It was an intense process. Both by addressing the key
values of the Amorepacific brand, the match with the
existing Arita Dotum typeface and the frequent (but
important) communications with your team. Both Peter
and I visited each other frequently to address those
values, which enabled us to elevate the quality of the
Sans. After numerous consults, we extended the project
by doing some initial exercises for a future extension of
the typeface: the Latin Italics and a Serif version.
The decisions we made at that particular stage might
affect the (unknown) outcomes of the future. In other
words, it was better to play safe, by doing some
preliminary extension tests, to avoid forthcoming
surprises with future type additions.

It was impressive that you exchanged questions
and answers with us in terms of the connectivity of
Amorepacific brands and typefaces. What is the
difference between Arita created with brand-integrated
fonts, rather than specific brands, with traditional
enterprise typefaces?
Yes, I've told your team that the quality of the Arita Sans
font should mirror the soul of the Amorepacific brands.
Reflecting those qualities makes it a perfect FIT, seamless
to the brand values and in a unique manner. This is very
different than "ready-made fonts" on the shelf. Not only
by the Latin typeface, but also in a larger extend towards
the whole family.

How did you define the keywords "healthy beauty,"
"femininity," and "modernity" of the Arita project and
reflect them in the typeface?
All those values and more are answered and translated by
the typeface design outcome. If you look closely at Arita
Sans, you will find elegant lines and rounded shapes.
It gives a feeling of feminine dignity but stands strong
and proud as a contrast at the same time. In the end,
it is a contemporary typeface, meaningful with natural
long-lasting beauty, not trendy as we are sure it will stand
the test of time.

You mentioned that Arita's proposed keyword "elegant
lady" would be a good clue to the design modification
process. How was this keyword realized in the typeface?
The elegant lady was brought up by your team after
several email exchanges. The answer is already partly
given in the above question. In short: elegance is part of
the beauty Amorepacific would like to address in their
products and services. So, it was key for us to express
these characteristics in the typeface. Our outcome
matches all these values, and always in shared harmony
with the Korean Dotum.

2011년 7월 28일에 공유된 세 점의 스케치 중에서 A안을 선택한 이유는 무엇인가?

A안은 명확하게 우리가 선호하는 방향이었다. A안은 우리가 생각한 타이포그래픽 아이덴티티의 정의와 거의 완벽하게 맞아떨어졌다. 브랜드의 차별성을 통해 독창적인 전용 글꼴을 만들 수 있다. A안의 세부에서 이러한 면이 가장 잘 드러났다.

아리따 산스 프로젝트의 디렉터로서 실험적이거나 도전이었던 점이 있는가?

첫 번째는 서구의 글꼴 체계와는 다른 한글 체계인 아리따 돋움을 시작점으로 안그라픽스와 밀접하게 작업한 일이었고 두 번째는 로마자 글꼴의 장점을 모아 균형을 찾는 것이었다.

아리따 글꼴은 누구나 사용할 수 있는 나눔 글꼴이다. 기업 글꼴 생태계에서 아리따 산스가 했으면 하는 역할이 있는가?

디자이너로서 다른 사람들이 작업을 인정해주는 것은 언제나 기분 좋은 일이다. 그러나 아리따 산스는 이제 독립된 존재로 글꼴가족의 사용 방법에 맞게 멋진 타이포그래피 이미지를 만드는 것은 다른 사람의 몫이다. 비록 '아리따 산스만'을 사용하기는 어렵겠지만 많은 사람이 아리따를 사용한다는 소식을 들으니 기쁘다. 사용에 제약이 있음에도 널리 퍼진다는 것은 중요한 사실이다. 이는 정말 대단하고 어려운 일이다.

마지막으로 아리따 산스 프로젝트를 정의한다면?

훌륭한 사회적 성격을 지닌 놀랍고 독창적인 글꼴. 디자인 품질을 위해 정성을 다한 사람들이 만든 글꼴.

There were three sketches shared on July 28, 2011. You gave the opinion that your team preferred sketch A. What was the reason?

Version A was for us clearly the preferred route. Most of all because it was the best outspoken one, besides matching the brief perfectly in regards of defining a Typographic Identity. The branding and related differentiation were clear reasons to create a typeface with a strong exclusive and individualistic character. With the particular detailing in version A, this came out best. In my email reply, I wrote about this vivid approach.

What was the most experimental/challenging part as a director of the Arita project?

Let me explain this on behalf of our team. The challenging aspect was twofold. One; to work closely with your team whereby we had a starting point (the Korean Dotum), which stands far away from our Western typeface/font knowledge and two; to find the balance and to make the best shared Latin typeface we ever did.

Arita is an open-license typeface, and many people are using it. What kind of role do you want Arita Sans to play in the corporate typeface ecosystem?

Being a designer and being admired by others in what you do is always a nice thing. However, the Arita typefaces stand on their own, and we cannot control the usage as it is up to others to embrace and to adapt the font family in such a way to remain a relationship with it by creating a nice typography image. It is good to hear from you that many people are using it, even though a Latin "Sans only" typeface makes it a bit limited in use. But even with this limitation it proves that people like it, next to the important fact that it is spread over the world in a free manner. This is a great and challenging thing.

Finally, please tell us about the Arita Sans project with some keywords.

One of the most remarkable initiatives in type design with a highly admirable social character. Founded by people with a great heart for design quality!

MADE IN KOREA

130 ml

ACIFIC

fic

am

Goudy Sans

a

a

a

n

m

n

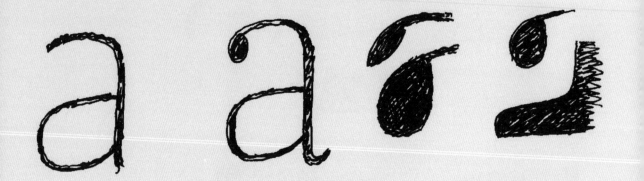

13 februari 2011

an amerbb
boatuda

Serif Anitta

Concept wordt bepaald door
sans (aanvankelijk) maar zal
zich er duidelijk van moeten
onderscheiden.

Verwantschap in:
- gewicht - breedteverhouding
- vorm eigenschappen
complementair
· wat houdt dat in dit geval in?

a

"From sans' to serif"
(Normaly it's from serif to sans)

A B

A is not meant to
be called sans
B is not meant to
be called serif

cursive elements marking feminine
character and creates a bigger contrast
next to Hangul.

□ 目 □ 目 hoekige
binnenvormen
masculine

e e

convention cursive approach, much more feminine

Expansie serif met veel vorm-
definitie.

Zowel sans als serif als headline
te gebruiken.

Op (kleine) tekstniveau moeten
de teksten evenwichtig ogen
met een lichte 'swing'.

? Kunnen de stokken in een
lichte hoek staan en toch
stabiliteit bewerkstelligen?

! vrouwelijk maar niet verwijfd!

modern:
Archer

Glyph Inseentions.

clean strokes / shapes
round, with tension.
- not sharp ⟋ pointed.
- friendly ⁻ ' modern ⁻
- not clumsy
— not mechanic
Display & Text features

g v e k

v

g e E

mixing genes'

a E

a S av

* finding the perfect
balance between non
✳ static beautiful (female)
feminin ingredients.

· soft, round
· elevating &
· modern

BUT: · variety of stroke ends
All in harmony · serifs
· basic shapes

피터 베르휠【아리따 산스】

글꼴 디자이너. 네덜란드 헤이그왕립예술학교Royal Academy of art
the Hague에서 그래픽과 인쇄 디자인을 공부했다. 1991년부터
헤이그왕립예술학교에서 글꼴 디자인을 가르쳤으며
'FF Sheriff' 'FF Berlin' 'OT Versa' 등 다양한 글꼴을
발표했다. 아리따 산스의 수석 디자이너로 참여했다.

Peter Verheul【Arita Sans】

Type designer. Peter Verheul studied graphic
and typographic design at the Royal Academy
of Art (KABK) in The Hague. He started teaching
type design at KABK in 1991, and released
various typefaces such as FF Sheriff, FF Berlin,
and OT Versa. He also participated in the Arita
Sans project as senior designer.

아리따 산스는 어떤 프로젝트였는가?
프로젝트에서 맡은 역할은 무엇이었는가?

나는 타이포그래픽 아이덴티티 작업의 책임자인 미셸 드 보어와
협업해 아리따 산스 글꼴을 디자인하는 역할을 맡았다.
프로젝트 시작 단계부터 작업을 심도 있게 분석했다. 수많은
회의를 통해 아리따 산스가 나가야 할 방향에 대해 의견을
나누었다. 디자인이 올바른 방향으로 나아가는 데 안그라픽스의
의견이 도움이 되었다.

아리따 산스의 디자인 과정이 궁금하다.
다른 로마자 글꼴과 비슷한 방식으로 제작되었는가?
다른 점이 있다면 어떤 것이었는가?

정기적으로 발표하면서 작업을 논의했다. 몇 년 전에 네덜란드
공기업의 글꼴가족을 미셸의 스튜디오와 개발하면서 아리따
산스와 비슷한 규모의 글꼴 설계에 필요한 경험을
꽤 많이 쌓았다. 아리따 산스 프로젝트는 글꼴 디자인뿐 아니라
굵기를 확장하는 방향도 제시해야 했다. 로만 산스roman sans,
세리프 글꼴가족과 대응하는 이탤릭 글꼴 디자인을 위한
초기 작업도 진행했다. 아리따 산스의 스타일에는 이 연구
결과가 완전하게 반영되었다. 이후에 훌륭한 동료 유스트
반 로섬이 글꼴 엔지니어로 합류해 꼼꼼하게 검토해주었다.
마스터링mastering은 외부 업체에서 했다.

글꼴 디자이너마다 글자를 그리는 방식이 다르다.
아리따 산스는 아날로그와 디지털 방식, 어떤 것으로
디자인되었는가?

초반에는 스타일을 탐구하기 위해 아날로그 스케치를
많이 한다. 나는 잉크와 종이를 쓴다. 다음 단계에서 대안과
함께 다른 선택지를 제안할 때 디지털로 깨끗하게 작업한다.
이를 통해 다양한 디자인을 글꼴에 적용하고 서로 다른
글자크기를 비교할 수 있다.

What kind of project was Arita Sans?
What was your role in it?

My role in this project was to design the typeface
Arita Sans in collaboration with Michel de Boer, who
was also responsible for the work on the corporate
Typographic Identity. From the start of the project, we
analysed the brief of Arita Sans deeply. During the design
process of Arita Sans there were many meetings and
communications between us in regards of the direction
in which the design of the typeface went. Also, the
comments of Ahn Graphics team helped us to steer the
design in the right direction.

How was the Arita Sans font making process?
Did you make it in a way similar to other Latin typefaces?
If it was different, what made it different?

We had regular meetings and briefings. Points of action
were discussed and decided. A few years before I finished
a corporate type family for the Dutch Government in
collaboration with Michel's studio. This project gave me
quite some experience in different aspects necessary to
design a typeface to be functional in such a scale as Arita
Sans for Amorepacific. The brief was to design the Sans
but also present other directions of an expanding set of
supporting weights. Initial drafts for a corresponding
Italic to the Roman Sans and a Serif family, in different
weights, were created as well. The results in that
extended research definitely reflected on the style and
qualities of the Sans. Later on, a good colleague of us,
Just van Rossum, joined the project as font engineer with
a critical mind and eye. The fonts were mastered at an
external company.

Every single type designer has different way to draw
letters. Did you design Arita Sans with an analogue
method or digital method?

At the start, many different analogue sketches were made
to explore the style. I used ink on paper. In a later stage,
when proposing different options, clean digital versions
with alternate solutions were created. So we were able to
apply the typeface in various designs and to judge them
in different text sizes.

곡선과 둥근 모서리, 좁은 너비는 아리따 산스의 특징이다.
디자이너로서 형태를 만들 때 어디에 중점을 두었는가?
프로젝트 주제어인 '건강한 아름다움, 여성성, 현대성'을
강화하는 것이었다.

'건강한 아름다움, 여성성, 현대성'을 어떻게 정의하고
글꼴에 반영했는가?
주제어는 글꼴 스타일을 특정하고 인상에 관해 소통하는 데
도움이 된다. 하지만 주제어와 글꼴 형태는 사람에 따라 다르게
해석된다. '건강한 아름다움'은 과도하게 꾸미고 드러내지 않는
개인의 순수함, 정확함, 자부심으로 정의할 수 있다. '여성성'은
무례하거나 약하거나 수동적이지 않은 요조숙녀, 자신감,
섬세함, 자부심, 활발함을 가리킨다. '현대성'은 장식이 없는,
과거에서 빌려오지 않은 동시대성을 의미한다.

2011년 7월 28일에 공유된 세 개의 스케치 가운데 A안을
선택한 이유가 무엇인가?
세 가지 스케치는 구조와 만듦새가 달랐지만, 굵기와 비례너비는
같았다. C안은 전형적인 산세리프 글꼴처럼 상대적으로
더 대칭적이고 덜 또렷하고 구조적이다. 이 안은 프로젝트의
'여성성'을 충분히 보여주지 못한 것 같았다. B안은 글꼴의
세부 형태가 C안보다 역동적이었다. A안은 B안을 기초로 필획의
머리와 모서리를 반쯤 둥글린 형태였다.

The great features of Arita Sans include curves,
half rounded edges, and narrow widths.
What features did you focus on from the designer's
point of view while creating forms?
Actually, these features strengthen the aspects of the
required style, which are "healthy beauty, femininity,
and modernity."

How did you define the keywords "healthy beauty,"
"femininity," and "modernity" and reflect them in
the typeface?
Using keywords to characterize the specific requested
style can help to communicate the expected impression
of a typeface. However, it still depends on how keywords
and shapes are interpreted by different people. Healthy
beauty will be defined as: Individual purity, accurate,
proud; without an overly exposed perfumed general
character. Femininity as a keyword stands for: elegant
lady, self-confidence, delicate, proud, active; without
being rude, weak or passive. Modernity stand for:
contemporary, of today; without frills, not restricted by
borrowing features from the past.

There were three sketches shared on July 28, 2011.
You gave the opinion that your team preferred sketch A.
What was the reason?
These examples show different aspects in both
construction and refinement. All three share the
same weight and width proportions. C shows a more
conventional construction like many Sans Serif typefaces,
which expresses a more symmetrical, less vibrant
construction. In our opinion, this does not express the
required level of femininity. B shows more dynamic
character than C within their specific individual letter
shapes. More based on a cursive construction wherein
the counters are asymmetric. A is based on B with
additional half rounded corners as refinements at stem
endings and terminals.

가장 애착이 가거나 작업이 어려웠던 글자가 있는가?
하나만 꼽기 어렵다. 결국 모든 글리프는 타이포그래피적으로
서로를 보완해야 한다. 글자끼리 서로 어울리면서도 독립적으로
만드는 것이 난관이자 도전이었다.

한글 글꼴인 아리따 돋움과의 조화를 어떻게 고려했는가?
그때까지 아시아 글꼴을 작업해본 적이 없었다. 반면에
다양한 스타일과 기능의 글꼴을 디자인해본 경험은 많았다.
아리따 산스 작업에 있어 중요하게 생각한 요소는 아리따
돋움과 아리따 산스 사이에서 회색도를 맞춰나가는 것이었다.

마지막으로 아리따 산스 작업에 대해 표현한다면?
아리따 산스 작업은 엄청난 도전이자 모험이고 기회였다.
산세리프에 대한 인상을 유지하면서 아모레퍼시픽 브랜드의
다양한 면을 구현하는 작업이었다.

What was the most preferred or challenging character?
This is very hard to say. In the end, all glyphs have the
duty to support each other within the typographical use.
To make them fit to each other and at the same time
being strongly independent is a difficulty and a challenge
on its own.

How did you consider the harmony between Arita Sans
and the Hangeul typeface Arita Dotum?
Personally, I never dealt with an Asian typeface before.
On the other hand, I have been designing quite a variety
of typefaces within different specifications for styles and
functions. An important and directive element is that the
different weight values, in both scripts (Dotum and Sans),
share a similar grayscale in their respective text sizes.

Finally, please tell us about the Arita Sans project
with some keywords.
Working on Arita Sans was a great challenge,
adventure and opportunity. To be able to maintain
the first impression of a sans serif typeface and
secondly implementing the different aspects of the
Amorepacific brand.

K k k a a g̃ g y ẉy v u w w

* Anita Hangul medium 25 03 2011
kleur met Anita Latin Serif Light

27 03 11

n ?

ε B D k k

serif

doorvoeren. →

semi-script

nn

Cutting corners
to get to a solution

Anta v.s. normaal

▷ Cuddly feeling
at the same time not childlike/ish in
its character.

▷ Creating features to identify
this sans serif and diverse it
from existing designs.

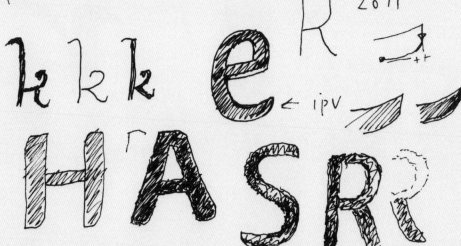

Latin serif:
Not Sans + serif
Example: n

E variation E G → G

Q a a ʔ

T l — toopassingtu.

AMORE PACIFIC

AMORE..

— Treatment
Cleansing
Foam

AMORE PACIFIC

CAPS
↓
— MOISTURE BOUND
Vitalizing
Creme

Amore Pacific

MOISTURE BOUND
Intensive
Vitalizing Eye
Complex

No small Caps?

a n schnne vormen

Presentatie:

ritme binnen/buiten vormen

vrouwelijke karakter in smalle
schreefloze. En tegelijk:
stabiel typografisch beeld in kleine
corpsen ▷ Laagte van contrast
Legibility (overzicht)
 mogelijk
Myriad zal/referentie zijn van klant.

mannelijke
schreeflozen

Baskerville.

Totale laagcontrast van de
20 februari 2011

Organic

a a

Hoekig karakter ∟

a ← Hangul concept contrast
in latin

Hamb
es

라이트와 볼드를 비교하며 그린 스케치, 2011. 10. 14
A sketch drawn while comparing Light and Bold, Oct. 14, 2011

denad

a

a
denad

met klokken maar rond en vloeiend

givor

A

givo

류양희【아리따 부리】

글꼴 디자이너. 홍익대학교 시각 디자인과를 졸업했다.
'고운한글바탕' '고운한글돋움' '동글한글'을 디자인했다.
2017년 영국 레딩대학교^{University of Reading}에서 타입 디자인
석사 과정을 마치고 현재 다국어 글꼴가족 '윌로우^{Willow}'를
그리고 있다. 아리따 부리의 책임 디자이너로 참여했다.

Ryu Yanghee【Arita Buri】

Type Designer. Ryu Yanghee graduated from
Hongik University, where she majored in Visual
Design. She designed Gowun Hangeul Batang,
Gowun Hangeul Dotum and Dongle Hangeul
typefaces. Ryu completed her master's program
at Reading University, UK, and is currently
developing a multilingual type family called
Willow. She participated in the Arita Buri project
as the senior designer.

아리따 부리 프로젝트에 어떠한 계기로 참여했는가?

2011년 초에 기획 담당자를 만났고, 1년 후에 본격적으로 프로젝트를 시작했다. 2010년에 개인적으로 발표한 '고운한글' 글꼴을 보고 연락을 준 것으로 안다. 전해 듣기로는 고운한글을 보고 안그라픽스 내부의 어떤 분이 안상수 선생님께 나를 추천했다고 들었다. 아리따 돋움과 아리따 산스에 각각 다른 디자이너가 참여했듯이, 개발할 글자의 스타일에 따라 적절한 디자이너를 찾았던 것 같다.

아리따 부리에 대해 소개한다면?

아리따 부리는 2004년 시작된 아리따 글꼴 개발의 3차 프로젝트로, 이미 개발된 돋움체와 함께할 바탕체 계열의 본문용 글꼴로 기획되었다. 아리따 부리는 형태는 물론 글자를 만드는 과정에 대한 이야기가 중요한 글꼴이다. 돋움과 바탕의 관계 설정에서 글꼴 이름, 글꼴가족의 구성, 문장부호까지 글꼴 디자인의 근본적인 부분을 논의하고 짚어나갔다. 또한 본문용 글꼴이자 기업 글꼴로서의 개성과 표정을 담기 위해 애썼다. 글꼴을 만드는 과정이 이전보다 한 단계 더 나아간 프로젝트라고 생각한다.

최초로 글꼴 이름에 '부리'라는 말을 붙였다. 어떤 배경으로 '부리'라는 이름을 사용하게 되었는가?

한글의 본문용 글꼴은 명조체와 고딕체 혹은 바탕체와 돋움체로 대표된다. 이전에 개발된 아리따 돋움의 이름짓기 방법을 따른다면, 당연히 아리따 바탕이라고 해야 한다고 생각할 수도 있었다. 그러나 같은 글자 계열 안에서 다시 세리프와 산세리프로 나뉘는 로마자처럼 형태로 구분하는 이름을 짓고자 했고, 한글 획의 꺾인 부분을 일컫는 '부리'를 생각해냈다. 하지만 부리와 민부리로 나눴을 때, 일반인이 받아들일 수 있을지 의문이 들기도 했다. 또 한 가지 문제는 돋움과의 연결성이다. 이미 발표된 아리따 '돋움'과 아리따 '부리' 이름의 관계를 어떻게 연결할지에 의문이 있었다. 그렇지만 아리따 프로젝트는 장기적으로 글꼴가족을 확장할 계획이었기 때문에 '부리'라고 결정했다. 아모레퍼시픽 또한 새로운 시도를 매우 반겨서 '아리따 부리'로 확정하게 되었다.

What made you take part in the Arita Buri project?
In early 2011, I met with the project planner and started the project in earnest a year later. As far as I know, the team contacted me after seeing the Gowun Hangeul typeface that I personally released in 2010. I heard that someone at Ahn Graphics recommended me to Ahn Sangsoo. Just as different designers participated in Arita Dotum and Arita Sans, they seemed to have found the right designer according to the style of the typeface to develop.

Can you introduce Arita Buri?
Arita Buri is the third project in Arita's typeface development, which started in 2004. It was designed as a body font that shared many characteristics with the Batang font so that they could be used together with the earlier developed Arita Dotum typeface. In the Arita Buri project, stories about the process of creating letters are essential as well as their forms. We discussed the fundamental aspects of typeface design that we then carefully examined, from setting the relationship between Dotum and Batang to the name of the font, the composition of the type family, and punctuation marks. We also sought to capture the personality and look of Arita Buri as a body type and a corporate font. I think this project has evolved the process of creating typefaces one step further than before.

This is the first time for a typeface to be named Buri. Tell us about how you chose this name.
Hangeul body fonts are represented by Myeongjo and Gothic, or Batang and Dotum. If you followed the naming method of the previously developed Arita Dotum, it might have been natural to call it Arita Batang. However, we wanted to name it based on forms, just like typefaces in the Latin alphabet are divided into serif fonts and sans serif fonts in the same font family. That's when we came up with Buri, which directly refers to the serif of the Korean stroke. However, when divided into Buri and the Minburi, I wondered whether the public would see those terms as natural. Another problem was connectivity with Dotum, as there was a question of how to link the relationship between the names of Arita Dotum to Arita Buri. However, we settled on Buri because the Arita project had plans to expand the font family further down the road. In addition, the client, Amorepacific, welcomed our decision, so Arita Buri was finalized as the name.

아리따는 '사랑스럽고 아리따운 여성'이라는 의미를 담고 있다.
이 의미를 어떻게 글꼴에 담았는가?

글꼴의 여성성을 단정하기는 어렵지만, 바탕체 계열의 글꼴인
아리따 부리는 구조 자체에 여성성이 담겨 있다고 생각한다.
돋움보다 작은 속공간, 유연한 획의 움직임, 곡선이 강조된
형태는 돋움에 비해 여성적으로 느껴진다. 초반에는 글꼴에
여성성을 표현하는 것보다는 미래지향적이고 현대적인 모습을
어떻게 표현할지 많이 고민했다. 그때 안상수 선생님이 오드리
헵번의 이미지를 제시했다. 오드리 헵번의 아름다움보다는
그 사람이 가진 강직하고 단정한 모습으로 이해했다. 그 느낌을
글자 형태에 반영하고자 공간과 구조를 시험해보고 조금 더
단단하고 단정한 부리의 모양을 찾으려고 했다.

아리따 돋움과 아리따 부리의 관계를 서로 다르지만 닮은
'남매 글자'로 설정한 이유는 무엇인가?

바탕체와 돋움체는 다른 계열이기 때문에 글꼴이 서로 닮을
필요는 없다. 그렇지만 세리프와 산세리프는 다르다. 그래서
부리와 민부리에 어떤 관계성을 부여해야 할지 고민이
많았다. 많은 분과 함께 논의하고 기본적인 부분부터 하나씩
짚어나갔다. 먼저 돋움과 부리를 같은 직선에 놓았을 때
이것을 글꼴가족으로 볼 수 있을지, 그렇다면 글꼴가족이란
어떠해야 하는지에 대한 이야기가 있었다. 그러던 중 두 가지
개념을 직선이 아닌 원에 놓아보았다. 멀리 떨어져 있는 관계가
아니라 태극의 음양처럼 서로 보완해 공간을 완성한다고
생각했다. 가까이 있으면 인력으로 서로를 보완해줄 것이고
멀리 있으면 공간을 완성해줄 수 있기 때문에 부리의 형태가
'그 무엇으로 되어도 좋겠다.'고 생각했다. 이러한 주제로
논의하다 나온 단어가 '남매'였다. 안상수 선생님은 남매
글자를 언급하며 DNA가 같다고 해서 형태까지 같을 필요는
없다고 했다. 남매라는 단어가 마음속에 들어오면서 돋움과의
관계를 확실하게 정리했고 글자의 형태를 그릴 수 있는
영역이 커졌다. 굵기의 변화 외에도 스타일의 변화, 용도의
변화처럼 글꼴가족의 다양한 확장성을 이야기해볼 수 있었다.
스케치 단계에서 돋움과의 관계 때문에 논의가 길어졌지만,
기본적인 부분부터 하나씩 짚어나갔기 때문에 이 프로젝트가
더 의미 있었다고 생각한다.

Arita refers to a lovely and beautiful woman. How did
you capture the meaning of this in the typeface itself?
It's difficult to define femininity in any typeface.
However, I think Arita Buri, which is similar to the
Batang font, has an inherent femininity in its structure.
The smaller counters, more flexible stroke movements,
and emphasized curved lines make its femininity more
highlighted than Dotum. In the early stage of the project,
I was concerned more about expressing a future-oriented
and modern look rather than expressing femininity in
the typeface. At the time, Ahn suggested we think about
the image of Audrey Hepburn. I understood the image as
an upright and wholesome figure, rather than the beauty
of Audrey Hepburn herself. To reflect the impression in
the form of characters, I carried out tests with the space
and structure, trying to create a somewhat fuller and
more wholesome shape for Buri.

Why was the reason to address this relationship between
Arita Dotum and Arita Buri as "sibling typefaces" that
have different faces but look similar?
Batang and Dotum are in different font families, so
they don't have to resemble each other. However, serifs
and sans serifs are different. That's why I thought a lot
about the relationship between Buri and Minburi.
We had this discussion with many people and examined
the basic aspects one by one. First, when Dotum and
Buri were placed in a straight line, there was an issue
about whether they could be seen as one font family, and
if so, what a font family should be like. Then I put two
concepts in a circle rather than a straight line. I thought
that two fonts are not in a distant relationship, but would
complete the space in a complementary relationship like
the yin and yang of the tai chi pattern. If the two fonts
were close, they would complement each other strongly
with the attraction, and if they were far apart, they could
complete the space, so I thought that the shape of Buri
could be "whatever it would be." The word that came
up during discussions on this topic was "siblings." Ahn
mentioned the word "siblings," and said that their DNA
is the same, but the forms do not have to be the same.
When I started thinking about the word "siblings," I was
able to clarify Buri's relationship with Dotum. That's
when the potential for drawing the letters increased. In
addition to the change in weight, we were able to discuss
the expandability of the font family, such as changes in
style and use. Although we had lengthy discussions due
to this relationship with Dotum during the sketching
stages, I think the project was more meaningful because
we examined the fundamental aspects step by step.

아리따 부리는 곧은 기역(ㄱ), 치읓(ㅊ)과 히읗(ㅎ)의 꼭지,
줄기와 기둥의 형태가 특징이다. 글꼴 디자이너로서 글자를
그릴 때 가장 중요하게 생각한 점은 무엇인가?

곧은 기역(ㄱ)은 아리따 돋움에서 이어받았다. 균형 있게
그리기가 무척 어려웠지만, 아리따 글꼴의 가장 큰 특징이며
아리따 돋움과의 연결성을 가장 확실하게 보여주는 형태이기
때문에 중요하게 생각했다. 글자를 그리며 가장 신경 쓴 부분은
부리의 모양과 크기였다. 부리의 모양은 맺음 모양에 영향을
주고, 부리의 크기는 글자의 가독성과 인상을 결정한다. 붓의
움직임을 상상하면서 다른 획들의 움직임을 함께 정리했다.
개인적으로 세로획의 맺음 부분을 좋아한다. 버선코와 한옥
처마의 곡선은 과한 인상이 없다. 맺음에서 그 인상이 표현된 것
같아 만족스럽다. 내림은 꽃잎의 형태에서 따왔다. 시옷(ㅅ)과
지읒(ㅈ)의 내림은 다른 부리 글자의 맺음과 다르지만, 부리의
인상을 유지하는 데 무리가 없다고 판단했다. 글자 형태를
결정할 때 중요하게 생각한 기준은 '모던함'이었다. 이응(ㅇ)의
경우 꼭지가 없는 이응(ㅇ)이 현대적이라고 생각했다. 기존의
갈래 지읒(ㅈ)은 예스러운 인상을 줄 수 있지만, 아리따 부리는
시옷(ㅅ)의 꽃잎 모양을 적용해 자연스러웠다.

글꼴가족에서 특별하게 공을 들인 부분이 있는가?

아리따 부리 글꼴가족을 만들며 특별하게 공을 들인 글꼴은
미디엄 굵기이다. 중간 굵기를 기준으로 글꼴을 확장했기 때문에
미디엄 디자인에 공을 들였지만 이야깃거리는 헤어라인과
볼드에 더 많다. 결과적으로 아리따 부리가 현대적이라는 인상을
가질 수 있었던 것은 헤어라인 때문이다. 또 하나 중요했던 점은
'글꼴가족 안에서 각 굵기 사이의 관계'이다. 굵기가 서로 다른
글꼴가족의 너비를 다르게 조정해야 하는지 같게 해야 하는지에
대한 논의도 있었다. 또 글꼴가족을 일렬로 배치했을 때
헤어라인의 글자 폭이 가장 좁아야 할 것 같지만, 획이 얇은
헤어라인은 좌우 여백이 라이트보다 약간 여유가 있는 것이
좋아 보였다. 그래서 헤어라인의 너비가 라이트보다 넓어졌는데
이때 안그라픽스 타이포그라피연구소 노은유 연구원이
각 글자에 맞는 공간을 갖는 것이 중요하다고 이야기해주었다.

Arita Buri has characteristic features such as a
straight *giyeok* (ㄱ) and the taps of *chieut* (ㅊ) and
hieut (ㅎ), as well as the shape of stems and pillars.
What was your highest priority while you drew
the characters as a type designer?

The straight *giyeok* (ㄱ) was inherited from Arita Dotum.
It was challenging to draw the letter in a balanced way,
but I thought it was important because the letter was
the most significant feature of the Arita typeface, and the
form of Arita Buri's straight *giyeok* most clearly shows
its connection to Arita Dotum. When I drew the letters,
my biggest concern was the shape and size of the *buri*.
The form of the *buri* affects the shape of the finish, and
its size determines the readability and impression of
each character. I imagined the movement of a brush,
and then arranged the other strokes together. I like
the finish of vertical strokes. The curves found in the
toe of a traditional Korean sock and the eaves of hanok
(traditional Korean homes) are not overly impressive. I'm
satisfied that the impression is expressed in the finish of
the letters. The descending stroke was taken from the
form of petals. The descending strokes of *siot* (ㅅ) and
jieut (ㅈ), for example, were exceptionally different from
the finish of other Arita Buri letters, but we thought it
was okay because they still kept our original impression
of Arita Buri. The most important point when deciding on
the form of types was "being modern." I felt that *ieung* (ㅇ)
without the *buri* was modern. The existing forked *jieut* (ㅈ)
may give an antiquated impression, but Arita Buri looks
natural because it applied the shape of petals, from *siot*
(ㅅ) to *jieut* (ㅈ).

What part of the font family did you pay particular
attention to?

In creating the Arita Buri font family, extraordinary effort
was made for the Medium weight. We worked hard on
designing Medium because the typeface was expanded
starting with Medium, but there are more stories related
to HairLine and Bold; the reason why Arita Buri has a
modern impression is the HairLine weight. Another
important point was the relationship between different
weights in the font family. There were also discussions
about whether the width of different weights in the font
family should be adjusted differently or kept the same.
Furthermore, the width of HairLine characters were
expected to be the narrowest when the font family was
arranged in a line, but HairLine characters with thin
strokes looked better when having a little more margin
on each side than Light. As a result, the width of HairLine
became wider than Light. Back then, researcher Noh
Eunyou at the Ahn Graphics Typography Institute said it
was important to give proper space for each character.

아리따 부리는 총 다섯 종의 굵기로 제작되었는데
'헤어라인'과 '볼드'의 굵기가 특이하다.
굵기는 어떻게 결정하고 어떠한 순서로 작업했는가?

돋움에서 결정한 굵기 체계 다섯 종을 기준으로 작업을
시작했다. 돋움의 글꼴가족에는 라이트보다 얇은 씬이 있다.
돋움과 달리 부리는 얇을수록 특징이 없어졌다. 그래서 한글
글꼴 디자인에서 한 번도 시도한 적이 없었던 헤어라인을
제안했다. 안상수 선생님과 아모레퍼시픽 모두 이러한 시도를
반겨서 돋움에서 만든 아리따의 규칙을 깰 수 있었다.
또한 헤어라인을 씨앗으로 삼아 이후에 다른 스타일의
글꼴가족을 계획할 수도 있다고 생각했다. 가장 먼저 디자인한
것은 미디엄이다. 중간 굵기에서 시작해 다른 가족으로
확장했다. 초반에는 미디엄은 본문용, 볼드는 제목용이라고
생각했다. 굵기 개발 과정에서 가로획과 세로획의 대비가 강한
글자도 제안했다. 본문에 쓰이는 볼드는 획이 너무 강하게
대비되는 것보다는 현재의 글꼴 방향이 적당하다고 의견을
나누었고, 획의 대비가 강한 형태는 글꼴가족을 확장할 기회가
있을 때 시도해보기로 했다.

아리따 부리는 조화로운 판짜기를 위한 비례너비 글꼴이다.
부리의 비례너비를 만드는 과정은 어떠했는가?

아리따 돋움에서 모임꼴에 따라 비례너비로 설정했던 원칙에
맞춰 자연스럽게 진행했다. 좌측 여백 값과 우측 여백 값을
설정하고 모임꼴별로 글자사이가 어색하지 않도록 조정했다.
하지만 한글은 로마자와 달리 모임꼴별로 낱글자의 농도와 획의
움직임이 다양해 좌우 여백 조정만으로 해결되지 않는 부분이
있다. 타이포그래피가 비례너비 글꼴에 적응할 시간도 필요했다.
기존의 조판에서 비례너비 글꼴이 어색하다고 느낀 사람도
있었다. 숫자의 경우 문장에서 사용하는 숫자는 비례너비로,
표에 사용하는 숫자는 고정너비로 만들었다.

Arita Buri was developed in five different weights, and
HairLine and Bold are unique. How did you determine
the weights, and in what order did you work on them?
We started our work based on the five weight systems
determined for Dotum. There is Thin, which is thinner
than Light in the Arita Dotum font family. Unlike Dotum,
Arita Buri's characters showed their features less clearly
as their strokes became thinner. That's when I suggested
HairLine, which had never been used before in Hangeul
typeface design. Ahn Sangsoo and Amorepacific both
welcomed this attempt, so we were able to break Arita's
rules that had been set with Dotum. I also thought that
we could later plan another style of font family based on
HairLine. The first one we designed was Medium. We
started from the Medium weight and then expanded to
other fonts in the family. At first, I thought Medium was
for the body text and Bold was for the titles. In the process
of developing weights, we also suggested characters with
a sharp contrast between horizontal and vertical strokes.
We agreed that Bold used in the body text was more
appropriate with the existing design of characters than
those with a sharp contrast between strokes, and decided
that we would try shapes with sharp contrasts of strokes
later when we would have an opportunity to expand the
font family.

Arita Buri is a proportional typeface for harmonious
typesetting. What was the process of creating the
proportional space of Buri like?
The process naturally followed the principle that was
put forth through proportional space in Arita Dotum.
I set the left and right margin values and adjusted the
types so that the space between letters would not look
awkward. However, Hangeul, unlike the Latin alphabet,
has a different font density and stroke movements
for each letter, so it was difficult to make characters
look nice simply by adjusting margins on each side
of the letters. We also needed time for typography to
adapt to proportional typefaces. Some people felt that
proportional typefaces were awkward in traditional
typesetting. In the case of numbers, those used in
sentences were made with proportional space, and those
used in tables were made with fixed width.

아리따 부리의 문장부호 개발 과정은 어떠했는가?

'멀티글리프multi-glyph 방식'을 채택해 다양한 표정의 문장부호를 개발했다. 헤어라인 글꼴의 문장부호를 만들 때 여러 시안을 제작했는데, 안상수 선생님이 모두 하자고 했다. 당시에는 멀티글리프가 흔하지 않았는데 글자의 형태와 쓰임 면에서 풍성해졌다고 생각한다. 또한 프로젝트를 통해 새로운 화두를 던지면서 한 번도 가보지 않은 길을 가는 느낌이 들었다. 새로운 시도를 통해 기업용 글꼴도 개성 있는 글자가 될 수 있었다.

가장 애착이 가거나 어려웠던 낱글자가 있는가?

아리따 부리의 시옷(ㅅ)을 좋아한다. 버선발이나 처마 곡선의 느낌이 시옷(ㅅ)에 잘 드러나는 것 같다. 시옷(ㅅ)의 곡선이 과해 보이지 않도록 마지막까지 조정했다. 음절로는 '삶'이라는 단어를 좋아한다. 그리고 곧은 기역(ㄱ)의 모양과 균형을 잡는 것이 어려웠다.

아리따 부리는 서른두 개의 스케치를 거쳐 완성되었다. 스케치는 어떻게 변화했는가? 기억에 남은 일화가 있는가?

돋움과의 관계를 고려하면서 전통의 현대적 안착, 아리따우면서 미래지향적인 여성상 등 여러 의미를 구체적인 형태로 표현하기가 쉽지 않았다. 초기 스케치를 보면 속공간이 큰 것도 있고, 자연스러운 흘림을 강조한 붓글씨 느낌도 있다. 기억에 남는 일화는 먼 곳에 돌을 던져본 일이다. 4차 회의 때쯤 구조를 결정하고 형태에 변화를 주고 있었는데 한재준 디렉터가 직선으로만 이루어진 글자를 그려보자는 새로운 제안을 했다. 5차 회의 때 그러한 시안을 준비해 갔는데 결과적으로 너무 과하다는 의견이었다. 이를 바탕으로 6차 회의 때 다시 이전 스케치와 조화롭게 조정한 세 가지 시안을 준비해 갔다. 이후 여러 차례의 회의 끝에 최종적으로 6차 때의 시안으로 결정되었다. 나는 그때 직선을 강조한 시안을 만들고자 한 것이 한곳에 머물러 있지 않고 먼 곳을 바라보게 돌을 던져준 것 같다고 생각했다. 그 과정이 없었다면 최종 시안을 확정하기 더 어려웠을지도 모른다. 수많은 회의와 여러 의견을 통해 성장한 프로젝트였다.

What was the development process behind Arita Buri's punctuation marks?

We adopted a multi-glyph method to create punctuation marks with various looks. When we were working on the punctuation marks of HairLine, I made a variety of drafts, and Ahn Sangsoo suggested that we adopt all of them. Multi-glyphs were not common back then, but I think the font has become more enriched in terms of forms and use of characters due to multi-glyphs. I also felt like we were taking a road not taken before, as we brought up new topics through the project. A corporate typeface was able to provide unique characters through new attempts.

What was the most preferred or challenging character?

I love *siot* (ㅅ) in Arita Buri. It seems that the impression of the curves (or arcs) found in a traditional Korean sock and the eaves of *hanok* (traditional Korean homes) are both captured well in the character. I adjusted the shape very carefully so that its curve doesn't look excessive. I also like the Korean word 삶 (life). In addition, it was challenging to complete the balanced shape of a straight *giyeok* (ㄱ).

Arita Buri was completed after 32 sketches. How did the sketches change? Tell us about some memorable moments over this time.

Considering the relationship with Dotum, it wasn't easy to express various meanings—whether the modern interpretation of tradition or the beautiful and futuristic image of a woman—in a concrete form. In the early sketches, there were designs with extensive counters and calligraphic impressions that highlighted a natural cursive style. The most memorable moment I can remember was a drastic change of perspective. By our fourth meeting, we decided on the structure of the typeface and were changing its form. That's when Han Jaejoon made a new proposal to draw characters that consist only of straight lines. At our fifth meeting, I proposed this idea, which at the time was considered too much of a change. Based on this feedback, I made three drafts that were harmonized with the previous sketches in time for the sixth meeting. After several meetings, a draft discussed at the sixth meeting was finally selected for the typeface design. I felt that making drafts with straight lines gave me a different perspective. Without that experience, it would have been more difficult to decide on the final design. It was a project that grew through numerous meetings and different opinions.

아리따 부리를 만들 때 아날로그와 디지털 가운데
어떤 방식을 사용했는가?

먼저 손으로 글씨를 써보며 구조에 대한 아이디어를 얻었다.
구조와 리듬이 손에 익었을 때의 인상을 기억하며 디지털로
그렸다. 손으로 글자를 스케치하는 일은 브레인스토밍 같은
것으로 형태를 완벽하게 완성하는 것은 아니다. 디지털로
글꼴을 그릴 때도 부리와 맺음의 세부 형태나 획의 움직임을
다듬을 때는 다시 손으로 쓰고 그리는 것을 반복했다.

아리따 부리 프레스키트 press kit에 포함된 설명은
디자이너를 위한 글처럼 보인다. 아리따의 주요 사용자는
누구로 설정했는가?

아리따 글꼴은 배포용 글꼴이지만, 1차적인 목적은
아모레퍼시픽의 브랜드에 적용하는 것이기 때문에 일반인이
주요 사용자는 아니다. 디자인 과정에서 우리가 염두에 두어야
할 주요 사용자는 디자이너여야 한다는 이야기도 나왔다.
(현재 어도비 Adobe 소프트웨어에서만 글꼴의 여러 가지 기능이
지원된다.) 그러나 아리따 글꼴의 사용자 층위는 여러 개다.
기본적으로 기업의 목소리를 표현한 글꼴이므로 1차 사용자는
기업이다. 디자이너가 2차 사용자이고, 일반 대중이 3차
사용자이다. 기업을 위해 기업이 추구하는 가치와 이미지를
담고자 했고, 디자이너를 위해 글꼴가족을 구성하고 매뉴얼을
만들었다. 일반 사용자의 편의를 위해 오토 힌팅 auto-hinting을
적용해 다양한 소프트웨어에서 사용할 수 있도록 했다.

아리따 부리 글꼴 개발 후반에 편집 전문 디자이너에게
사용성 테스트를 한 것이 글꼴을 다양하게 보게 된
기회가 되었다고 했다. 구체적으로 설명해줄 수 있는가?

편집 디자이너와 진행한 사용성 테스트는 아직도 인상적이다.
심우진, 이용제, 문장현, 김병조, 총 네 명의 디자이너가
참여했는데 모두 다른 의견을 주었다. 판짜기 조건이나 세대에
따라서 의견이 달랐고 같은 디자이너라 할지라도 작업 성격에
따라 다른 판짜기를 하면서 다양한 의견이 나왔다. 글꼴
제작 과정에 사용자 평가가 포함된 것은 의미 있는 일이다.
다른 글꼴회사와 달리 안그라픽스는 편집 디자이너와
소통할 수 있는 것이 장점이다.

When you created Arita Buri, which method did you use,
analogue or digital?

In the beginning, I wrote the characters by hand and
came up with ideas about their structure. When I got used
to the structures and rhythms of the characters, I began
to draw them digitally, remembering their impressions.
Sketching characters by hand is like brainstorming—it's
not about perfecting the shapes on paper. In the process
of digitally drawing fonts, I repeated the handwriting
process again while refining the details of the *buri*
and the completion of the letters or the movement of
the strokes.

The description included in the Arita Buri Press Kit
seems to be for designers. Who did you envision as the
primary user of Arita?

The Arita typeface was made for free distribution, but the
general public is not the main user because its primary
purpose is to apply it to Amorepacific brands. That being
said, during the design process, some people said that
the primary user we needed to keep in mind would be
designers. (At present, many features of the Arita typeface
are only supported by Adobe software.) However, there
are several "levels" among Arita users. It is a typeface that
expresses the voice of a company, so the primary user is
the company. Designers are the secondary user, and the
general public is tertiary. For the company, we tried to
capture the value and image that the company pursues;
for designers, we formed a font family and created a
manual. For the convenience of general users, auto-
hinting was applied so that it could be used in various
software programs.

You told us that the usability test with editorial designers
in the later stages of the development of Arita Buri gave
you a chance to see the typeface from various angles.
Could you tell us more about that?

The usability test done with the editorial designers still
resonates with me. Four designers—Shim Woojin, Lee
Yongje, Moon Janghyun, and Kim Byungjo—participated
in the meetings, and all were giving different opinions.
Opinions differed according to the typesetting conditions
and generations of the designers; some of these same
designers even gave other views while testing different
styles of typesetting, depending on the nature of the
work. In the end, it was meaningful to include user
reviews during the typeface development process. Unlike
other font companies, Ahn Graphics has the benefit of
allowing easy communication with editorial designers
inside the company.

아리따의 인지도 조사 결과에서 글꼴 디자이너가
누구인지 잘 인지되고 있다고 나타났다.
디자이너로서 아리따 부리 작업은 어떤 의미가 있는가?

프리랜서 글꼴 디자이너로서 큰 프로젝트에 참여할 수 있어서
좋았다. 검증 과정을 거치며 다양한 사람과 협업하고 새로운
과정을 만들어낸 프로젝트였다. 기업 글꼴 제작에서 아쉬웠던
점이 기업을 강조하다 보니 디자이너는 보이지 않는다는
것이었다. 심지어 디자인 회사도 남지 않는 경우가 많았다.
디자이너를 남기는 것을 당연하게 생각해준 것이 고맙다.

기업 전용 글꼴로서 아리따 부리는 어떤 역할을 하고 있는가?

아리따 부리 프로젝트에서 나왔던 이야기 가운데 '목소리를
만든다.'는 말이 좋았다. 장식품을 만드는 게 아니라
목소리를 만드는 것. 알아차리기 어렵지만, 사람을 매력적으로
만드는 것 가운데 하나가 목소리이다. 아리따 부리가
목소리로서 역할을 하는 것이 좋다.

아리따 부리 글꼴 작업을 하면서 도전해보고
싶은 것이 있었는가?

로마자와 기호를 더 공부하고 싶어졌다. 한글 디자이너는 한글
글꼴 세트를 잘 만들기 위해 다른 문자를 공부할 필요가 있다.
KS 코드Korean industrial Standards code에는 로마자, 숫자, 그리스 문자,
키릴 문자, 일본어 등이 포함되어 있기 때문이다. 아리따 부리
프로젝트를 마치고 몇 년 후 영국 레딩대학교의 타입 디자인
석사 과정에 진학했다.

아리따 부리 작업에 대해 표현한다면?

개인적으로는 '도전'이고 프로젝트 자체는 '씨앗'이라고
생각한다. 아리따 부리를 만들며 나온 이야기와 문장부호, 글꼴
디자인 과정, 글자 이름의 체계 등이 연구되기도 했다. 회의록을
보면 글꼴 프로젝트의 견적을 내는 방식, KS 코드에 대한
의견도 있다. 한글을 개발하는 프로젝트 대부분이 형태를
디자인하는 데서 끝나는데, 아리따 프로젝트는 시간과 예산이
있었기 때문에 여러 가지를 논의하고 테스트할 수 있었다.
모든 문제를 해결했다고 할 수는 없지만, 씨앗을 뿌리고 가지를
치는 역할을 했다. 프로젝트를 시작한 해의 식목일에 안상수
선생님이 보고서 표지에 '아리따 나무를 심자'라는 문장을
쓰셨다. 모두 아리따 부리라는 나무가 무럭무럭 자라길 바랐다.

Arita's Awareness Survey reveals that the designers
of the typeface are well recognized. As a type designer,
what is the meaning of the Arita Buri project to you?
As a freelance type designer, it was great to be able to
participate in such a big project. For the project, various
people collaborated with each other and created a new
work process, all the while going through an evaluation
process. The thing to be desired in corporate typeface
projects is that designers are often invisible as they
emphasize the identities of companies. Even design
companies are left in the dark in some cases. I appreciate
the fact that designers were duly given credit for their
work in the Arita project.

What is the role of Arita Buri as an exclusive
corporate typeface?
I loved the idea of "creating a voice," which is something
that arose from the project. This refers to letting voices
being heard, and something that is not simply an
ornament. It is hard to notice, but one of the things that
makes people attractive is their voice. I love that Arita
Buri acts as a voice.

Was there any challenges you wanted to overcome
while working on Arita Buri?
I wanted to further study the Latin alphabet and
different symbols. Hangeul type designers need to
explore letters from other languages to come up with
the best Hangeul fonts. That's because the Korean
Industrial Standards (KS) code includes the Latin
alphabet, numbers, Greek and Cyrillic alphabets, and
Japanese. A few years after the Arita Buri project got
started, I started my master's degree in Type Design at
the University of Reading in England.

Describe your work on Arita Buri in a few keywords.
It was a "challenge" for me as an individual, and the
project itself was a "seed." The stories, punctuation
marks, typeface design process, and the naming system
of Arita Buri were closely studied. The minutes of our
meetings also included how to quote a typeface project,
as well as comments on the KS code. Most of the projects
that develop Hangeul typefaces end up in designing
forms. However, the Arita project had enough time and
money so that we could discuss and test many things. Not
all issues were completely handled, but we—figuratively
speaking—planted seeds and pruned branches. On
Korea's Arbor Day in 2012, the year that the project
began, Ahn wrote "Let's plant Arita trees" in Korean on
the cover of a report. We all hoped that an Arita Buri
tree could grow healthily.

안상수의 메모, 2012. 4. 5
A memo written by Ahn Sangsoo, Apr. 5, 2012

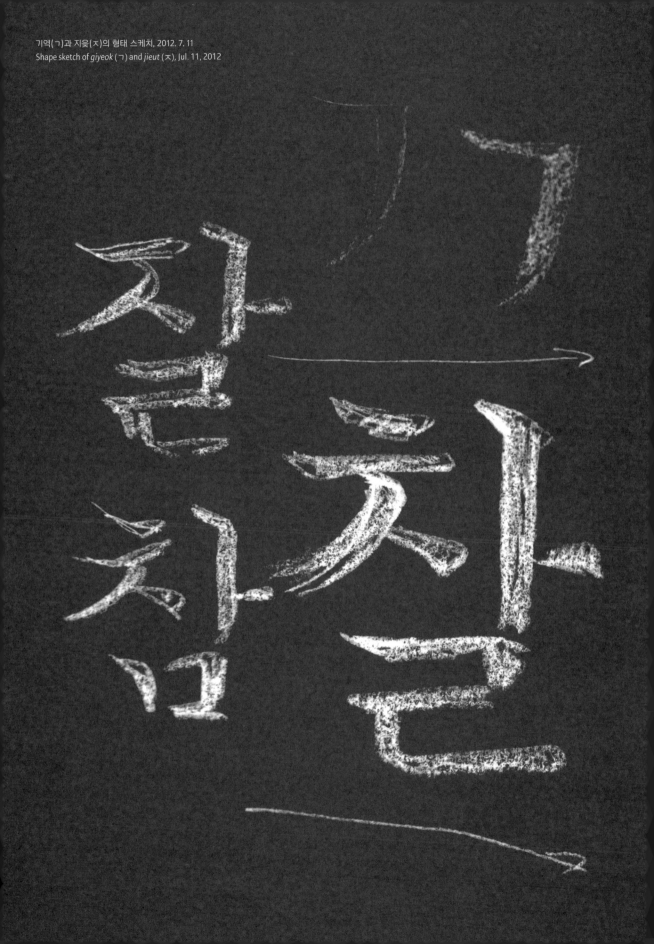

기역(ㄱ)과 지읒(ㅈ)의 형태 스케치, 2012. 7. 11
Shape sketch of *giyeok* (ㄱ) and *jieut* (ㅈ), Jul. 11, 2012

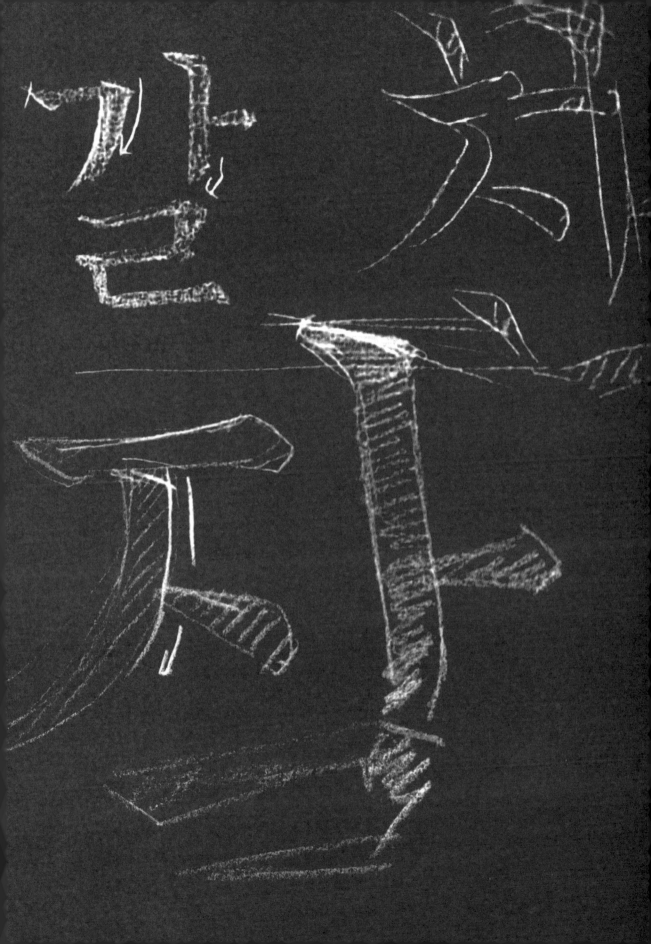

주즈웨이 【아리따 흑체】

글꼴 개발 디렉터. 1971년부터 1991년까지 중국 베이징
외국어인쇄공장北京外文印刷厂에서 인쇄 활자 조각 작업을
했으며, 1991년 중국 베이징대학교北京大学가 설립한
글꼴회사 방정方正에서 글꼴 디자인 디렉터와 수석 기술
디자인 전문가를 맡았다. 대표 글꼴로는 '북위해서北魏楷书'
'철근예서铁筋隶书' '조송粗宋' '박아송博雅宋' '아송雅宋'
'풍아송风雅宋' '현송玄宋' 등이 있으며, 현재 글꼴회사
한이汉仪의 아트 디렉터로 활동하고 있다. 아리따 흑체의
글꼴 디렉터로 참여했다.

Zhu Zhiwei 【Arita Heiti】

Type development director. From 1971 to 1991,
Zhu Zhiwei worked on printing type engraving at
the Beijing Foreign Language Printing Factory. In
1991, he became the design director and senior
technical expert at Founder Type, a type foundry
established by Beijing University. Well-known
typefaces include Bei Wei Kai Shi, Tie Jin Li Shu,
Cu Song, Bo Ya Song, Ya Song, Feng Ya Song, and
Xuan Song. He is currently working at Hanyi Font
as its art director. He participated in the Arita Heiti
project as a type director.

아리따 흑체 프로젝트에 어떤 계기로 참여하게 되었고
맡은 역할은 무엇이었는가?

한이에서 일하기 전부터 아리따 흑체 프로젝트는 이미
시작되었다. 내 기억으로는 젊은 디자이너 몇 명이 찾아와
이미 진행 중이던 아리따 프로젝트에 관해 함께 논의하자고
했다. '어떻게 하면 여성성이 드러나게 흑체를 디자인할 수
있을까.'라는 내용이었다. 이후 한이에서 일하게 되면서
프로젝트의 고문을 맡게 되었고, 주요 단계마다 글꼴의
품질과 스타일에 관한 의견을 냈다.

아리따 흑체 디자인을 디렉팅할 때 어디에 중점을 두었는가?

품질 관리이다. 글꼴을 정기적으로 검토하면서 필획과 스타일을
통일하고 굵기의 균형이 맞지 않거나 자면 크기가 일치하지 않는
등의 문제를 수정하도록 했다.

아리따 흑체의 제작 과정이 다른 한자 글꼴 제작과
다른 점이 있었는가?

다른 글꼴 제작 과정과 크게 다르지는 않았다. 다만 아리따
흑체는 아모레퍼시픽의 전용 글꼴이기 때문에 기업의 특징과
의견을 반영해 제작했다.

아리따 흑체는 아모레퍼시픽의 브랜드 관점과 연결해
한자의 아름다움을 확장하고자 한 프로젝트이다.
아리따 흑체가 기존 기업의 글꼴과 어떤 점이 달랐는가?

아리따 흑체가 지향하는 미감은 '간결'과 '세련'이다. 이러한
측면에서 기존 흑체 디자인과 가장 다른 점은 '갈고리'이다.
전통 흑체와 다르게 갈고리를 위로 올리지 않고 간결하게
정리했다. 이러한 시도는 처음이었고 아리따 흑체만의 독특한
아름다움을 만들어냈다.

What made you take part in the Arita Heiti project,
and what was your role?

The Arita project had already begun even before
I worked for Hanyi. From what I remember, several young
designers came to discuss the Arita project, which was
already underway. It concerned how we could design
Heiti to reveal its femininity. After that, I became an
advisor for the project when I got to work at Hanyi. I then
made comments on the quality and style of the fonts at
every significant step.

At which point did you focus on directing Arita
Heiti's design?

It was about quality management. We reviewed fonts
regularly, unifying strokes and style, and having them
correct problems, such as the unbalanced weight or the
inconsistent size of the squares for characters.

Is there any difference in the development of Arita Heiti
from other Chinese typefaces?

It wasn't much different from other Chinese typefaces
in terms of the design process. However, Arita Heiti
is a unique font for Amorepacific, so it was created by
reflecting the characteristics and beliefs of the company.

Arita Heiti was a project that aimed to extend the beauty
of Chinese characters by connecting Amorepacific's
brand perspective to the type design itself. What was
the most significant difference between Arita Heiti and
traditional corporate fonts?

The aesthetics of Arita Heiti is conciseness and
refinedness. In this respect, the most striking difference
from the existing Heiti design is the "hook." Unlike
traditional Heiti, the hooks on the strokes are put
together in a succinct fashion, and not raised upward. It
was the first attempt to adopt such artistic choices, and it
has consequently led to the unique beauty of Arita Heiti.

아리따 흑체의 바탕 생각은 정정옥립, 자연미려, 기운생동이다. 세 가지 바탕 생각은 글꼴에 어떻게 반영되었는가?
'정정옥립'은 글꼴의 날씬하고 단정한 짜임새에서, '자연미려'는 인위적으로 꾸민 흔적이 없는 간결하고 평온한 스타일에서 나타난다. 시원하게 뻗어 나간 라인과 삐침, 파임, 점, 갈고리의 곡선 표현, 필획에서는 부드러움 속의 강직함과 '기운생동'이 드러난다. 특히 갈고리 디자인이 글꼴에 생동감을 더한다.

아리따 흑체는 한글과 어울리면서 새로운 이미지를 갖고자 했다. 어울림과 차별성 사이에서 어떻게 디자인적 균형을 맞추고자 했는가?
한자와 한글의 균형을 맞추기 위해서는 두 가지 중요한 점이 있다. 하나는 줄기이고 다른 하나는 무게 중심이다. 한자와 한글은 다른 글자이지만, 직선과 곡선으로 구성되고 네모꼴 글자라는 공통점이 있다. 강하고 부드러운 줄기와 필획의 굵기, 자면의 크기, 글자의 무게중심인 기준선 높이를 맞추면 서로 어울릴 수 있다.

아리따 프로젝트를 디렉팅하면서 실험적이거나 도전적인 부분이 있었는가?
글꼴을 만들 때마다 완성도를 높이는 데에 도전적인 마음으로 임한다. 늘 더 좋게, 더 낫게 만드는 것이 목표이다.

아리따 흑체가 기업용 글꼴 생태계에서 어떠한 역할을 하기를 원하는가? 아리따 흑체가 중국 글꼴 시장에서 갖는 의미와 평가는 무엇인가?
아리따 흑체가 어떤 역할을 할지는 내가 말할 수 없을 것 같다. 글꼴의 가치는 실용성에 비례한다. 아리따 흑체의 경우 글꼴의 바탕 생각인 정정옥립, 자연미려, 기운생동이 대중의 공감을 얻는 것도 중요하다. 아리따 흑체가 브랜드 전용 글꼴로서 중국 글꼴 시장에 유익한 시도임은 의심의 여지가 없다.

마지막으로 아리따 흑체 프로젝트의 주제어를 꼽는다면?
청춘, 간결, 세련.

The basic ideas behind Arita Heiti are "a slim and slender beauty," "a natural beauty," and a "lively and vigorous charm." How did you apply these ideas to the typeface?
A slim and slender beauty appears in the slim, neat structure of the typeface, while a natural beauty appears in a concise and serene style, with no traces of artificial embellishment. The shape of the lines that freely spread out, *ppichim*, as well as *paim*, dots, the curves of hooks, and strokes reveal the strength in softness as well as a lively and vigorous charm. What's most noticeable is the hook design, which adds a sense of vitality to the typeface.

Arita Heiti aimed to establish a new image while harmonizing with Hangeul. How did you create a balanced design between harmony and uniqueness?
There are two crucial points in balancing Chinese characters and Hangeul. One is the stem, and the other is the center of gravity. Chinese characters and Hangeul are different, but they have something in common: They are composed of straight lines and curves in a square. Strong, soft stems and the weight of the strokes, the size of the square, and the height of the baseline (the center of gravity in a character) can be made to fit together harmoniously.

What was the most experimental or challenging part while directing the Arita project?
Every time I create a typeface, I try to improve the level of perfection with a pioneering spirit. My goal is always to make it better.

What kind of role do you want Heiti to play in the corporate typeface ecosystem? What is the meaning of Arita Heiti in the Chinese typeface market, and how is it expected to affect the Chinese market?
I don't know what role Arita Heiti will play. The value of typefaces is proportional to their practicality. With Arita Heiti, it is essential that the typeface's underlying motifs—"a slim and slender beauty," "a natural beauty," and "lively and vigorous charm"—resonate with the general public. There is no doubt that Arita Heiti is a useful attempt in the Chinese typeface market as a brand-exclusive typeface.

Lastly, please describe the Arita Heiti project in a few keywords.
Youth, simplicity, and refinement.

您是如何参与到阿丽达项目的？

您在项目中担任了什么角色？

阿丽达项目开始的时候我还没到汉仪，记得当时有几位年轻的设计师找到我探讨"如何设计一款女性化的黑体字"，后来到了汉仪才知道是这个项目。我在项目中担任的主要角色是设计顾问，当项目进展到某一节点时我会根据项目的要求，针对项目的整体质量和风格的把控发表意见和建议。

您指导阿丽达黑体设计项目时重点放在了哪些部分？

重点指导质量的把控上。我会定期检查并修改笔画风格不统一、粗细不匀称、字面大小不一致等问题。

阿丽达黑体的开发过程与其他中文字体的开发有差别吗？

与其他中文字库的卡法方式没有什么区别，所不同的，因为这是一款企业定制字库，所以，要考虑企业的特点和诉求。

阿丽达黑体是关联爱茉莉太平洋集团的品牌观点，扩张中国字体之美的项目。阿丽达黑体与现有的企业专用字体大不相同的部分是什么？

阿丽达黑体的整体审美取向是简约时尚，从设计角度看，它与现有的黑体字最大的不同是"钩"的设计，如竖钩，没有像传统黑体那样横向勾出，而是向左下出锋收笔，再如，横折弯钩，没有像传统黑体那样向上勾出，而是向右上出锋收笔，这样设计黑体字的钩应该是首创，也形成了阿丽达的独特性。

阿丽达中文设计理念是亭亭玉立、自然美丽、气韵生动。

想了解这三个设计理念是如何反映到字体设计中的。

亭亭玉立，表现在字形修长，结构端庄；自然美丽，表现在风格简约，没有刻意的修饰痕迹，结体和平稳，气韵生动，表现在线条舒展流畅，撇、捺、点、钩这些用曲线描述和造型的笔画，舒缓有致，柔中带刚，特别是"钩"的设计增强了整副字体的生动元素。

阿丽达中文与韩文既要协调也要含有新的形象。

在协调性和差异性上如何让字体保持设计的均衡？

协调好两种文字的均衡性主要有两个方面的问题，一个是线条，另一个是重心，中文和韩文虽然不同，但依然是由直线和曲线构成的方块字，所以处理好了线条的刚柔，笔画的粗细，字面的大小，重心的高低的话，可以互相协调。

指导阿丽达项目时哪些部分具有实验性或者需要挑战？

对我来说，做任何一款字的挑战性都是"成熟度"，我追求的目标是：更好一点，更好一点……

阿丽达黑体是一款大众可以自由使用于非商用的字体。

您希望阿丽达黑体在企业专用字体以及字体生态界中，担任什么角色？ 想了解阿丽达黑体在中国字体市场的评价和意义。

这不是我能希望的事情。一款字体的核心价值是由这款字体的实用性来决定的，重要的是"亭亭玉立、自然美丽、气韵生动"能得到大多数人的认同。阿丽达黑体在中国市场无疑是品牌字体定制的一项有益的尝试。

最后，请问阿丽达黑体项目的关键词是什么？

青春，简约，时尚

OⅠ

!"#$%&'()
+,/:;<=>?@
ABCDEFGH
MNOPQRSTU
[\]^_`abcde
nopqrstuvwxy

Arita Chinese Medium

Arita Chinese Medium

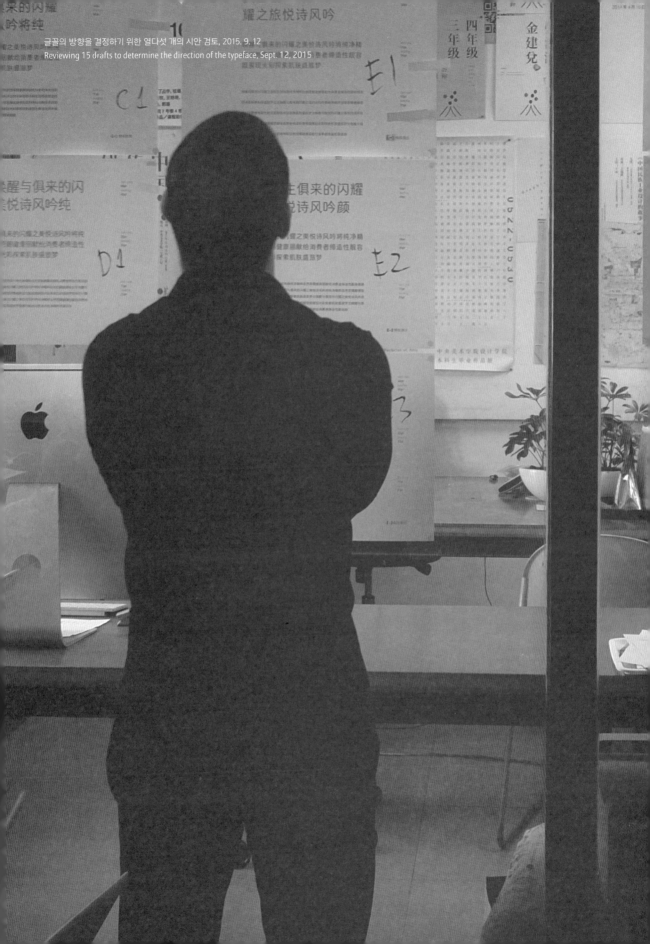

글꼴의 방향을 결정하기 위한 열다섯 개의 시안 검토, 2015. 9. 12
Reviewing 15 drafts to determine the direction of the typeface, Sept. 12, 2015

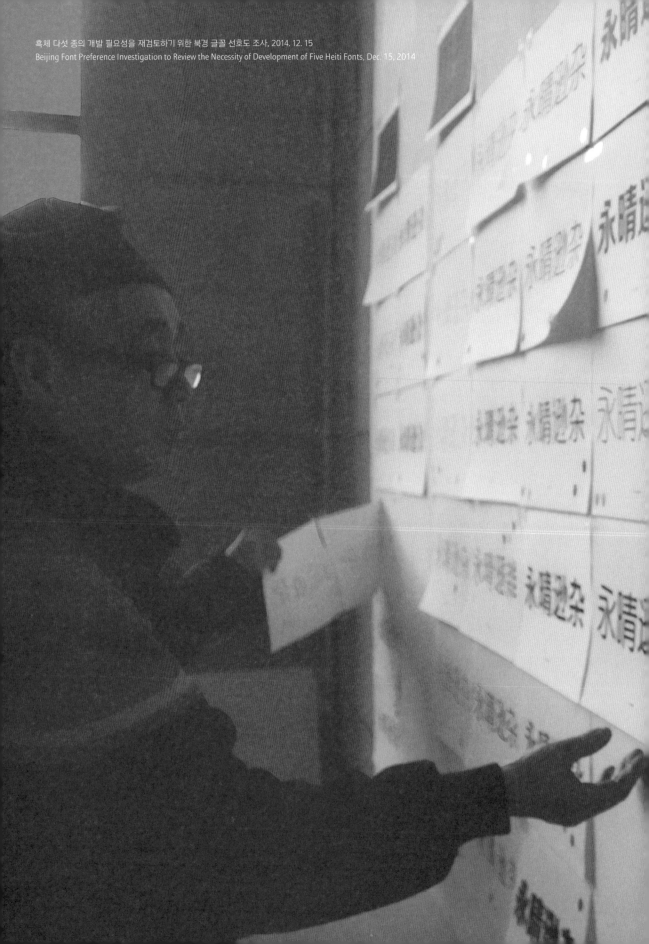

흑체 다섯 종의 개발 필요성을 재검토하기 위한 북경 글꼴 선호도 조사, 2014. 12. 15
Beijing Font Preference Investigation to Review the Necessity of Development of Five Heiti Fonts, Dec. 15, 2014

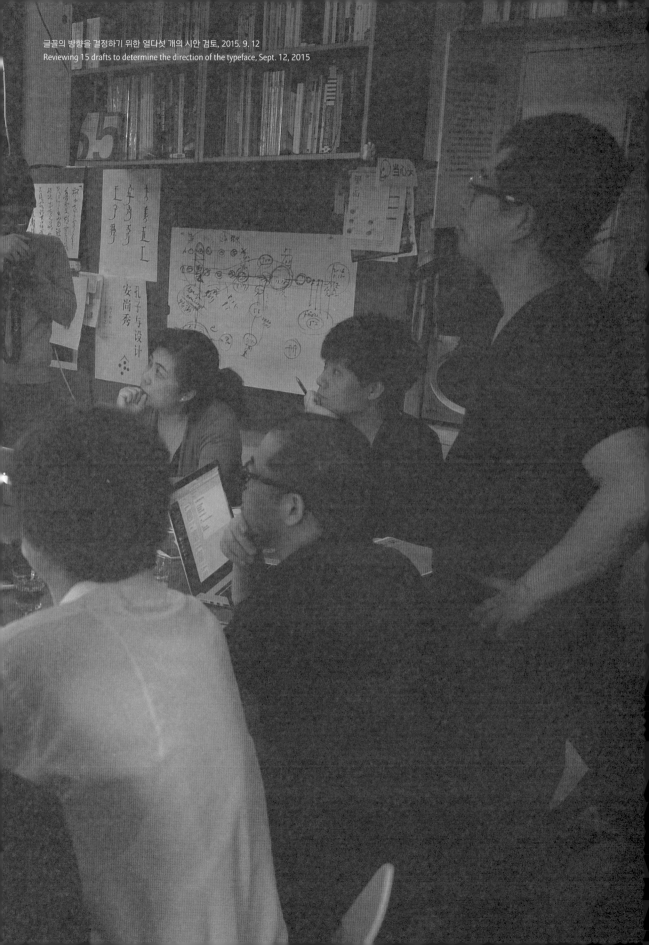

글꼴의 방향을 결정하기 위한 열다섯 개의 시안 검토, 2015. 9. 12
Reviewing 15 drafts to determine the direction of the typeface, Sept. 12, 2015

류위【아리따 흑체】

글꼴 디자이너. 중국 베이징복장학원北京服装学院 시각 커뮤니케이션과를 졸업했다. 글꼴회사 한이의 수석 디자이너로서 '역량흑체力量黑' '도도체跳跳' '악묘체樂喵' 등을 만들었다. 중국의 다른 지역에서 글꼴에 대한 강의와 워크숍을 진행하며 더 좋은 글꼴 제작 환경을 구축하기 위해 애쓰고 있다. 아리따 흑체의 책임 디자이너로 참여했다.

Liu Yu【Arita Heiti】

Type designer. Liu Yu graduated from the Department of Visual Communication at the Beijing Institute of Fashion Technology (BIFT). As a senior designer at Hanyi, she developed LiLiangHei, TiaoTiao, and YueMiao. She delivers lectures and workshops about different Chinese typefaces across China. She also participated in the Arita Heiti project as a senior designer.

아리따 흑체 프로젝트에 어떤 계기로 참여하게 되었고
맡은 역할은 무엇이었는가?

아리따 흑체 개발이 시작된 2015년 말에 한이에서 글꼴
디자이너로 일했다. 흑체 프로젝트는 글꼴 디자이너에게 좋은
기회였기 때문에 모든 디자이너가 적극적으로 시안 제안에
참여했다. 안상수 선생님, 주즈웨이 선생님, 치리쿄ㅍ 선생님의
지도 아래에서 끊임없이 디자인을 발전해나갔고 최종적으로
프로젝트 책임 디자이너를 맡게 되었다.

아리따 흑체의 바탕 생각은 정정옥립, 자연미려, 기운생동이다.
세 가지 바탕 생각은 글꼴에 어떻게 반영되었는가?

글꼴의 특징은 구조와 필획에서 비롯된다. 아리따 흑체는
진나라 때 한자 서체인 소전小篆의 구조적 특징을 참고했다. 좌우
대칭이고 균일한 필획, 가늘고 긴 형태, 높은 무게 중심을 지니고
있어 정적인 아름다움과 서서히 떨어지는 공간감을 보여준다.
또한 축소된 중궁과 손글씨 느낌이 자연스러움을 더한다.
필획에서는 예서의 갈고리, 점, 파임, 삐침 등 서예의 정수精髓를
받아들이면서 간결하고 현대적으로 디자인했다.

글꼴 디자이너마다 글자를 그리는 방식이 다르다.
아리따 흑체는 아날로그와 디지털 방식을 함께 진행했는가?

초반에는 손으로 스케치를 하고 디자인이 확정된 뒤에는
디지털 방식으로 완성했다.

What made you take part in the Arita Heiti project,
and what was your role?

I was working as a font designer at Hanyi at the end
of 2015 when the development of Arita Heiti began.
The Heiti project was an excellent opportunity for
typeface designers, so many designers applied with draft
proposals. Under the leadership of Ahn Sangsoo, Zhu
Zhiwei and Qi Li and I gradually developed the design,
which is when I became a senior designer for the project.

The basic ideas of Arita Heiti are "a slim and slender
beauty," "a natural beauty," and "lively and vigorous
charm." How did you apply these ideas to the typeface?

The characteristics of a typeface come from its structure
and strokes. Arita Heiti referred to the structural
features of the Small Seal Script from the Qin Dynasty.
Arita Heiti has symmetrical left and right sides, uniform
strokes, long and thin shapes, and a high center of
gravity, displaying a static beauty and spatial impression
of slow falling. The reduced counter and impression of
handwriting add a naturalness to it. For its strokes, we
adopted the essentials of calligraphy, such as hooks,
dots, *paim*, and *ppichim*, and developed simple and
contemporary designs.

Every type designer has different ways to draw letters.
Did you design Arita Heiti using both analog and
digital methods?

In the beginning, I sketched the typeface by hand, and
after the design was finalized, I completed it digitally.

**아리따 흑체의 제작 과정이 다른 한자 글꼴 제작과
다른 점이 있었는가?**

아리따 흑체는 세 팀이 끊임없이 토론하고 연구하고 부딪혀
얻은 결과물이다. 디자인의 바탕 생각을 정립하는 것에서
브레인스토밍을 통해 디자인을 개발하고 최종 방안을
확정하기까지 모두 한국 측과 중국 측의 깊은 고민 끝에
결정되었다. 3년에 걸친 디자인 기간은 기나긴 마라톤 같았다.
디자인 공모에는 총 열여섯 명의 디자이너가 참여해 열다섯 종의
시안을 선보였다. 경험이 풍부한 글꼴 전문가와 그래픽
디자이너를 초청해 여러 차례 워크숍을 진행하며 선택의 범위를
좁혀갔다. 한국과 중국을 오가며 정기 회의를 진행하고
수십 개의 시안을 놓고 선별과 수정을 반복했다. 모든 단계를
토론을 통해 추진하는 방식으로 작업을 엄격하게 관리했다.
이 과정 덕분에 마라톤에서 빠르고 가볍게 달릴 수 있었다.
보통의 글꼴은 디자이너가 자체 제작한다. 글꼴의 개념과
스타일은 창작하는 디자이너의 취향과 연관되기 때문에 정답이
없다. 그에 비해 기업 글꼴은 클라이언트마다 요구가 다르고
브랜드의 속성이 반영되어야 하며 기능성에도 신경을 써야 한다.
전용 글꼴은 브랜드 시각화의 일부분으로 해당 브랜드의 정신을
반영하고 이미지를 더욱 풍부하고 입체적으로 보여준다.
또한 제품에 깊게 파고들어 브랜드 체험의 일부가 되기도 한다.
아리따 흑체 개발 과정은 나에게 새로운 글꼴 디자인 작업
방식이었다. 프로젝트를 통해 어떻게 글꼴을 디자인하고 과정을
조정해야 하는지 뚜렷하게 알게 되었으며 눈과 손의 기술이
향상되는 경험을 했다.

중국의 다른 흑체와 아리따 흑체의 차이는 무엇인가?

아리따 흑체는 완전히 새로운 구조와 필획으로 구성되었다.
기존 흑체에 비해 산뜻하고 뚜렷하며 부드럽다. 또한 아리따
돋움과 어울리도록 세 가지 굵기로 제작되었고 제목과 본문
모두에 적합하다.

Was there any difference in the development of Arita Heiti from other Chinese typefaces?

Arita Heiti is the result of work from three teams that were constantly debating, researching, and challenging one another. From establishing the basic idea to the development of designs through brainstorming— right to the end of the final design—we decided upon everything after thoughtfully considering the ideas of the Korean and Chinese team members. The three-year design period was like a long marathon. A total of 16 designers participated in the design contest, preparing 15 different drafts. We invited experienced typeface specialists and graphic designers to conduct a series of workshops to narrow down our choices. We held regular meetings between Korea and China, and repeated the selection and correction process over dozens of proposals. The work was strictly controlled in a way that promoted discussions every step of the way. This allowed us, figuratively speaking, to run fast and effortlessly, like in a marathon. Typefaces are usually created by individual designers. Since the concept and style of a font are related to the thoughts of the designer who creates it, there is no right answer as to which is best. A corporate typeface, on the other hand, has different needs for different clients. It must reflect the attributes of each brand, and also requires functionality. An exclusive typeface is part of the brand's public face, reflecting the brand's spirit, while displaying images more vibrantly and in a more multidimensional way. In addition, it becomes deeply embedded within a product's brand experience. The development process of Arita Heiti was a new way for me to design a typeface. Through the project, I learned clearly how to create a typeface and adjust the process, which then allowed me to make technical improvements by using my eyes and hands.

What is the difference between Arita Heiti and other Heiti typefaces in China?

Arita Heiti has an entirely new structure and strokes. Compared with the existing Heiti, it is fresh, distinct and soft. It is also made in three weights to match Arita Dotum and is suitable for both titles and body text.

아리따 흑체는 한글과 어울리면서 새로운 이미지를 갖고자 했다. 어울림과 차별성 사이에서 어떻게 디자인적 균형을 맞추고자 했는가? 이전에 한글을 다뤄본 적이 있었는가?

한글은 영화와 드라마에서 주로 접했다. 한자와 한글의 어울림에는 글꼴 스타일과 판짜기의 조화가 포함된다. 아리따 흑체는 '갈고리'를 간결하게 정리해 기존 한자 필획의 복잡성을 줄이고, 파임과 삐침에서 아리따 돋움의 부드러운 곡선을 적용해 우아하고 아름다운 느낌을 주고자 했다.

아리따 흑체 디자인에는 열여섯 명의 디자이너가 참여해 열다섯 개의 시안을 만들었다. 최종적으로 'E-4' 디자인이 선정된 이유는 무엇인가?

시안과 자형을 끊임없이 비교했다. 기존의 흑체와 다르면서도 아리따 돋움과 어울리는 디자인을 찾았다. 디자인 심화 단계에서는 정정옥립, 자연미려, 기운생동, 이 세 가지 바탕 생각과의 연관성을 중심으로 봤다.

한자에서 갈고리를 떼어내는 표현이 파격적인 것인가? 이와 비슷한 다른 글꼴도 있는가? 중국 현지 글자 사용자들의 반응은 어떠했는가?

현재 아리따 흑체와 비슷한 글꼴은 없다. 아리따 흑체의 갈고리 디자인은 한이 디자이너들이 반복해서 생각하고 다듬은 끝에 만들어낸 집단 지성의 결과이며 이 글꼴의 큰 특징이다. 대부분 사용자가 아리따 흑체 디자인을 수용하고 일부는 이 디자인의 특징을 빠르게 알아차린다.

가장 애착이 가거나 어려웠던 낱글자가 있는가?

가장 좋아하는 글자는 생각해보지 않았지만, 마치 어머니가 아이에게 지어준 이름처럼 '아리따'라는 이름이 각별하다.

아리따 프로젝트의 글꼴 디자이너로서 실험적이거나 도전적인 부분이 있었는가?

프로젝트 초반이 가장 어려웠다. 팀이 프로젝트에 적응하는 시기였기 때문에 프로젝트에 대한 이해가 서로 다른 상황에서 적합한 방법을 찾아내는 것이 도전적이었다.

Arita Heiti aimed to have a new image while harmonizing with Hangeul. How did you make a balanced design between harmony and differentiation? Have you ever dealt with Hangeul in the past?

I have mostly seen Hangeul in movies and TV shows. The harmony between Chinese characters and Hangeul includes a combination of typeface styles and typesetting. For Arita Heiti, we succinctly organized the "hooks" to reduce the complexity of traditional Chinese strokes and to end up with an elegant and beautiful impression by applying the soft curves of Arita Dotum to *paim* and *ppichim*.

16 designers participated in the project, and they developed 15 drafts. What is the reason that draft E-4 was eventually decided upon?

We constantly compared the drafts and the shapes of characters. We also looked for a design that was different from the existing Heiti but matched Arita Dotum. In the latter stages of the design, we focused on the relation between the design and three key ideas: "a slim and slender beauty," "a natural beauty," and "lively and vigorous charm."

Is it unconventional to take the hook out of the Chinese character shape? Are there other fonts similar to Arita Heiti? What was the reaction of users in China?

There is currently no similar typeface to Arita Heiti. In fact, Arita Heiti's hook design is the result of the collective intelligence that designers at Hanyi created after thinking about it at length and polishing it over and over. It now represents the core of this typeface. Most Chinese users adopt the design of Arita Heiti, with some quickly recognizing the characteristics of the design.

What was your favorite or most challenging character? I haven't thought of my favorite characters, but the name "Arita" feels special, just like the name a mother gives her child.

What was the most experimental or challenging part as a type designer for the project?

The beginning of the project was the most difficult. It was a time for the team to adapt to the project, so it was challenging to find the right way to move forward when each person had a different understanding of the project.

您是如何参与到阿丽达项目的？

您在项目中担任了什么角色？

项目启动的2015年底，我在汉仪字库担任中文字体设计师，黑体项目对设计师是个很好的机会所以大家都积极参与了提案，在安尚秀老师、朱志伟老师、齐立老师的指导下，不断优化设计，最终担任了项目的中文主创设计师。

阿丽达中文设计理念是亭亭玉立、自然美丽、气韵生动。

想了解这三个设计理念是如何反映到字体设计中的。

字体的特征由笔画和结构共同作用。在结构上，阿丽达黑体借鉴了秦朝小篆的结构特点，左右对称、笔画匀称、字形修长、重心抬高，不仅有一种静态的美感，还具有向下徐徐坠落的空间感，缩小了字体的中宫，强化了阿丽达黑体手写的自然美感。在笔画上，阿丽达黑体借鉴了隶书对于钩、点、撇、捺等书法笔画的特点，吸取精华部分进行再设计，使字体更加简洁、现代。

阿丽达黑体的设计是同时用了传统方式（非数码）和数码方式吗？

最初草图的设计是借助草图完成，定稿后的工作用数码方式完成。

阿丽达黑体的开发过程与其他中文字体的开发有差别吗？

阿丽达黑体的制作过程一直是三方团队不断切磋和思想碰撞的结果；从设计理念的确定、设计方案的头脑风暴、最终方案的选拔都经过了韩方与中方深入的思考和考究的决定。历时三年的设计执行期，宛如一场漫长的马拉松。在征集设计方案的阶段，共有16名设计师参加，提出了15种设计方案。我们邀请资深字体专家和平面设计师举行了数次研讨会，对设计方案进行了筛选，缩小了设计方案的选择范围。往返于中韩两地轮流举行定期会议，对几十个设计方案进行了层层筛选和修改。作业过程得到严格管理，每个阶段都经过研讨后再予以推进，所有这些经历，都帮助我们在这场马拉松赛中越跑越快，越跑越轻松。普通字体设计通常为自命题创作，字体的概念和风格往往也和设计者的审美、喜好有关系，所以没有标准答案。相比而言，定制字体是命题创作，各个甲方的定制需求也有所不同，有些需要具有品牌的属性、有些注重功能上的设计。字体作为品牌视觉的一部分，已经渗透到品牌精神当中，帮助品牌的画像更加丰富、立体的展现；字体也更多的深入到产品的内容，作为品牌体验中重要的一部分。对我而言阿丽达黑体的开发过程是全新的工作方式。通过项目逐步清晰如何设计和把控，体验了眼和手的共同提高。

阿丽达黑体与中国现有的其他众多黑体的最大的差异是什么？

全新的结构和笔画的设计使得阿丽达在阅读感受上更佳疏朗、清晰、柔和。为了与韩文更佳匹配做了三个字重，满足标题、正文的使用需求。

阿丽达中文与韩文既要协调也要含有新的形象。在协调性和差异性上如何让字体保持设计的均衡？之前有接触过韩文吗？

对韩文的接触大多在电影、电视剧等银幕上出现的韩文。中韩文匹配这主要包括字型风格的匹配和版面效果的协调，阿丽达黑体简化处理了带有"钩"的笔画，稍微削弱了中文笔画的复杂性；在撇捺等笔画线条上保留了阿丽达韩文（Arita-dotum）柔美的弧度，线条优美自然。

阿丽达黑体是由16位设计师参与输出了15个设计方案。最终选择E-4方案的理由是什么？

经过多次提案和不断的对比字型，寻求与市面现有黑体不同，并可以与阿丽达韩文匹配的设计。在设计深化的阶段，着重看了字型与亭亭玉立、自然美丽、气韵生动这三个关键词的关联上。

简化中文"钩"的表现是一种破格吗？

有类似的字体吗？想了解中国的使用者有什么反馈？
中文目前还没有类似的字体，阿丽达黑体的这个设计亮点是汉仪设计师集体智慧的结晶，也是经过大家反复的推敲后，诞生的想法。大部分使用者对这个设计是接受的，一部分会很快注意到这个细节。

您觉得最至爱的或者最有难度的字是？

挚爱的字，这个问题还没想过，不过对产品名称的情感似乎不浅哦，就像妈妈给孩子取的名字吧~

作为阿丽达黑体的中文设计师，具有实验性或者挑战性的部分有哪些？

最有挑战性的部分大概在项目初期，团队内部相互磨合的时期，在大家对项目的理解程度各有不同的时候，找到什么样的方法适合推进工作比较具有挑战性。

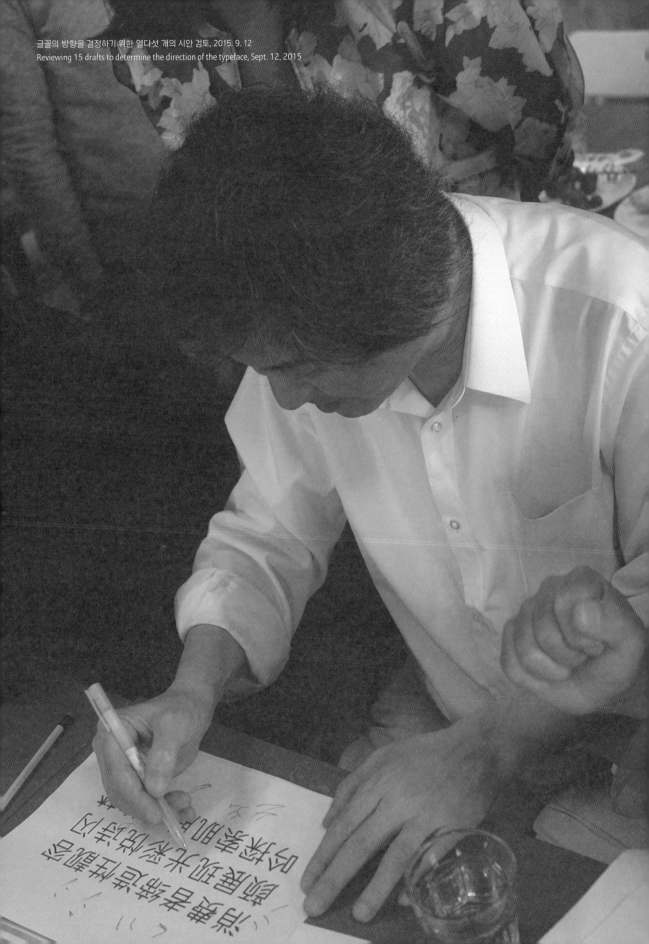

ABCDEFGHIJKL
MNOPQRSTUVWXYZ
abcdefghijklm
nopqrstuvwxyz{|}~
. : ; ' < = > ? @
* () ` [\] ^ _ `

Arita Chinese Medium 4.28

장쉬안 【아리따 흑체】

그래픽 디자이너. 중국 칭화대학교清华大学에서 건축학을 전공하고 미국 로체스터공과대학교Rochester Institute of Technology에서 그래픽 디자인을 공부했다. 현재 글꼴회사 한이에서 로마자 디자인팀을 이끌며 커스텀 프로젝트팀의 수석 팀장을 맡고 있다. '한이기흑체汉仪旗黑' '의송체意宋' '군흑체军黑' 등의 로마자 디자인에 참여했다. 아리따 흑체의 로마자 글꼴 디자이너로 참여했다.

Zhang Xuan 【Arita Heiti】

Graphic Designer. Zhang Xuan majored in Architecture at Tsinghua University and then studied graphic design at the Rochester Institute of Technology. At present, he leads the Latin alphabet design team and is chief team leader of the custom project team at Hanyi Fonts. He was involved in designing the Latin alphabet of Hanyi QiHei, YiSong, and JumHei. He also participated in the Arita Heiti project as its Latin alphabet designer.

아리따 흑체 프로젝트에 어떠한 계기로 참여하게 되었고
맡은 역할은 무엇이었는가?
아리따 흑체는 아모레퍼시픽의 전용 글꼴 가운데 가장 최근에
마무리된 프로젝트이다. 아리따 흑체 디자인의 목표는 브랜드의
정신을 구현하면서 한자의 다양한 수요를 맞추는 것이었다.
운이 좋게도 한이가 이 프로젝트에 참여했다. 내가 맡은 역할은
한자 글꼴 디자인 외 모든 알파벳과 문장부호 디자인 영역에
대한 관리였다. 디자인 작업에 필요한 기술적 요구 사항뿐
아니라 여러 부서가 소통해야 하는 작업에도 참여했다.

아리따 흑체의 바탕 생각은 정정옥립, 자연미려, 기운생동이다.
세 가지 바탕 생각은 글꼴에 어떻게 반영되었는가?
글꼴에 대한 이해가 부족한 클라이언트를 대할 때 글꼴을
사람의 이미지로 상상하게 하면 디자인 방향을 정하는 데
도움이 된다. 아리따 흑체의 경우 안상수 선생님 덕분에 초기에
세 가지 명확한 디자인 방향을 정할 수 있었다. 그중 '정정옥립'은
그 이미지를 쉽게 상상할 수 있었다. 글꼴에 적용해보면 글자의
폭이 좁아지면서 우아해지고 무게중심은 높아져 생기 있어
보인다. '기운생동'은 중국 화가 세허謝赫의 전통 회화 이론에서
비롯했다. 중국 심미審美의 최고 기준인 이 개념은 필획筆劃의
곡선에서 오는 활력, 글자 구조의 해체가 주는 여운 등으로
아리따 흑체 곳곳에 녹아 있다. '자연미려'는 추상적인 개념으로
글꼴로 설명하기는 어렵다.

아리따 흑체는 한글과 어울리면서 새로운 이미지를
갖고자 했다. 로마자 또한 이에 대한 고민의 흔적이 보인다.
한글과 어울리도록 아리따 흑체 로마자와 문장부호
디자인에서 고려한 점은 무엇인가?
아리따 돋움의 '가' '갸' 등에서 보이는 세로 줄기의 편안한
각도는 상징성이 있어서 통일할 가치가 있다고 생각했다.
이러한 아리따 돋움 필획의 특징을 아리따 흑체의 삐침, 파임,
갈고리에 반영했다. 아리따 흑체 로마자는 한글과 같은 시각적
개방감과 글자가 작을 때의 가독성을 높이기 위해 자모가
개방된 형태인 휴머니스트humanist의 글꼴 골격을 채택했다.
또한 필획의 끝맺음을 아리따 돋움과 비슷하게 처리해
제목용 글자 등으로 함께 사용했을 때 통일감이 들게 했다.

What made you take part in the Arita Heiti project,
and what was your role?
Arita Heiti is the latest project among Amorepacific's
exclusive typefaces. The goal of the Heiti design is to
meet the various demands of Chinese characters, while
realizing the spirit of the brand. Fortunately, Hanyi got
involved in the project. My role was to manage the design
of every alphabet and punctuation mark, except for all
the Chinese characters. I took part in works that required
not only technical skills for designing, but also close
communication between several departments.

The basic ideas of Arita Heiti are "a slim and slender
beauty," "a natural beauty," and "lively and vigorous
charm." How did you apply these ideas to the typeface?
When dealing with a client who doesn't have a strong
understanding of typefaces, letting them imagine a font
as a human image helps guide the design direction.
In the case of Arita Heiti, Ahn Sangsoo initially set three
clear design directions. Of these, the image of "a slim and
slender beauty" can easily be imagined. When applied
to a typeface, the width of the letters becomes narrower
and elegant, and the center of gravity becomes higher,
making it look more vibrant. The idea of "lively and
vigorous charm" comes from the traditional painting
theory of the Chinese painter Xie He. This concept—the
highest standard of Chinese aesthetics—is melded into
Arita Heiti through the vitality which stems from the
curves of the strokes and the lingering imagery of the
deconstructed letter structure. "A natural beauty" is
an abstract perception, and so it is difficult to describe
in the typeface.

Arita Heiti aimed to have a new image while
harmonizing with Hangeul. The Latin alphabet of
Arita Heiti also shows traces of deep consideration
behind it. What did you consider in designing the Latin
alphabet and punctuation marks of Arita Heiti so that
they would be in harmony with Hangeul?
The comfortable angle of the vertical stroke, seen in "가"
and "갸" with Arita Dotum, was symbolic. As a result,
it was considered worthy of applying it consistently.
We reflected the characteristics of the Dotum strokes
in *ppichim*, *paim*, and the hooks of Arita Heiti. For the
Latin alphabet of Arita Heiti, we adopted a humanist font
structure, which has open forms of letters, in order to
give the same visual openness as Hangeul and enhance
readability when letters are small. The finish of these
strokes was also treated similarly to Arita Dotum,
making it feel consistent when it was used together,
such as for titles.

중문에서만 쓰이는 문장부호가 있는가?
있다면 디자인할 때 유의해야 할 점이 있는가?
다른 언어와 다르게 어미 인용부호(【】〖〗)와 육각
인용부호(〔〕)가 있다. 중문에만 존재하기 때문에 오히려
고려해야 할 것이 많지 않다. 굵기를 일치시키면 된다.

아리따 흑체의 제작 과정이 다른 한자 글꼴 제작과
다른 점이 있었는가?
프로젝트 초기의 상황은 순조롭지 않았다. 첫 번째 시안이
난관에 봉착하자 한이의 모든 디자이너가 비장한 각오로
2차 시안에 참여했다. 재시도로 많은 것을 얻었고 최종적으로
약 스무 개의 시안을 제작했다. 현재의 아리따 흑체는 2차
시안의 다양한 요소를 모은 결과이다.

가장 애착이 가거나 어려웠던 낱글자가 있는가?
한국의 화폐 부호인 '₩(원)'이다. 한글 프로젝트가 아니면
이 부호를 그려볼 일이 없어 특별했다. 글꼴 디자인의 중요한
목표 중 하나가 사용할 때 어색함이 없게 하는 것인데,
'₩'은 필획이 한데 모여 있어 뭉쳐 보이기 쉬웠다. 중국인은
'¥(위안)'을 쓸 때 가로획을 한 개로 쓸지 두 개로 쓸지
늘 고민하기 때문에 한국인에게 '₩'의 가로획을 몇 개로
쓰는 것을 선호하는지 물어보기도 했다. 사소하지만 이런
섬세한 작업이 쌓여 글꼴이 완성된다.

아리따 프로젝트의 글꼴 디자이너로서 실험적이거나
도전적인 부분이 있었는가?
CJK 겸용 글자 작업이었다. 기술 실현 방법을 소통하는 역할을
맡으면서 처음으로 겸용 글자를 접하게 되었다. 간단하게
설명하자면 한국과 중국의 서로 다른 글꼴 표준 코드를 정리해
양국 사용자 모두 글꼴을 사용할 수 있게 하는 일이었다.
이 작업은 글꼴 사용자가 의식하기 어려운 부분이지만 세계화는
이런 보이지 않는 작업으로 이루어진다. 아리따 프로젝트에
참여해준 진쥔靳駿 외 엔지니어에게 감사의 말을 전한다. 그들의
작업은 좋은 글꼴을 만드는 것만큼 중요했다.

마지막으로 아리따 흑체 프로젝트의 주제어를 꼽는다면?
새로움, 세밀함, 우정이다. 이 프로젝트는 한이와 안그라픽스의
잊을 수 없는 경험이었다. 작업을 주제로 토론하고 글꼴을
다듬는 과정에서 언어를 뛰어넘어 우정을 느꼈다.

Are there any punctuation marks that can only be
used in Chinese? If so, what requires your attention
when you design them?
There are quotation marks like 【】, 〖〗, and 〔〕 in
Chinese. Since these are found only in Chinese, there's
not much to think about; you just need to match the
proper weight.

Was there any difference in the development of Arita
Heiti from other Chinese typefaces?
Things did not go smoothly at the beginning of the
project. When the first drafts hit a snag, every designer
of Hanyi played a role in the second drafts with resolute
determination. We learned a lot from the second attempt,
and in the end we finally produced about 20 drafts. The
current Arita Heiti resulted from assembling various
elements of these second drafts.

What was the most preferred or challenging character?
It was "₩," the Korean price unit mark. If not for the
Korean typeface project, I wouldn't have needed to draw
this symbol, so it became something special for me. One
of the critical goals of font design is to make sure that
there is no awkwardness when used, but ₩ could easily
seem like a lump because its strokes are so close to each
other. Chinese users are always concerned if they need
to write "¥ (yuan)" with one stroke or two, so I asked
some Koreans how they would prefer to write ₩, with
one stroke or two. It looks like a minor matter, but these
delicate tasks complete a typeface.

What was the most experimental or challenging part
as a type designer for the Arita project?
It was an ideograph design for all three CJK (Chinese-
Japanese-Korean). As I took on the role of communication
on how to realize the necessary technology, I first came
across these compatibility ideographs. In short, it was
about organizing different types of standard codes in
Korea and China so that people in the two countries could
use the typeface. It's a task that's difficult for users to be
cognizant of, but these invisible accomplishments really
represent globalization. I appreciate the engineers that
were a part of this, especially Jin Jun. Their jobs were as
crucial as developing a great typeface.

In conclusion, can you describe the Arita Heiti project
in a few words?
It symbolizes novelty, minuteness, and friendship.
This project was an unforgettable experience between
Hanyi and Ahn Graphics. I felt an affinity between
designers who transcended language in discussing work
and fine-tuning fonts.

阿丽达黑体是什么项目？您是如何参与到阿丽达项目的？您在项目中担任了什么角色？

阿丽达黑体（Arita Heiti）是ARMORE Pacific集团的品牌定制字体家族中最年轻的一员，主要设计目标是在体现品牌精神的前提下，满足中文环境下的各种使用需求。汉仪字库有幸参与了这个项目。我负责的部分是本项目中所有的非中文部分的拉丁文、标点符号设计指导。也参与了设计和技术之间的需求细化与检测等各部门的沟通工作。

阿丽达中文设计理念是亭亭玉立、自然美丽、气韵生动。想了解这三个设计理念是如何反映到字体设计中的。

面对很多不了解字体设计的客户，引导他们去想象字体是怎么样的人，以帮助他们确定设计意向。这次有安尚秀老师作为项目Director，帮助我们在项目初期很快得到了这三个非常明确的设计意向。比如设计理念中的「亭亭玉立」就是一个很容易想象的意象，反映到汉字字形上的特征就是字面收窄，显得修长优雅，而重心也相应提高。「气韵生动」源于谢赫对于传统绘画的相关理论，进而延展至中国审美的最高标准——这个概念几乎融入了字体的所有细节中，无论是推敲笔画弧度所获得的活力，还是重新解构的骨骼所带来的韵味。而「自然」「美丽」这种非常模糊的意向，甚至难以依靠单字来进行说明。

阿丽达中文与韩文既要协调也要含有新的形象。能看出阿丽达黑体的拉丁文对此考究的痕迹。阿丽达黑体的拉丁文、标点符号与韩文的协调性方面是如何考虑的？

Arita Dotum中谚文的가、갸等字母的撇画的舒展角度是非常有标志性的，这点很值得进行统一，所以汉字的撇、捺、勾等笔画都从中汲取了特征元素，而拉丁文主要为了视觉上有类似与谚文的开放感，并提高文字在小字号或远距离场景下的易认性，选择了字母会有比较开放的字腔的Humanist字形骨骼。拉丁字母的笔画末端角度等细节也会刻意和谚文寻求一致，这样它们作为标题字使用时统一度会非常高。

是否有只在中文里使用的、在韩文中不会出现的标点符号？设计时需要留意哪些部分？

比如中文特有的鱼尾引号【】〖〗和六角引号〔〕之类的。因为只在中文中存在，所以反而做起来不用考虑太多，保持粗细一致就可以了。

阿丽达黑体的开发过程如何？与其他中文字体的开发有差别吗？

阿丽达黑体的前期并不是一帆风顺的，尤其是在第一次提案陷入瓶颈之后，我们破釜沉舟地发动汉仪全体设计师进行了第二轮重新提案。最终我们收到了大约20份的方案。现在的阿丽达黑体是吸取了第二轮提案中的各种要素的集大成结果。

您觉得最至爱的或者最有难度的字是？

₩（韩元货币符号）。因为除了韩国的定制项目之外，很少会做到这个字，所以挺特别的。正文字体设计很大的一个目标就是让用户没有任何突兀感。这个符号除了笔画拥挤非常容易黑成一团之外，制作时候咨询了韩国人对于单横和双横的趋好——因为中国用户不是经常纠结¥到底是一横还是两横。似乎是很鸡毛蒜皮的事情，字体设计就是这么一个用细节堆砌出来的工作。

作为阿丽达黑体的中文设计师，具有实验性或者挑战性的部分有哪些？

CJK兼容性文字工作。作为技术实现方案沟通的角色，第一次接触CJK兼容性文字。简单解释的话就是整理韩国与中国相互不同的字库编码标准，让两国的用户都毫无问题地使用这个字体。这些工作是难以被用户感知的，但是全球化就是建立在这些看不见的工作上。在此也要特别感谢参与本项目的靳骏等几位工程师，他们的工作和我们呈现的优质字形同样重要。

最后，请问阿丽达黑体项目的关键词是什么？

新鲜，细腻和友谊吧。无论是汉仪字库还是AhnGraphics，都是一个难忘的合作经历，在一次次精益求精的细节沟通与打磨中，我们得到的就是跨越的语言的视觉设计师们的友谊。

展遇捩荪赐给苴

喱丝荷验潭耀

感英谬莼颜探

琉莓苓专幻夏

酸情萤容卢谧

致卤缔谒菠描

苞厅秀菊洁维

→ 공간이 넓다. 획으로 사각형을 채워야한다.

획이 더 부드러워야 한다.

마찬가지로
1획짜리가 그림으로 보인다.
글자의 개성으로 둘 것인지
규범을 맞출 것인지
정해야 한다.

크기가 작아서
글자가
내려앉아 보임
획이 더 짧아야

통일성 필요

글자의
폭을 위로
올려서 아래공간을
넓힘

획을 더 시원하게 바깥으로

다른 것과 통

①崔 ②崔

본래는 3획의 부수인데 5획으로 보

菜 [莹] 匏 境 刁 疵

花 撕 矿 燥 菜 罍

建 掷 潺 瑕 原 凄

眉 莜 针 富 将 淞

夜 素 籽 料 性 萎

羊 卧 流 潮 舒 康

方 套 靓 菱 薄 蠹

主

E-4 字样展示

동일한 필획이 다른 글자에서 나타날 때의 모습, 2016. 1. 24
Shapes when the same stroke appears in different letters, Jan. 24, 2016

彩幕美莉精类展碚荐莓酵彩褶
碳碜廷莜彪锄穆鬃窖层足屡
髶尺垒鹹康翘役脊僵伊
�菊兼菜伞件磊井
鬃静煎碳，罢

字面 1000
行宽 120mm

阿丽达

阿麗達

앞리ㄷ시-
(品)　(E)

荷惯镡冀鞴柒粉
镑兽施呵孟犒呓方
菝满规呶垛号鞴狒

堇羚彩褶

會鬈尺楪颜
菊粟。粟

EMbody Jewelry

likE

an

ar

Arita-dotum Bold
Arita-dotum Medium

글꼴의 방향을 결정하기 위한 열다섯 개의 시안 검토, 2015. 9. 12
Reviewing 15 drafts to determine the direction of the typeface, Sept. 12, 2015

아리따와 사람들

노은유 【아리따 돋움, 아리따 부리】
글꼴 디자이너. 활자공간을 거쳐 안그라픽스
타이포그라피연구소 책임 연구원으로 일했다. 활자공간에서
아리따 돋움 프로젝트의 회의 기록과 글꼴 파생을 맡았고
안그라픽스에서 아리따 부리의 프로젝트 매니저로 참여했다.

이환 【아리따 산스】
그래픽 디자이너. 2010년부터 2011년까지 안그라픽스
디자인사업부에서 아리따 3.0과 4.0 프로젝트에 참여했다.
아리따 산스의 디자이너인 미셸 드 보어, 피터 베르휠과
조율하고 소통하는 역할을 담당했다.

노민지 【아리따 돋움, 아리따 부리, 아리따 흑체】
글꼴 디자이너. 활자공간, 날개집, 안그라픽스를 거치며
아리따 프로젝트에 참여했다. 아리따 부리의 디자인 보조를
시작으로 아리따 돋움의 힌팅 작업을 진행했고, 이후
안그라픽스 타이포그라피연구소에서 아리따 흑체 프로젝트
진행과 감수를 맡았다.

Arita and People

Noh Eunyou 【Arita Dotum, Arita Buri】
Type designer. After working at Type-space,
Noh worked as a senior researcher at the AG
Typography Institute. She worked on the Arita
Dotum project, and was in charge of taking the
minutes at meetings and typeface derivation
when she was at Type-space. She also took part in
the Arita Buri project as project manager at Ahn
Graphics.

Lee Hwan 【Arita Sans】
Graphic designer. He was part of Arita project
3.0 and 4.0 at Ahn Graphics from 2010 to 2011,
mostly communicating with designers Michel De
Boer and Peter Verheul.

Noh Minji 【Arita Dotum, Arita Buri, Arita Heiti】
Type designer. Noh participated in the Arita
project while working for Type-space, Nalgaejip,
and Ahn Graphics. She started as an assistant
designer for Arita Buri, took part in the hinting of
Arita Dotum, and then carried out the Arita Heiti
project at the AG Typography Institute.

정준기【아리따 흑체】
그래픽 디자이너. 2014년부터 2018년까지
안그라픽스 디자인사업부에서 아리따 흑체 프로젝트의
매니저로 참여했다. 한국 측과 중국 측의 원활한
소통을 돕는 역할을 했다.

황리링【아리따 흑체】
그래픽 디자이너, 기획자. 아리따 흑체를 시작하기에
앞서 「아리따를 위한 중문 글꼴 리서치」 논문 연구와
집필을 맡았다. 이를 계기로 아리따 흑체의 중국 측
프로젝트 매니저로 참여해 중국 글꼴회사 한이,
중국 베이징중앙미술학원, 안그라픽스, 아모레퍼시픽의
소통을 담당했다.

구모아【아리따 확장】
글꼴 디자이너. 현재 안그라픽스 타이포그라피연구소
연구책임으로서 AG최정호스크린, AG훈민정음체 등 다양한
글꼴을 설계, 연구하고 있으며, APHQ 한글 글꼴의 프로젝트
진행과 감수를 맡았다.

Jung Junki【Arita Heiti】
Graphic designer. Jung was a project manager for
Arita Heiti from 2014 to 2018 in the AG design
business department. He was mainly in charge
of communication between those involved in the
project in South Korea and China.

Huang Liling【Arita Heiti】
Graphic designer and contents provider. Before
taking part in the Arita Heiti project, Huang
wrote a research paper titled "Chinese Typeface
Research for Arita." The publication of the paper
eventually led her to become a project manager
on the Chinese side of Arita Heiti, in charge
of communication between Hanyi, CAFA, Ahn
Graphics, and Amorepacific.

Ku Moa【Arita Extension】
Type designer. Ku is currently the research director
of the AG Typography Institute. She designs
and researches various typefaces, such as AG
Choijeongho Std. and AG Hunminjeongeum, and
is also conducting/supervising the APHQ Hangeul
font project.

아리따 프로젝트는 어떤 점이 특별한가?

노은유 많은 기업용 글꼴이 일회성 프로젝트에 그치는 것에 반해 아리따는 여전히 진행 중이다. 안상수 선생님이 '아리따 나무를 심자'라고 한 것과 같이 아리따는 '자라나는 나무와 같은 글꼴'이라는 점이 특별하다고 생각한다.

노민지 많은 사람의 의견을 듣고 조율하는 과정이 매우 흥미로웠다. 마감에 쫓기며 일을 처리하는 경우가 많은데 아리따 프로젝트는 늘 충분한 연구, 대화, 이견 조율의 과정을 거쳤기 때문에 기대 이상의 결과물을 얻을 수 있었다.

정준기 아리따는 10년 이상 진행된 프로젝트로 역사가 깊다. 긴 역사 덕분에 아모레퍼시픽과 안그라픽스는 신뢰 관계 속에서 작업할 수 있었고, 이는 프로젝트에 추진력을 더해주었다. 모든 참여자가 다른 외적인 요소보다 프로젝트의 목적인 '좋은 글꼴 만들기'에 집중할 수 있는 환경이었다. 아리따 프로젝트에 처음으로 참여한 중국 글꼴회사 한이와 중국 베이징중앙미술학원 5공작실 또한 이러한 역사가 지닌 의미를 알고 무거운 책임감으로 임해주었다.

구모아 아리따는 태어난 이후 여러 방향으로 가지를 뻗어 자라고 있다. 많이 고민하고 긴 시간을 들였기에 중심을 잃지 않고 글꼴 자체에 집중할 수 있었다. 긴 시간 프로젝트가 진행되며 거쳐 간 많은 사람의 생각이 모였다는 것이 아리따의 특별한 점이다.

아리따에서 새롭게 시도한 부분이 있는가?

노은유 아리따 돋움에서 곧은 기역(ㄱ)과 비례너비를 시도했다. 특히 곧은 기역(ㄱ)은 발표 초기에는 낯설다는 평이 많았는데 결국 그 낯선 형태가 아리따만의 아이덴티티가 되었다. 아리따 부리에서는 헤어라인 글꼴을 만든 것이다. 처음 류양희 선생님이 시안을 가져왔을 때 회의에 참여한 모두가 감탄했다. 그래서 원래 기획했던 씬을 빼고 헤어라인을 넣게 되었다.

What makes the Arita project so special?

Noh Eunyou While many corporate typefaces are usually only one-off projects, Arita is still a work in progress. As Ahn Sangsoo said, "Let's plant Arita trees." Arita is special in that it is a typeface growing like a tree.

Noh Minji The process of listening to and coordinating many people's opinions was very interesting. I often get caught up with deadlines, but the Arita project was always well-researched and discussed before coming to an agreement, so we often gained better results than expected.

Jung Junki Arita has been around for more than 10 years. As a result, Amorepacific and Ahn Graphics have been able to work in a relationship of trust, which added momentum to the project. It was an environment where everyone involved could focus on the project's purpose, which was "making a great typeface," rather than other external factors. Both Hanyi, a Chinese typeface company that was part of the Arita project for the first time, as well as the 5th Studio of the Chinese Academy of Fine Arts (CAFA), understood the significance of this project and assumed a significant responsibility.

Ku Moa Arita has been branching out in various directions since its birth. Participants took a lot of time thinking and focusing on the typeface itself, without losing the heart of what it represented. The special thing about Arita is that a lot of people's ideas were reflected in this project over a long period of time.

Were there any new attempts made with Arita?

Noh Eunyou In Arita Dotum, we tried a straight giyeok (ㄱ) that featured a proportional space. On top of that, we received comments about the straight giyeok (ㄱ), with people saying that its movements were unfamiliar right after its release. Ultimately, the unfamiliar form became the identity of Arita. A new attempt in Arita Buri was the creation of the HairLine font. When Ryu Yanghee presented a new draft design, everyone at the meeting was impressed. That's why we included HairLine, not Thin, which had been the original plan.

프로젝트를 진행하면서 언제 보람을 느꼈는가?

노은유 서점의 책에서나 길거리의 간판, 포스터에서 우연히 아리따와 마주칠 때면 아리따가 많은 사람에게 사랑받고 있는 것 같아 보람을 느낀다. 특히 일본 출장을 갔다가 나리타공항 안내판에 아리따 돋움이 쓰인 것을 보고 정말 반가웠다.

노민지 소논문 「아리따 흑체를 통해 본 중문 글자체」를 게재하고 한국타이포그라피학회 학술대회에서 발표하던 순간이 가장 보람 있었다. 상업적인 프로젝트가 학회 논문지에 정식 게재되고 학술대회에서 발표까지 한 사례는 드물기 때문에 발표 이후 여러 전문가의 주목과 찬사를 받았다.

이환 『아리따 산스 글꼴보기집』을 만든 것이 기억난다. 아리따 산스 개발을 기념하며 디자이너와 여러 담당자가 함께했던 워크숍에서 결과물을 가지고 이야기를 나눴다. 오랫동안 준비했던 프로젝트가 이제 끝난 것 같아 홀가분했던 것이 기억에 남는다.

정준기 중국의 훌륭한 글꼴 디자이너와 전문가가 함께 멋진 결과물을 만들어가는 과정을 본 일, 그들 옆에서 보조할 수 있었다는 사실이 큰 보람이었다. 안상수 선생님이 혜안과 끈기로 프로젝트를 이끌어가는 과정을 본 일도 큰 자극이자 배움이었다. 프로젝트를 마치고 중국 베이징중앙미술학원 미술관에서 아리따 흑체에 관한 전시와 강연이 열렸을 때 길었던 지난 모든 시간이 글꼴을 사용하는 이들에게 편리함과 아름다움을 주는 밑바탕이 되었음을 느꼈다.

구모아 아리따를 거쳐 간 사람들의 흔적을 보며 보람을 느낀다. 아리따의 긴 여정에 함께 손을 보태고 있다는 것과 나의 뒤를 이을 누군가가 지금의 기록을 보며 새로운 일을 만들어갈 것이라는 생각이 들어 뿌듯하다.

When did you feel rewarded in this project?

Noh Eunyou When I unexpectedly come across Arita at bookstores, on street signs or posters, I feel genuinely rewarded, as the typeface seems to be loved by so many people. It was really special to see Arita Dotum used on signage at Narita International Airport on one of my business trips to Japan.

Noh Minji It was the most rewarding moment for me when I published a short essay titled "Chinese Typefaces as Seen through Arita Heiti" and presented it at an academic conference of the Korean Society of Typography. It is rare that commercial projects are officially published in academic journals and presented at conferences, so Arita gained a lot of attention and earned praise from many experts after the presentation.

Lee Hwan I remember when I designed *Arita Sans Type Specimen Book*. We talked about the results of the project at a workshop that was held by designers and many staff members to celebrate the development of Arita Sans. I can still think back to how free it made me feel because such a long-term project was finally over.

Jung Junki Seeing all the incredible results being created by Chinese type designers and experts is amazing. I felt such a sense of fulfillment that I played a role in assisting them. It was also a great source of confidence—and learning—for me to see Ahn Sangsoo lead the project with such insight and persistence. When the exhibition and lecture on Arita Heiti were held at China's Central Academy of Fine Arts (CAFA) after the completion of the project, I felt that all our past efforts had laid the foundation for providing typeface users with greater convenience and beauty.

Ku Moa I feel a real sense of accomplishment when I see traces of people who have worked with Arita. I am proud of the fact that I have been a part of Arita's long journey and that someone will follow after me and create something new based on what we have achieved.

프로젝트의 진행 과정은 어떠했는가?

노은유 아리따는 수년에 걸친 작업 기간 동안 그 어떤 글꼴 프로젝트보다 많은 사람과 긴 회의를 진행했다. 그 자리에는 글꼴을 만드는 사람들뿐 아니라 아모레퍼시픽의 여러 담당자가 항상 자리했다. 지금 생각해보면 지루할 수도 있는 글자 이야기를 장시간 함께 들어준 분들에게 고마운 마음이 든다. 클라이언트로서 회의 결과를 보고만 받는 분위기가 아니라 직접 제작 과정을 보고 참여하려는 의지가 지금의 아리따를 만들었다고 생각한다. 아리따 부리를 만들 때는 주로 성북동 안그라픽스에서 회의를 했는데, 아침 일찍 조찬을 함께하기 위해 새벽 공기를 맡으며 회사를 향하던 기억이 아직도 선명하다.

노민지 많은 사람의 참여와 대화가 이 프로젝트의 핵심이었다고 할 수 있을 만큼 다양한 의견을 참고하고 프로세스에 대한 실험을 꺼리지 않았다. 특히 아리따 흑체의 초반 스케치 작업을 할 때 한이의 젊은 디자이너들이 적극적으로 참여한 것이 기억에 남는다. 도제식 작업이 보편적인 중국 디자인 회사에서 젊은 디자이너가 직접 참여해 시안이 채택된 것은 이례적인 일이었다.

이환 아리따 산스의 디자이너인 미셸 드 보어, 피터 베르휠과 주고받은 수많은 이메일이 기억에 남는다.

정준기 프로젝트는 전반적으로 순탄하게 진행되었지만, 초기에는 몇 차례 우여곡절이 있었다. 첫 여섯 달은 최상의 디자인을 찾기 위한 회의와 워크숍이 집중적으로 열린 시기로 모두가 긴장한 상태로 업무에 임했다. 글꼴 모양새의 첫 매듭을 잘 짓고 넘어가야 이후 파생 단계가 원활히 진행될 수 있기 때문이었다. 이때 한이에서 전 직원을 동원해 총 열다섯 개의 안을 가지고 왔던 일화가 기억에 남는다. 경력이 오래된 디자이너에서 신입 디자이너까지 총 열여섯 명이 참여했고, 가장 나이가 어린 팀장 류위의 디자인이 글꼴 전문가 워크숍을 통해 최종안으로 선정되었다. 좋은 디자인을 찾기 위한 여정은 경력과 상관없이 누구에게나 힘들고, 또 한편으로는 그만큼 평등하고 공정하다는 사실을 알게 해준 일이었다.

What was the procedure of the project like?

Noh Eunyou For Arita, we had long meetings with more people than for any other typeface project over the years. Amorepacific's staff was always there, as well as the type designers. Looking back on it now, I'm grateful to those who listened to long stories that might have been boring. I believe that the client's willingness to see and participate in the production process, rather than just receiving the reports on the results of the meetings, has made what Arita is now. In the Arita Buri project, people usually had meetings at Ahn Graphics in Seongbuk-dong, Seoul, and I still have a clear memory of going to work early in the morning for breakfast meetings.

Noh Minji We took many people's opinions into account and didn't hesitate to experiment with the process— so much so that many people's participation and conversations were the heart of the project. I especially remember when we were working on the early sketches of Arita Heiti. I recall that Hanyi's young designers were very active in their participation. It was unusual for someone so young to have their design proposal selected as the final draft at a Chinese design company, where apprenticeship was common.

Lee Hwan I still vividly remember plenty of e-mail correspondences with Arita Sans designers Michel De Boer and Peter Verheul.

Jung Junki The project went smoothly overall, but there were several twists and turns in the beginning. The first six months were filled with days of intense meetings and workshops to find the best design, and everyone worked nervously. That's because the first stage of the typeface shape needed to be made well before we could proceed to the derivation stage smoothly. At this time, I remember all of Hanyi's employees working on it, and eventually brought forth a total of 15 proposals. A total of 16 people, from senior to junior designers, participated. The youngest team leader, Liu Yu, had her design selected as the final draft after a typeface experts' workshop. That was when I realized that a journey to find a great design is a challenge for everyone, regardless of their career, yet equal and fair to all.

황리링 진행 과정은 먹구름을 헤쳐나가는 것과 같은
난관의 연속이었다. 한국과 중국이 처음으로 협업하는 글꼴
프로젝트이기도 했고 중국 내부에서도 기업을 위한 전용 글꼴
디자인이 일반적이지 않던 시점이었다. 그래서 글꼴 전문
분야에서 경험이 풍부한 한이도 새로운 협업 방식과 작업
프로세스를 구축해야 했다. 아리따 흑체의 이념인
'화이부동和而不同'의 핵심은 아리따만의 개성을 만드는 것인데
프로젝트 초기에 제안한 시안은 기존 흑체와 크게 다르지
않았다. 한이는 중국 출판을 기준으로 흑체의 구조를
유지하려다 보니 새로운 흑체를 선보이기 어려웠는데 지속적인
워크숍을 통해 해결점을 찾게 되었다. 국제 협업 프로젝트에서
서로를 이해하고 의견을 적극적으로 좁혀나가는 일이 얼마나
중요한지 깨닫게 해주었다.

구모아 현재 안그라픽스 타이포그라피 연구소에서 함께 일하는
김주경 연구원과 아리따의 또 다른 목소리를 만들고 있다.
아리따 프로젝트는 긴 시간 축적된 노하우가 있으며, 아리따만의
프로세스가 단단히 정립되어 있다. 현재 개발 중인 APHQ 한글
글꼴도 다른 아리따 프로젝트와 같은 단계를 밟아가고 있다.

글꼴에서 특별히 공을 들인 부분이 있는가?

노은유 글꼴에 대한 새로운 시도와 연구를 거듭했다. 글꼴을
개발하는 과정에서 논문을 발표하고 좌담회를 열고 그래픽
디자이너를 초대해 아리따를 활용한 전시를 열기도 했다.
아모레퍼시픽이 아리따에 애정을 듬뿍 쏟지 않았다면 이렇게
공이 많이 드는 일은 상상할 수 없었을 것이다.

황리링 아리따 흑체에서 가장 공을 들인 부분은 새로운
흑체 구조의 균형을 잡는 것이었다. 기존 흑체와 다른 구조에서
글꼴의 균형을 맞추는 것은 디자이너에게 큰 도전이자
모험이었다. 중국과 한국을 오가며 워크숍을 진행했고 글꼴
전문가의 도움을 받아 끊임없는 수정을 거쳐 아리따 흑체를
만들었다. 모든 단계에서 긴장을 놓을 수 없었기 때문에
단계별로 늘 힘들었다. 그러나 프로젝트를 진행하는 모두가
글꼴 전문가이며 품질 좋은 글꼴을 만들자는 목표가 명확했기
때문에 협업 과정에서 해결하기 힘든 어려움은 없었다.

Huang Liling The process was a series of challenges, like
navigating through the clouds. It was the first typeface
project that Korea and China had collaborated on, and
it was a time when designing an exclusive corporate
typeface was not common in China. Even Hanyi, with its
experience in the type foundry industry, needed to come
up with fresh ways to collaborate with each other and
manifest new work processes for the Arita project. The
core of Arita Heiti's ideology, "harmony in diversity (和
而不同)," is to create a unique personality for Arita. The
proposal for Arita Heiti's design at the beginning of the
project was not much different from the existing Heiti.
Hanyi tried to maintain the structure of Heiti based on
Chinese publications, so it was difficult to introduce a new
Heiti. However, through numerous workshops, we finally
found a solution. This made us realize how important
it is to better understand each other and openly discuss
opinions in an international collaboration project.

Ku Moa These days I'm working on another voice for
Arita together with researcher Kim Jookyung, who works
with the AG Typography Institute. The Arita project has a
great amount of know-how, and its unique work process
is firmly established. The APHQ Hangeul font, which is
currently in development, is taking the same steps with
other Arita projects.

**Is there any part of this typeface in which you made a
particularly special effort?**

Noh Eunyou Many new attempts and studies on
typefaces have taken place over the years. In the process
of developing this typeface, those involved presented
papers, held talks, and invited graphic designers to hold
exhibitions using Arita. If Amorepacific hadn't poured a
lot of effort into Arita, it would have been impossible to
bring about such a demanding project.

Huang Liling The most elaborate part of Arita Heiti was
striking a balance in the structure of a new Heiti. Creating
a balance in a typeface with a different structure from
that of the existing Heiti fonts was a big challenge—
and adventure—for designers. We conducted workshops
both in China and Korea, and created Arita Heiti after
continuous modification with the help of type experts.
Each step was always difficult because we couldn't really
relax at any level. However, there were no difficulties in
dealing with the collaborative process, as everyone who
worked on the project was a type expert, and the goal to
create quality fonts was clear.

아리따 프로젝트에서 영향을 받은 점이 있는가?

노은유 아리따는 내가 새내기 글꼴 디자이너로 사회에
첫발을 내디딜 때부터 함께한 글꼴이다. 안상수, 한재준,
이용제, 류양희 선생님이 이야기를 나누는 모습을 보고 들으며
많은 것을 배웠다. 그리고 단순히 시간에 맞춰 글꼴을
제작하는 것이 아니라 그 과정에서 연구하는 자세를 갖게
해주었다. 덕분에 글자 하나를 그릴 때도 생각이 많아져서
손이 느린 디자이너가 되었지만, 연구하는 글꼴 디자이너,
그것이 나의 정체성이 되었다.

정준기 아리따 프로젝트는 맡은 업무를 조금 더 주체적으로
생각하게 하는 훈련의 과정이었다. 수동적으로 움직이면
아무 일도 진행되지 않지만, 내가 생각하고 움직이면 일이
진행될 수 있음을 여러 차례 느꼈다. 이러한 교훈은 안상수
선생님이 보여주고 강조한 '주체적 태도'에서 배울 수
있었던 것이고, 디자이너로서 늘 되새기는 마음가짐이 되었다.

노민지 실무자 입장에서 아리따 프로젝트는 매우 지루한
싸움이기도 했다. 기본 2년이 넘는 시간을 헤매지 않고 진행하기
위해 꼼꼼하게 일정을 관리하고 자료를 정리해야 했다.
그 어떤 프로젝트보다 정확하게 기록을 해나가면서 프로세스에
대해 많이 배웠다.

황리링 단기 프로젝트에 익숙해져 있던 중, 5년의 장기
프로젝트에 참여한 건 아리따가 처음이었다. 글꼴을 만드는
과정을 함께하다 보니 글꼴에 대해 조금 더 진지해졌고
글꼴 제작의 무게를 깨달았다. 또한 글꼴이 사용자를 통해
새롭게 해석되고 활력을 얻는 것을 보며 글꼴은 만들어지는
순간부터 시작이라는 생각을 하게 되었다.

구모아 글꼴이 무엇인지도 잘 모르던 대학교 새내기 시절
아리따를 접했다. 현재는 함께 자란 소꿉친구 같기도 하고
함께 가는 동료 같기도 하다.

Were you influenced by the Arita project?

Noh Eunyou Arita is a typeface that has been a part of my
life since I entered the workforce as a junior type designer.
I learned a lot from conversations with Ahn Sangsoo, Han
Jaejoon, Lee Yongje, and Ryu Yanghee. Instead of just
making a typeface on time, they imparted on me the way
a researcher thinks in the process. Although I became very
thoughtful when drawing a single letter, which ultimately
slowed down my work, I also became a researcher in type
design, something that still defines me.

Jung Junki The project was a training process to think
of the work based more on my own initiative. There
were several times I felt that if I were passive about
the whole thing, there would be no forward progress.
However, I then thought, if I think and get going, things
can move forward. I learned this lesson from the sense
of independence that Ahn Sangsoo showed me and
emphasized time and again. It also became a constant
reminder for me as a designer.

Noh Minji The Arita project was also a very boring
fight from a working level staff member's point of view.
In order to keep the project going smoothly for more
than two years, we had to carefully manage the schedule
and organize the data. I learned a lot about work
processes while keeping more accurate track of these
work processes than any other project I'd worked on
before then.

Huang Liling While I was used to short-term projects,
Arita was the first long-term (five-year) project that
I worked on. The process of creating a typeface with
other people led me to be a little more serious about the
typeface, and made me realize the hardship associated
with typeface production. At the same time, as I saw the
typeface garnering compliments from users, I thought
that a typeface really does start its life from the moment
it is created.

Ku Moa I first learned about Arita as a university
freshman, someone who knew pretty much nothing
about typefaces. Today, I feel that typefaces are like
childhood friends I grew up with, and colleagues I now
work with.

다양한 한글 글꼴 중에서 아리따가 지닌 가치는
무엇이라고 생각하는가?

노민지 아리따 프로젝트는 글꼴을 함께 나누며 기업의
공공 이념을 실현했다. 결과물뿐 아니라 과정도 함께 나눴다.
사용자는 물론 디자이너에게도 큰 영감을 준 프로젝트이다.

정준기 짧은 주기로 생산되었다가 사라지는 글꼴이 범람하는
가운데 아리따는 하나의 글꼴이 얼마나 긴 수명을 가질 수
있는지, 가치를 알고 긴 시간 글꼴을 짓는 일이 얼마나 값진지
일깨워준다. 아리따 프로젝트와 같이 긴 안목으로 글꼴을
만드는 여건이 더 조성된다면, 한글 타이포그래피뿐 아니라
한국의 시각 문화 전반에 건강한 토대가 만들어질 것이다.
더불어 최근에는 다국어 타이포그래피 환경의 개선이 대두되고
있기에 한글과 로마자, 한자를 함께 개발한 아리따가 미래를
향한 길목에서 좋은 선례가 될 수 있다.

아리따 글꼴 확장에 대해 어떻게 생각하는가?

노은유 먼저 아리따 세리프, 아리따 송체와 같이 비어 있는
글꼴가족을 채워나가야 하고 다른 언어도 만들어지면 좋겠다.
또한 아리따 배리어블variable과 같이 새로운 기술에도 유연한
글꼴이 되어야 한다. 그동안 보여주었던 것처럼 새로움을
두려워하지 않는 아리따의 도전 정신이 계속되길 바란다.

마지막으로 아리따 프로젝트를 몇 가지 주제어로 표현한다면?

노은유 '성장하는'이라는 형용사로 말하고 싶다. 앞으로도
아리따 나무가 무럭무럭 자라서 울창한 숲이 되길 바란다.

노민지 디자인의 정석, 대화, 실험, 퀄리티.

정준기 지속성, 사회공헌, 아름다움.

황리링 씨앗, 환기, 관계.

구모아 성장, 새로움, 기록, 가족.

What is the unique value of Arita compared to other
Hangeul typefaces?

Noh Minji We shared the Arita project's typeface
with the public, living up to its pledge to make the
company more public. The project greatly inspired not
only users, but also designers by sharing the output and
the work process.

Jung Junki With a flood of typefaces that are produced
and disappear in a short cycle, Arita reminds you of how
long a typeface can have a life and how valuable it is
to build a typeface by spending a long time on it. If the
conditions for creating typefaces in the long run like the
Arita project are further created, a healthy foundation
will be laid not only in Hangeul typography, but also
in overall Korean visual culture. In addition, with the
recent improvement of the multilingual typography
environment, Arita—which developed Korean, Latin,
and Chinese characters together—can serve as a solid
precedent for the future.

What do you think of the expansion of the Arita typeface?

Noh Eunyou First, it's necessary to fill in the missing parts
of the font family, such as Arita Serif and Arita Songti, and
I hope fonts for other languages will also come about.
In addition, a new creation should be a flexible typeface
for new technologies, such as Arita variable. As has been
shown so far, I hope that Arita's pioneering spirit will
continue without any fear of newness.

Finally, describe the Arita project in a few keywords.

Noh Eunyou I'd like to say it is "growing." I hope that
Arita trees will grow rapidly and become a dense forest in
the future.

Noh Minji Standard procedure of design, conversation,
experiment, and quality.

Jung Junki Sustainability, social contribution, and beauty.

Huang Liling Seed, thought-provoking, and relationship.

Ku Moa Growth, newness, documentation, and family.

ssahn@ssahn.com

보낸 사람:	ahn sang-soo <ssahn@chol.com>
보낸 날짜:	2004년 9월 8일 수요일 오후 5:13
받는 사람:	이재만-jae
제목:	Re: 전화메모. 2004.09.08

011 9911 5069

----- Original Message -----
From: 이재만-jae
To: 안상수
Sent: Wednesday, September 08, 2004 4:30 PM
Subject: 전화메모. 2004.09.08

태평양 디자인팀 이태경씨에게서 전화왔었습니다.
02-709-5430

이상입니다.

아리따.글꼴.멋지음.열여섯.해는.아리따.고운.글씨를.널리.심고.
꽃피우기.위한.긴.여정이었습니다..'나눔'을.드높은.가치로.둔.기업을.만나.
함께.걸었던.길이어서.무엇보다.즐겁고.뜻깊었습니다..

It.took.us.16.years.to.develop.the.Arita.typeface..
This.was.a.long.journey.to.plant.and.flower.beautiful.types..
It.was.both.enjoyable.and.meaningful.to.walk.alongside.
a.company.that.puts.sharing.as.its.highest.value..

아리따를.만드는.과정은.마치.새로운.씨앗을.만드는.것과.같았습니다..
좋은.씨앗.하나를.만드는.것은.하루.이틀에.할.수.있는.일이.아닙니다...우리.문화에.
심을.씨앗을.만든다는.생각을.모았기에.긴.시간에.걸쳐.이루어낼.수.있었습니다..

The.process.of.developing.Arita.was.like.creating.a.new.seed..
Making.a.good.seed.is.not.something.you.can.do.in.a.day.or.two..
We.were.able.to.do.it.over.a.long.period.because.we.shared.the.idea.
of.creating.a.seed.for.our.culture..

앞으로도.묵묵히.제자리에서.아리따.씨앗으로.아름드리.나무를.꿈꾸며.
나눔을.위한.멋지음에.즐거이.힘쓰겠습니다..

안상수, 아리따 글꼴 디렉터

We.will.continue.to.dream.of.large.trees.growing.from.the.Arita.seeds.
we.have.planted,.and.work.hard.on.future.designs.to.share.with.the.public..

Ahn Sangsoo, Director, Arita Typeface Project

글꼴 디자인 | Type Design

아리따 돋움 / **Arita Dotum**

총괄 디렉터	안상수
글꼴 감수	한재준
글꼴 디자인	이용제

Director	Ahn Sangsoo
Type Supervisor	Han Jaejoon
Design	Lee Yongjae

아리따 산스 / **Arita Sans**

총괄 디렉터	안상수
글꼴 감수	미셸 드 보어
글꼴 디자인	피터 베르휠

Director	Ahn Sangsoo
Type Supervisor	Michel de Boer
Type Design	Peter Verheul

아리따 부리 / **Arita Buri**

총괄 디렉터	안상수
글꼴 감수	한재준
글꼴 디자인	류양희

Director	Ahn Sangsoo
Type Supervisor	Han Jaejoon
Type Design	Ryu Yanghee

아리따 흑체 / **Arita Heiti**

총괄 디렉터	안상수
글꼴 디렉터	주즈웨이
글꼴 감수	왕쯔위안, 치리, 류융칭, 노민지, 정하린
글꼴 디자인	류위, 류옌란, 장쉬안

Director	Ahn Sangsoo
Type Director	Zhu Zhiwei
Type Supervisor	Wang Ziyuan, Qi Li, Liu Yongqing, Noh Minji, Jung Harin
Type Design	Liu Yu, Liu Yanran, Zhang Xuan

아리따 글꼴 여정 | The Journey of Arita

기획	아모레퍼시픽
프로젝트 관리	허정원, 이오경, 강유선
제작	(주)안그라픽스
총괄 디렉터	김성훈
아트 디렉터	안마노
콘텐츠 디렉터	윤주현
디자인	박유선, 양효정
디자인 도움	노서아, 우수민
자문	노은유
리서치	김지화, 박윤수, 이민주, 이홍유진
편집	서하나
교정·교열	소효령
번역	이기은, 김현경
번역 감수	리처드 해리스
인쇄	효성문화

발행일	2020. 8. 1
펴낸이	안미르
펴낸곳	(주)안그라픽스
	10881 경기도 파주시 회동길 125-15
ISBN	978.89.7059.2268(93650)
CIP	2020031091

Commissioner	Amorepacific
Management	Heo Jungwon, Lee Ohkyung, Kang Yousun
Production	Ahn Graphics Ltd.
Creative Director	Kim Sunghoon
Art Director	An Mano
Contents Director	Yoon Joohyun
Designers	Park Yuseon, Yang Hyojung
Design Assistants	Nho Seoa, Woo Sumin
Advisor	Noh Eunyou
Researchers	Kim Jihwa, Park Yoonsue, Lee Minjoo, Lee Hongyoojin
Editor	Sur Hana
Proofreader	Soh Hyoryeong
Translators	Rhee Kieum, Kim Hyunkyung
Translation Supervisor	Richard Harris
Printing	Hyosung Printing

First Published	August 1, 2020
Publisher	Ahn Myrrh
Publishing House	Ahn Graphics Ltd.
	125-15, Hoedong-gil, Paju-si, Gyeonggi-do, Republic of Korea
ISBN	978.89.7059.2268(93650)
CIP	2020031091